Patrick Chaleyssin

James McNeill Whistler

Grange BOOKS

Text: Patrick Chaleyssin

© Confidential Concepts, worldwide, USA
© Sirrocco, London, UK, 2004 (English version)

Published in 2004 by Grange Books
an imprint of Grange Books Plc
The Grange Kingsnorth Industrial Estate
Hoo, nr Rochester Kent ME3 9ND
www.Grangebooks.co.uk
ISBN 1 84013 572 7

Printed in Singapore

Contents

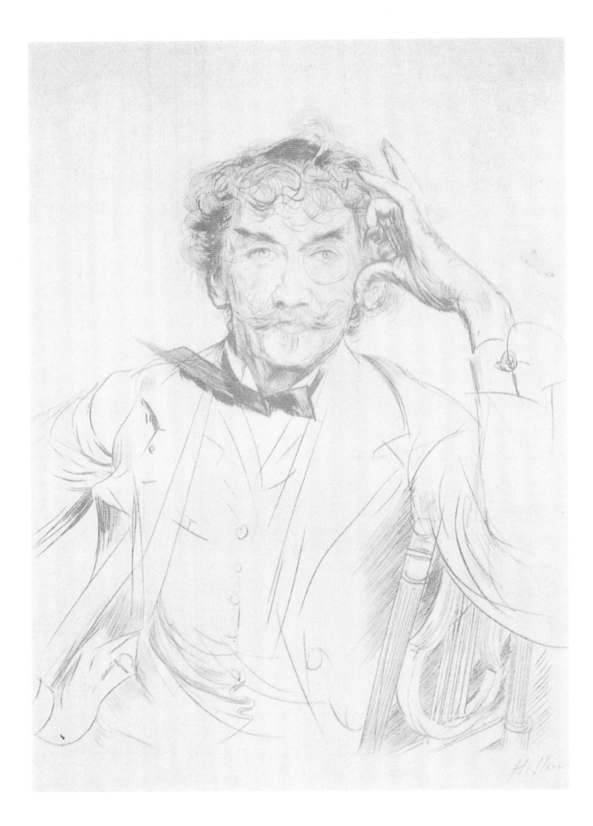

PREFACE

Whistler suddenly shot to fame like a meteor at a crucial moment in the history of art, a field in which he was a pioneer. It was not by chance that the painter settled in London. Europe was, at the time, the greatest artistic and aesthetic battleground and this artist had a suitably combative temperament. Like the Impressionists, with whom he sided, he wanted to impose his own ideas. Whistler's work can be divided into four periods. The first was a research period in which the artist was influenced by the Realism of Gustave Courbet and by Japanese art. Whistler then discovered his own originality in the *Nocturnes* and the *Cremorne Gardens* series, thereby coming into conflict with the academics who wanted a work of art to tell a story. When he painted the portrait of his mother, Whistler entitled it *Arrangement in Gray and Black* and this is symbolic of his aesthetic theories. When he painted the Cremorne Pleasure Gardens it was not to depict identifiable figures, as did Renoir in his work on similar themes, but to capture an atmosphere. He loved the mists that hovered over the banks of the Thames, the pale lights, the factory chimneys which at night turned into magical minarets. Night redrew landscapes, effacing the details. This was the period in which he became a precursor and adventurer in art; his work, which verged on abstraction, shocked his contemporaries. The third period is dominated by the full-length portraits which brought him his fame. He was able to imbue this traditional genre with his profound originality. He tried to capture part of the souls of his models and placed the characters in their natural habitat. This gave his models a strange presence so that they seem about to walk out of the picture to come towards us. By extracting the poetic substance from individuals, he created portraits described as mediums by his contemporaries, and which were the inspiration for Oscar Wilde's *The Picture of Dorian Gray*.

Toward the end of his life, the artist began painting landscapes and portraits in the classical tradition, strongly influenced by Velasquez. Whistler proved to be extremely rigorous in constantly ensuring that his paintings coincided with his theories. He never hesitated in crossing swords with the most famous art theoreticians of his day. His famous lawsuit against John Ruskin is an outstanding example. How could two people who were so enamored of aesthetics, so deeply in love with art, find themselves in such violent opposition? Whistler the American sowed ill-feeling into an art world defended by Ruskin, Turner's friend; it was a great moment. He delivered lectures to explain his theories about art and published a work whose very title is a delight – *The Gentle Art of Making Enemies*. As a pioneer and forerunner in so many ways, Whistler was one of the first to conceive the idea of the total exhibition. When he held one-man shows, he handled the entire event, from the decor of the location to the attendants' uniforms, and even the invitation cards, thus maintaining his standards of overall consistency. Whistler – like William Morris in a different way – was among the first to consider interior design as an art form.

He created inspirational decorative backgrounds both for himself and for others. His personality, his outbursts, and his elegance were a perfect focus for curiosity and admiration. A close friend of Stéphane Mallarmé, admired by Marcel Proust who rendered homage to him in *A La Recherche du Temps Perdu*, a provocative dandy in the vein of Beau Brummel or Théophile Gautier, a prickly socialite, a demanding artist, he was a daring innovator.

His life is a cloak-and-dagger romance in the tradition of *Cyrano de Bergerac*, a rousing adventure which should serve as an inspiration to a young generation.

1. *James A. McNeill Whistler,*
 after a drypoint by Paul-César Helleu.

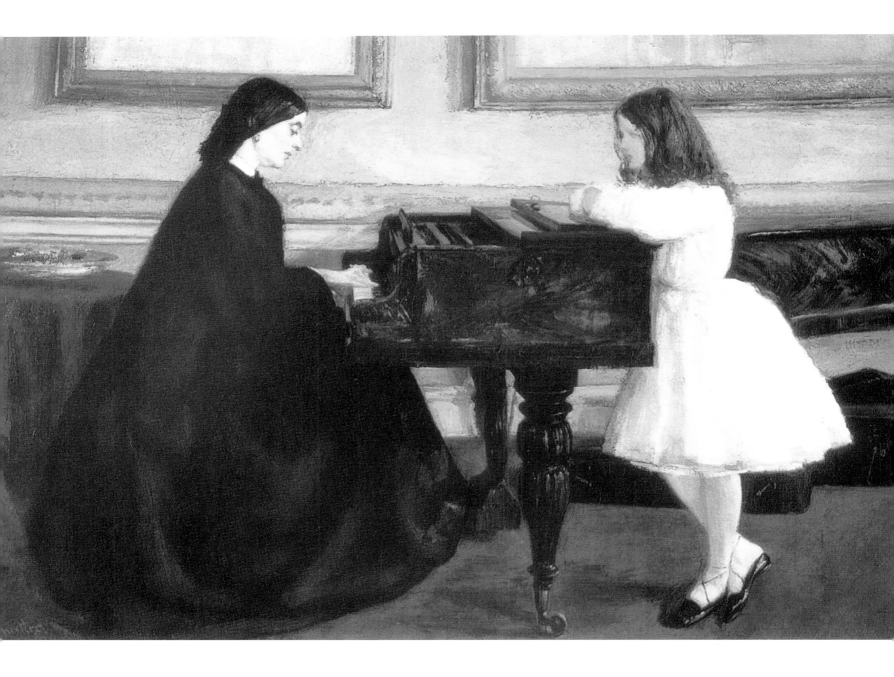

BORN UNDER A WANDERING STAR (1834-1863)

During the last half of the 19th century, three American artists were to work in Europe, mainly in England and France. Each of them was to play an important role. Mary Cassatt participated in the Impressionist movement in France, John Singer Sargent was to be considered one of the greatest painters of his day, and James McNeill Whistler, to whom this biography is dedicated, was to create a completely original style.

James Abbott McNeill Whistler was born on July 10, 1834 in Lowell, a little town in Massachusetts. His family could trace their origins back to 13th-century England; it was a line full of clerks and soldiers who had settled in the Thames Valley. The American Whistlers were descendant of John Whistler, who belonged to the Irish branch of the family. James' father was a graduate of the West Point military academy. He took Anna Mathilda McNeill as his second wife. Whistler was a railroad engineer in Lowell, and this is where James and his two brothers were born. In 1842, Nicholas I, Tsar of Russia, chose John Whistler to build him a railroad from St. Petersburg to Moscow and Major Whistler left for Russia. On August 12, 1843, a year after her husband's departure, Mrs. Whistler and her children took the same route and left for Boston on a journey which at the time was long and dangerous. The Whistlers stayed in London for two weeks, then traveled to Hamburg where they embarked on the steamship *Alexandra*, bound for St. Petersburg. During the trip, the youngest son fell gravely ill and died. James was nine years old at the time. Despite his strict upbringing, the child encountered many of the influences which were to shape his future career as an artist. He was allowed relative freedom at home. When the town was lit up on winter nights, everyone stayed up late. Ice-skating or canoeing parties were organized and visits from other American families prevented too brutal a feeling of displacement. In the spring of 1844, the Whistlers rented a house by the road to Peterhof, the town which was originally founded as the Tsar's summer residence, near St. Petersburg. They all went together to Tsarskoye Selo, the "Russian Versailles" which had been built in 1714 by Peter the Great.

Whistler and his family then visited the palace standing in its magnificent park, which was considered among the greatest in the world. Colonel Todd, who represented the American government, took them to visit the palace built by the Empress Catherine. Here they often attended the events held at the Tsar's court and in the evening the child marveled at the fireworks and the military parades of foot soldiers and cavalry. The Scottish artist Sir William Allen was a frequent visitor to the Whistlers', and James greatly enjoyed the conversations which he heard in the drawing-room. In her journal, his mother recorded, "Jemmie took such an interest in the discussion that we immediately discovered his passion for art. He had to show his sketches to Sir William Allen." Once the children were in bed, the painter took Mrs. Whistler aside

2. *At the Piano*. 1858-1859. 26 x 36 in. (67 x 91 cm). Taft Museum, Cincinnati, Ohio.

and confided to her, "Your son has an exceptional talent." She would later say, "Often, at eight o'clock I was still reading and sewing with a lamp, and I could not persuade James to leave his drawing and go to bed before nightfall." Of these first attempts there remains a portrait of his aunt, Alicia McNeill, who visited Russia in 1844. From his time in St. Petersburg, Whistler retained a passion for fireworks. He was then a student at the Academy of Science and could only draw in his leisure hours. He and his brother were boarders and only went home on Saturdays. They had to wear a uniform, their short hair topped with a black felt beret. James spent his time drawing and leafing through a large volume of engravings by Hogarth, whom he would always consider to be England's greatest artist. On March 23, 1847, the major was rewarded for his work by being received by the Tsar. But a cholera epidemic had broken out in St. Petersburg. Mrs. Whistler had to leave hurriedly for England with her children. James was convalescing after a serious attack of rheumatic fever. He spent his time aboard the ship making drawings. In England, the family attended the wedding of Whistler's half-sister and Seymour Haden (1818-1910), a doctor who was also a well-known engraver. In England, the young James enjoyed walking along the shore. He would sit on the sand and make sketches. On November 9, 1849, Major Whistler died without ever seeing his family again, and the repercussions of his demise on the family finances forced them to go back to Connecticut, where they settled at Pomfret. James was now a tall, lanky teenager with a slender figure and a mild expression. He had a vaguely European air which combined with his natural gifts gave him great charm. In short, a delightful youth whom everyone loved. Despite his mother's strictness, his personality began to show through and his opinions started to take shape. He was a wilful yet helpful youngster, considerate and with a strong sense of humor. He would retain his sense of humor throughout his life, but would frequently hide it behind a serious outward appearance, thus creating a sort of "hot and cold" impression, and a sarcasm which would hurt his victims more than mere jokes.

He continued his studies at a religious academy run by a man with a severe nature who had a puritanical mode of dress. One day, Whistler decided to amuse himself at the expense of this gentleman by turning up in the school playground dressed in a stiff white collar and a tie similar to those worn by the headmaster. His school friends tried to conceal their mirth. The offense was dissimulated behind what passed for homage to the principal, so it was difficult to punish and the victim had to contain his anger. However, he decided to pay special attention to this mocking pupil and took advantage of a subsequent prank to pounce on him, cane in hand. Whistler tried to escape but was unable to avoid a severe caning which caused him more amusement than pain. The Whistlers and the McNeills both had a tradition of military men in the family. James's mother, despite her awareness of his artistic gifts, fully intended to send him to a military academy to ensure that he had a career worthy of the family name. She thus tried to enroll him at the greatest military academy in the United States, West Point, which he entered in 1851 thanks to the intervention of President Fillmore himself. Even in his first year, his examination results were revealing: he was first in drawing, but thirty-ninth out of forty-three in philosophy and last in chemistry (asked about the nature of silicon, he replied that it was a gas).

One day, in the art class he drew a young French peasant girl. The professor went from table to table examining the work of his students, then returned to his desk to take up the paintbrush and ink with which he was in the habit of correcting their work. As he approached Whistler, the young man saw him

coming and raising a hand to ward off the paintbrush, exclaimed, "Please sir, don't do anything to it, you'll ruin it." The teacher smiled understandingly and moved away... James showed his ignorance of history by not knowing the date of the Battle of Buena Vista. "But if you dine with friends," he was asked, "the conversation might turn to the Mexican War and if someone were to ask you the date, what would you say?" "What would I say?", replied Whistler, "I would refuse to converse with people who speak of such things at table!" During horseback riding lessons, Whistler was often thrown over his horse's head. On one such occasion, the major instructing the cadets remarked, "Mr. Whistler, I am happy to see you at the head of the class for once." His fellow cadets would retain the memory of a young man who was quick-tempered but likable. His short-sighted stare and rumpled hair gave him a neglected air. He was fond of food and often gave in to his gastronomic impulses, which he would satisfy unhesitatingly by sneaking out of school to buy buckwheat cakes, oysters, and club soda. He took little notice of the academy's discipline and the disapproval of his lateness and his careless dress. In the three years he spent at West Point, Whistler would decorate his exercise books with caricatures of his fellow cadets, his teachers, and illustrations of the works of Victor Hugo, Alexandre Dumas or Charles Dickens, evidence of his European background and strong personality. He admired the strictness of the academy's training, the values which were defended there and the impeccable uniforms. Guided, like his fellows, by a sense of honor, James could not prevent himself from revolting internally against its traditions, despite his respect for certain ideas of chivalry. Like Edgar Allan Poe, his predecessor at West Point, the young man was not cut out for a military career, being incapable of submitting himself to the strict discipline. He was informed of his dismissal in June, 1854. Nevertheless, he remained quite proud of having spent some time at West Point, where one entered as a child and always came out a man. These three years were decisive for his character. The discipline (even if accepted with an ill grace) had forged a moral force which would help him cope with life's difficulties. He had also learned how to fight there.

Much later, in England, he was always eager to hear news of West Point and showed his attachment to the school when he sent the library a copy of his pamphlet, *Whistler v. Ruskin: Art and Art Critics*, with the following dedication: "Souvenir of an alumnus who glories in his years at West Point." After leaving the academy, Whistler was apprenticed at a locomotive factory in Baltimore and spent his days wandering around the workshops and offices. Frederick B. Mehrs, one of his colleagues, recounts that Whistler was in the habit of doodling on his worksheets, which enraged his workmates. One of these drawings, a symbolic one, no doubt, represents a gentleman locked in a dungeon with only a tiny window, everything lit as in a Rembrandt painting. Soon, the boredom became intolerable, and Whistler left Baltimore.

On November 7, 1854, he joined the Geodetic Coastal Survey thanks to an old friend of his father's, Captain Benham, who was then director of the Survey. Here again, he found he disliked office routine and did his work without enthusiasm. Mapping and the constraints which cartographic drawing imposed soon became as unbearable to the young man as military discipline. Mehrs later recalled that James was often late and that in January he only did six and a half days' work, while in February he only spent five and three-quarter days in the office. When he was reproached for his tardiness, the young man replied that he deeply regretted it but it was not his fault if the office opened too early. Whistler led a very active social life. He was often to be seen at receptions, dressed in the latest fashion, including a Scotch bonnet.

Following pages:
3. *Wapping*. 1860-1864. 28 x 39 in. (71.1 x 101.6 cm). Signed and dated Whistler 1861. National Gallery of Art, John Hay Whitney Collection, Washington.

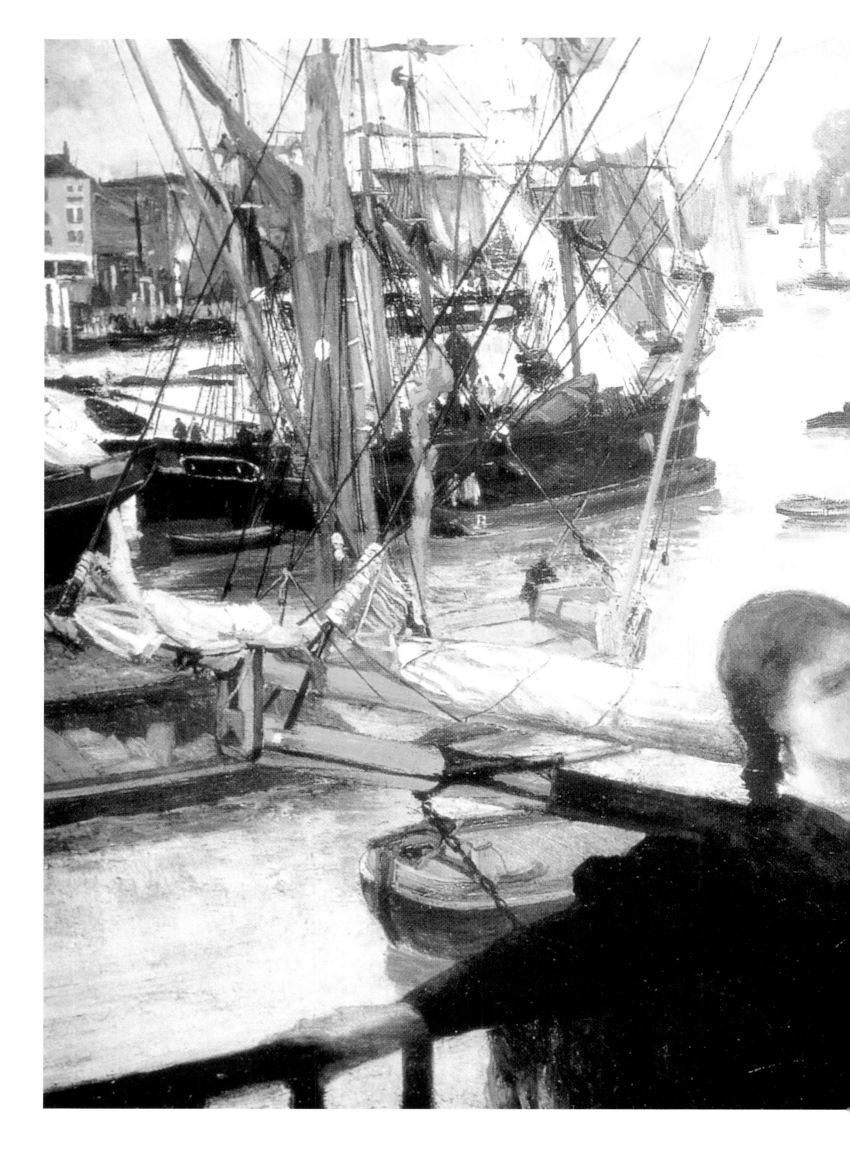

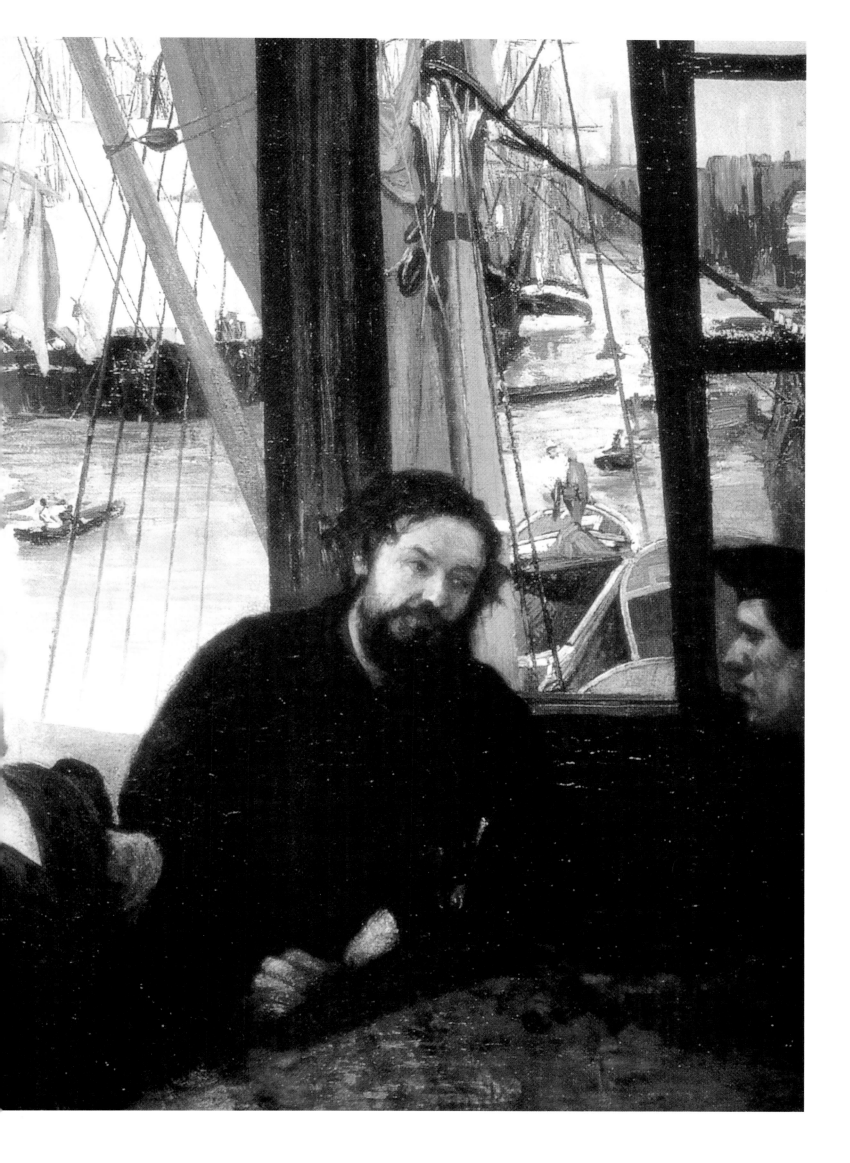

His delicate features bore a tender yet alert expression which belied his impulsive and often violent nature. The young James Whistler was passionate about drawing and painting and despised anything not directly related to it. The maps on which he worked were very laborious, needing to be created meticulously on copper plates. He used any blank space to make sketches. Examples of this can be seen in etchings of his entitled "Outline of a Coast Plate No. 1" and "Outline of a Coast Plate No. 2; the Island of Anacapa." On the first, one sees two perspectives of rocky coasts. A town is represented in the background. Whistler could not content himself with doing what he was asked to do. Smoke rises from the chimneys, and at the top of the engraving he had sketched profiles of human heads, including an old lady, an Italian wearing an enormous hat and a French soldier. On another plate, there is a flight of birds which from a topographical point of view could not possibly be of importance. Whistler was regarded as something of a practical joker. Benham, the director, was in the habit of touring the workshops to check the work of the engravers, looking at them through their own magnifying glasses.

Whistler had engraved an image of a little demon on his magnifying glass. One can imagine the director's surprise when, putting the glass to his eye, it revealed a huge mocking devil (Twenty years later, Whistler would be visited by an old man carrying a magnifying glass on a chain who would invite him to look through it... That evening, the two men exchanged happy memories). James became very bored in the Geodetic Coastal Survey and resigned in February, 1855. Yet, as in the case of West Point, the few months he had spent at the office were of great importance for his career. In fact, he had learned how to make etchings, a technique in which he would come to excel.

As soon as Whistler came of age, he decided to go to Paris with an annual allowance of 350 dollars from his family. Since he had learned to speak and write French from an early age, while living in Russia – his conversation and his writings were peppered with French phrases – he had no problem with the language from the moment he arrived in the French capital. Major Whistler's son was received at the United States legation and in the British pavilion at the Universal Exposition. The artist Gustave Courbet had been refused a place to show his works at the official exhibition and launched his first manifesto on behalf of the Realist School of painting. Whistler became friendly with the artist and thus began a relationship with the Realists. This is how he met Fantin-Latour and Edgar Degas. On November 9, 1855, the young engineer enrolled at the Ecole des Arts Décoratifs (School of Applied Arts) in the famous studio of Lecoq de Boisbaudran. He never dreamed of entering the Ecole des Beaux-Arts, Paris's leading school of art, but like his English friend George du Maurier, he became a pupil of Charles Gleyre in 1856. Gleyre was a well-known teacher of painting, who had inherited the Delaroche studio.

The master welcomed into his studio those who wanted to escape the influence of classes in which the teaching was too classical. They attended Gleyre's courses, which he gave for free, in parallel with the schools of art, or after classes. Gleyre's teaching was original, based as it was on personal theories which horrified the academic painters. He recommended preparing color on the palette before beginning to paint.

Whistler adopted this technique, which had the advantage of releasing the painter from constraints, leaving him completely free to work on the modeling. The master also taught that ivory black is the basis of all hues, because when mixed with other colors, it gives very subtle shades. At Gleyre's workshop, Jimmie Whistler met Edward Poynter, Frederick Leighton, Thomas Armstrong and Alico Ionides, who called themselves the "The Trilby Group" and who

4. *Blue and Silver; Blue Wave, Biarritz.* 1862. 24 x 34 in. (62.2 x 86.4 cm). Hill-Stead Museum, Farmington, Connecticut.

would become well-known English painters twenty years later, as well as Rodin, Dalou, Bazire, Regamery, Quentin, Legros…

Whistler became something of a character by walking through the streets with his unusually wide-brimmed straw boater, worn slightly askew. Sometimes he would replace the hat with a soft felt one trimmed with a large black ribbon. The art students led unorthodox lives and were deeply contemptuous of ordinary mortals. The combination of the English and American good manners learned in St. Petersburg and West Point, and "artistic", eccentric, and sardonic behavior was an explosive mixture. Whistler did not work very hard (one of his projects was to copy, with Tissot, *Angélique*, the painting by Ingres) and enjoyed himself greatly, sharing a room with Poynter for a while. In a speech to the Royal Academy of Art in 1904, after Whistler's death, Edward John Poynter declared, "I was very attached to Whistler at first; I knew him very well when he studied in Paris, if working for about eight days a year can be called studying. Before coming through, his genius had to triumph over the laziness and love of pleasure which is the trait common to all art students."

James moved to a little hotel on the Rue Saint-Sulpice near his friends, the painters Delannoy and Drouet. They would meet in a restaurant in the nearby Rue Dauphine, of which the owner's son, called Bibi Lalouette, is immortalized in an etching, the only way in which Whistler could pay the debts he had accumulated in this establishment. He would normally rise at 11:30 a.m. or midday, and go out with his sketchpad to make quick sketches of scenes from everyday life. He was feared for his sudden outbursts of anger and several years after he had left, he was still talked about in the neighborhood. He was a favorite among the "bar-girls" of those days. The one he liked best was Héloise, who would recite verses from Alfred de Musset while she was posing and would tear up the artist's drawings when she was angry. Whistler then took on a calmer model of a completely different type, "Mère Gérard" the old woman who sold flowers and matches at the gate of the Luxembourg Gardens.

Unlike most of his friends, James lived well, but his natural tendency to spend often placed him in difficulty. He once pawned his coat so as to be able to afford an ice cream in a bar on a very hot day. His friends found him walking around in his shirtsleeves. "Well, what can I do, it's so hot!" Another time, he and his friend Delannoy brought a mattress to the pawnshop but this worthless object was rejected. "That's fine," replied Whistler with dignity and deposited the mattress on the ground. "I'll have it picked up by a messenger boy." They tried to sell a copy of *The Wedding at Cana*. Not finding any buyers and irritated at having to keep running around carrying this cumbersome canvas without finding any takers, Whistler had a stroke of genius while passing over the bridge of the Pont des Arts…. The canvas soon took a dive into the Seine. The onlookers sent up a cry of horror, the peace officers came running, ships left the shore. For the two partners-in-crime this was "a fantastic success!". Whistler also had to pay his cobbler with paintings when the man came to claim what was due to him. When the situation became intolerable, he scrounged money among his American friends.

In 1856, Delannoy and Whistler took a trip to Eastern France, traveling to Nancy and Strasbourg, and ending up in Cologne, Germany, where they ran out of money. The innkeeper whose hostelry they were patronizing became impatient at his unpaid bill. As a token of good faith, Whistler decided to leave him some copper plates which he was using for engraving. The trip back to Paris was a painful one and every meal was paid for with a portrait. The friends slept on straw and walked around with holes in the soles of their shoes. On the way, they encountered two travelling musicians who, each time they all

arrived in a town, would announce with great ballyhoo that the two artists would paint pictures for a hundred sous. They finally abandoned the musicians in a town in which the U.S. consul, who had known Whistler's father, lent them enough money to make it home. There remains to us from this trip a series of etchings, including *Liverdun*, *A Street in Saverne*, *The Kitchen*, and *Portrait of Gretchen*.

By learning to work from memory on the principles of Lecoq de Boisbaudran, Whistler perfected his technique, especially the effects of light at night-time, working on the basis of one tone, one color, and its variants. He respected the tradition of painting, studied the techniques of the Old Masters and, like his fellow students, went to the Louvre to copy the paintings. He admired Rembrandt and Velasquez. A series of thirteen etchings made in Paris, Alsace, and London, and now known as "The French Set," was published in a limited edition by the printer-engraver Auguste Delâtre. Whistler made himself personally responsible for the sales. The first paintings he produced were commissions. He made a few copies for Captain Williams of Stonington. His painting *At the Piano* (which he used to call "The piano picture") was submitted to the Salon of 1859 but was rejected since it was judged to be too "original."

This painting revealed an early desire for unity and a harmonious distribution of color. The jury also rejected the paintings of Fantin, Ribot and Legros, causing a scandal. Some of the rejected paintings were exhibited at the Atelier Bonvin, and on this occasion, Whistler was congratulated by Courbet. Fantin-Latour was to paint Whistler five years later in his work called *Homage to Delacroix*, which featured such promising artists as Manet, Legros, and Braquemont, who surround the poet Baudelaire. In 1865, Fantin sent a second painting to the Salon which also depicted Whistler, this time dressed in a Japanese robe, among a group of artists. He later destroyed this painting, having cut out Whistler's head in order to turn it into a portrait.

In 1859, Whistler decided to move to London to live with his half-sister, Lady Haden, at 62 Sloane Street. He would never again live in France, although he would visit several times.

Her husband, Seymour Haden, president of the Society of Etchers, bought paintings from his brother-in-law and his brother-in-law's friends, thus supplying them with valuable financial assistance. For a while Whistler shared a studio with George du Maurier, a cartoonist whose work often appeared in *Punch* magazine. In the four years between 1859 and 1863, Whistler stopped being a "rebel" and turned into a well-known artist. This did not stop him from playing the fool on Sunday, when he went to visit his friend, Ionides, whose father was a generous philanthropist. He would stand on a chair and sing songs from the Paris dives. Whistler had adopted a very unusual style of dress. People would turn to stare at him as he passed in order to get a good look at this outrageous dandy decked out in a suit of white twill topped with a yellow boater. Sometimes he would carry a parasol, a pink silk handkerchief, and he always wore a monocle and his famous lock of white hair. This lock which stood out from the rest of his black hair, fell across his forehead and was often taken for a feather. A real legend was born, the most farfetched rumors emerged, affirming that it was a birthmark, a sign of his race or even that in reality his hair was white and he dyed all of it but this lock. Whistler considered his white lock as a protection against the devil and looked after it like a precious object. The years 1860 through to 1870 were dominated by his triumph at the British Royal Academy. Whistler submitted *At the Piano* and five etchings to this institution, which was going through a strong pre-Raphaelite phase. The paintings were accepted and the critics received them quite favorably.

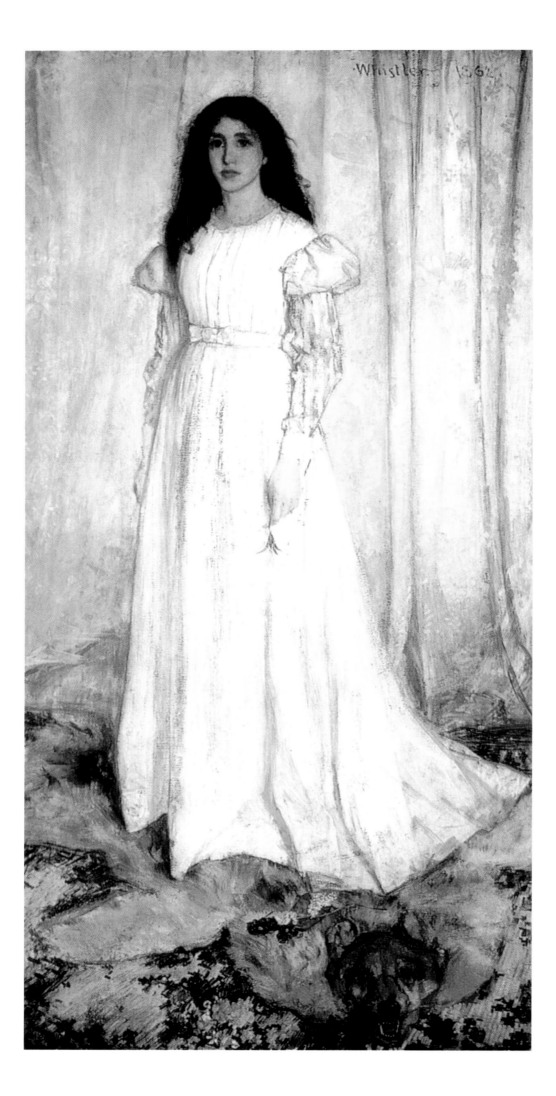

The painter took his first step on the ladder of fame. The artist began a series of eight works on the theme of the River Thames. To complete the project, he lived in a little inn frequented by bargees next to the dock. He would often move to the other bank of the Thames, to Cherry Gardens, where he would sit on the deck of a barge and draw.

He would sometimes be interrupted by the movement of the current, and more than once found himself stuck in the mud. His friends would come and visit him at the inn, among them the lawyer Mr. Thomas, who was wild about painting and patronized the pre-Raphaelites. Thomas decided to publish the series of French etchings as well as the Thames series and gave Whistler the opportunity of using the same method of engraving as used by Rembrandt. In 1859, Whistler produced one of his most beautiful engravings, entitled *Rotherhithe*. In 1863, the artist worked hard on a canvas which he called *Wapping* (he started four times on it!). "Hush, don't tell Courbet," he begged Fantin in one of his letters. The painting was exhibited at the Royal Academy in 1864 and at the Universal Exhibition in Paris in 1867. It had been painted at the bargees' inn. It shows three people, a workman, Legros and Jo Heffernan, his model at that time. Courbet, who met her at Trouville, painted her portrait, calling it *La Belle Irlandaise* (*The Beautiful Irish Girl*), exhibiting it at the Ecole des Beaux-Arts in 1882 under the title *Jo, Femme d'Irlande* (*Jo, A Woman of Ireland*).

Whistler worked on a drypoint entitled *Annie Haden*, for which the artist's niece posed wearing a crinoline and a fashionable hat. A society of engravers ordered two etchings to illustrate a book of poems. The work involved was considerable; Whistler claimed to have spent three weeks on each of them. In 1861, he sent *La Mère Gérard* to the Royal Academy and was acclaimed by the press. In the summer, he sailed to the coast of Brittany in France and painted some realistic landscapes. One of the paintings has an anecdotal title, *Alone with the Tide*, in the tradition and style of Courbet.

Returning to Paris with Jo Heffernan, Whistler rented a studio on the Boulevard des Batignolles, to paint a life-size full-length portrait of her. She is dressed in white, with a white curtain behind her and a white flower in her hand, her arms are by her sides. The painting is entitled *The White Girl*. "There is a mysterious charm about the work," wrote Paul Mantz in the *Gazette des Beaux-Arts*. The young girl represented looks like a medium or an apparition. The expression on her face and the pose are simple yet disturbing.

In the winter, Whistler fell ill and went down to the Pyrenees. It was thought he might have been poisoned by the zinc white which he used extensively in this painting. While at Guétary, he was saved from drowning by Jo. At Biarritz he painted *The Blue Wave*, with short, sharp stabs of paintbrush. The painting is very unusual, in that there are no more color gradations, no chiaroscuro, and the composition is simple. Whistler was beginning to disassociate himself from "this damned realism," as he called it. The Royal Academy refused to exhibit *The White Girl*, which was judged to be too original, but his etchings were admired and compared to those of Rembrandt. The rejection of *The White Girl*, which revealed all of Whistler's originality, says much about the period. The subject disconcerted his contemporaries as well as his treatment of it, with its white on white. The painting was accepted in the same year at the Berners Street Gallery, which gave the public the chance of viewing the work of young painters. "It was a real success of execration," the painter said at the time. Only the newspaper *The Athenaeum* emphasized that despite the absence of a "subject" the canvas could under no circumstances be said to be an illustration of the book of the same name by Wilkie Collins.

5. *Symphony in White, No. 1: The White Girl*. 1862. 86 x 43 in. (214.6 x 108 cm). Harris Whittemore Collection, National Gallery of Art, Washington.

Whistler was furious and this marked the beginning of his lengthy crusade against the art critics in the press. He protested that he had never intended to illustrate the book which, in any case, he had not even read. He had simply wanted to paint a young girl in white standing in front of a white curtain, that was all there was to it.

Early in his career, Whistler had copied famous paintings in museums, where he constantly encountered the work of Watteau (as well as seeing it at the home of his friend and benefactor, Eseltin). Like Baudelaire, he had a gift for taking existing concepts and bringing them back to life by placing them in a contemporary context. In 1860, Whistler had the same concerns as the French artists who were no longer particularly interested in the art of the early 19th century. The Goncourt family were largely responsible for this situation. They had elevated Watteau, a pleasing artist but no more than that, to the status of the greatest artist of the 18th century. His painting became synonymous with the art of elegance of the Old Regime of the French monarchy.

Under Louis XVIII and the July Monarchy, the deposed aristocracy looked down on the middle classes. The elegance of the 18th century had become a distant dream which they could only recapture in the work of Watteau. His paintings, associated with the Old Regime, were very fashionable from 1830 through 1880. The diminutive figures lost in huge gardens influenced Whistler considerably and he attempted to convey the same poetic vision and musical analogy as his predecessor. An elitist, though a bohemian, he tried to serve as a mirror for the aristocracy and side with them in their liberation from bourgeois convention. Although Whistler had posed his model slightly in profile in the painting *The White Girl*, the shoulders are in exactly the same position as in the model who posed for Watteau's painting entitled *Gilles* and the hands are in the same position. Jo's hair surrounds her face like a dark halo just as the round hat in *Gilles* throws a dark shadow on the model's face. The details of the white yoke are an echo of the vertical embroidery on the clothing in *Gilles*. Whistler changed the decor, moving it from a theater stage to the interior of his studio, but retained the general look of the painting. Instead of an androgynous character, he presents us with an elegant woman. The trees which surrounded *Gilles* are reduced to patterns on the Victorian curtains. Whistler turned the donkey's head into a bearskin rug, but he has taken the idea of white-on-white further than did Watteau. Despite the removal of any anecdotal detail, the ambiguous and melancholy presence conveyed by the two subjects is very similar. Paul Mantz understood this in 1863, when he wrote, "If we dare to claim that Whistler is an eccentric when on the contrary he has a whole past and tradition which we ought not to ignore, especially we in France, we would appear to be very ignorant of the history of Art. Whistler must have known that Jean-Baptiste Oudry has sought to group different white objects together and that at the Salon in 1753 he exhibited a large painting depicting various white objects against a white background, including a duck, a damask table napkin, porcelain, and a creamer …all of them white." On the subject of Watteau's paintings, the Goncourts had written, "It is love, but a love that dreams and thinks. Modern love with its aspirations and its crown of melancholy." The individuals depicted in *The White Girl* and *Gilles* are both pursuing their dreams. At that period, the Cremorne Gardens, where Whistler spent a lot of his time, held performances featuring pierrots. Whistler reproduced this theme and the erotic connotations of the painting are directed toward Gavarni's depictions of Pierrot. He copied a Gavarni lithograph entitled *Airs: Larifla* or *Two Clowns Dancing*. Clowns were popular in the 19th century and people often attended masquerades dressed as clowns where they could engage in brief affairs in semi-anonymity.

6. *Purple and Rose: The Lange Lijzen of the Six Marks.* 1864. 35 7/8 x 22 1/8 in. (91 x 56 cm). The John G. Johnson Collection, Philadelphia Museum of Art.

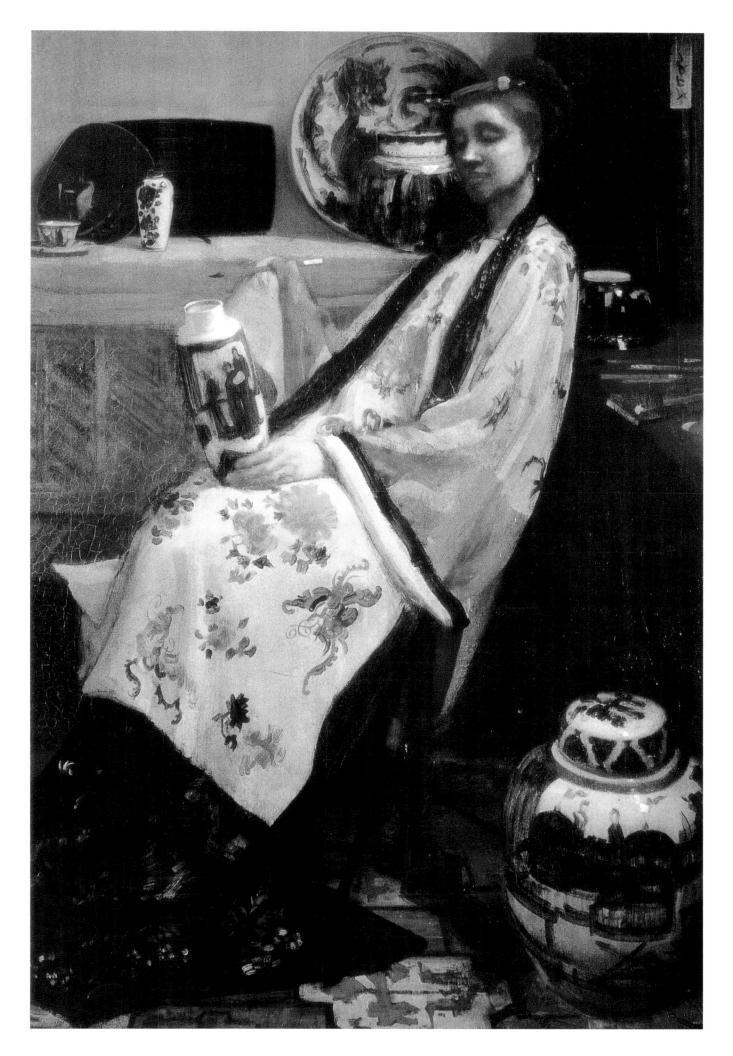

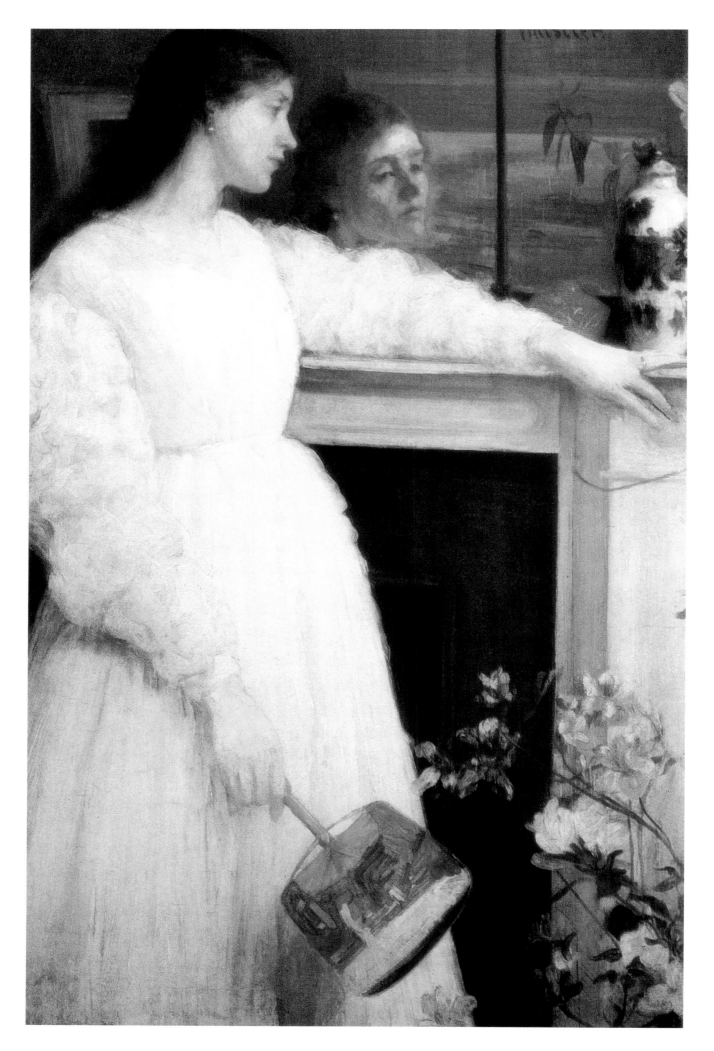

All the great themes beloved by Whistler are present in *The White Girl* – the purified shapes, the play of colors, tone upon tone. In 1856, the Goncourt brothers were asking themselves, "Which school do Watteau's paintings belong to? They are painted with an originality of color that is unprecedented. In Watteau, the fantasy of color seems to have an additional dimension." In 1884, a fashion magazine stated that "women are particularly fond of Watteau because he created 'a style' for them. He is the magician who taught them to be beautiful, his name remains synonymous with exquisite elegance and graceful purity." It is this same purity which Whistler seeks in his paintings; the hats, dresses, buttons, and all the fashion accessories bear the Watteau stamp. Whistler paid great attention to the accessories and clothing chosen by his models when he painted them. He never hesitated to insist on a particular accessory or a particular color and was certainly well aware of the importance of clothing in Watteau's work.

The etchings were soon shown in Paris. The poet Baudelaire admired them, demonstrating his perspicacity. This is what he wrote about the engravings, "A young American artist, Mr. Whistler, exhibited a series of etchings at the Martinet Gallery, improvised and inspired, representing the banks of the Thames and brilliantly executed, packed with rigging, sails and ropes; a chaos of mists, furnaces and uncorked smoke; the profound and complicated poetry of a vast capital city." In the course of that summer, Whistler made the acquaintance of Rossetti and did six drawings for illustrated publications. Four of them appeared in *Once a Week* and two others in *Good Works*. He also completed an important painting, *Old Westminster Bridge*, which he sent to the Royal Academy in 1863, with six engravings. Despite his London disappointment with *The White Girl*, he decided to exhibit it in Paris. Unfortunately, that year the Salon rejected a whole generation of painters, including Manet and Whistler. Napoleon III decided to inaugurate a Salon des Refusés, which was held at the Palace of Industry, the same place as the official Salon. The opening on May 16, 1863 owed much of its success to the scandal which preceded its announcement. The public and the critics visited the Salon des Refusés to have a good time. Fernand Desnoyers wrote that Whistler's painting was the portrait of a medium and claimed that the artist was "the most spiritualist of the painters," adding that his portrait was the most remarkable. The public hesitated for a moment, shocked out of their normal habits but confusedly sensitive to the simplicity and strange beauty of the work. Later, Whistler would re-christen the portrait *Symphony in White*. The painting was the event of the exhibition, becoming even more notorious than Manet's *Déjeuner sur l'Herbe* (which at the time was called *Le Bain (The Bath)*). At the time of the exhibition, Whistler was in Amsterdam with Legros to look at the Rembrandts. It was here that he learned that his painting was causing a sensation in Paris. Fantin wrote to him, "Courbet is calling your painting an apparition and Baudelaire finds it charming… We all think that it is admirable." After the Parisian triumph came new honors from England and Holland. The etchings exhibited at The Hague won him a gold medal, the first in his career, and the British Museum bought twelve of his engravings. Whistler decided to return to London. His mother came to join him, after having experienced a difficult time: she and her son William, a doctor in the Confederate Army, had been in Richmond throughout the siege of that city. By the end of this period, James had acquired a reputation thanks to his works on classical lines but totally modern in their style. His paintings were not devoted to particular themes, and Whistler seemed to be totally original but he had won the admiration of his fellow artists and of connaisseurs.

7. *Symphony in White, No. 2: The Little White Girl*. 1864. 29 7/8 x 20 in. (76 x 51 cm). Tate Gallery, London.

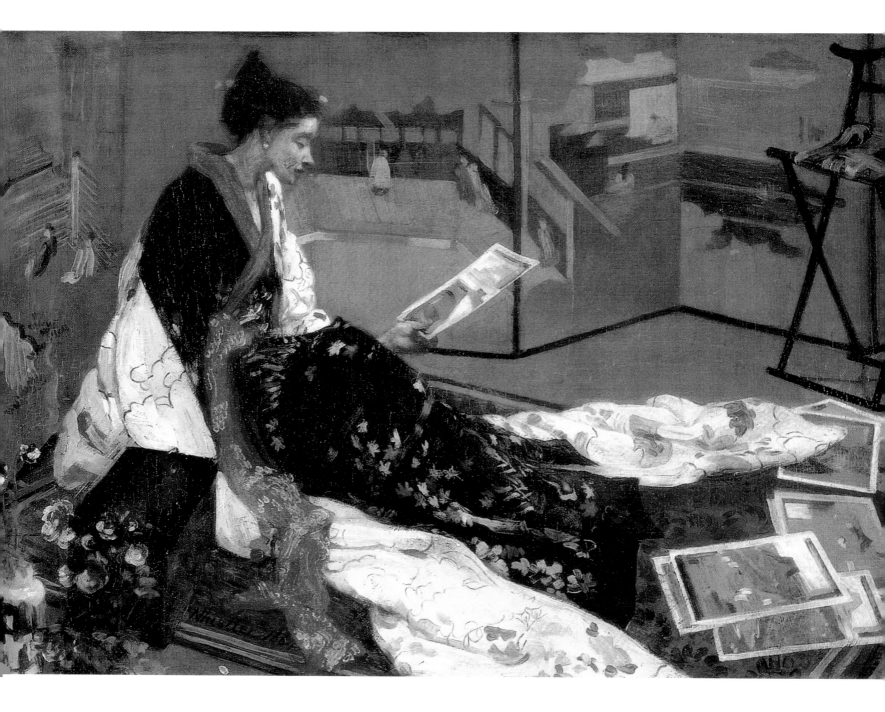

JAPANESE INFLUENCE, THE MISTS OF VALPARAISO, NOCTURNES ON THE THAMES AND CREMORNE GARDENS (1863-1874)

At the age of 29, Whistler moved in with his mother to 7 Lindsay Row, Chelsea, a three-story house with a garden. It was separated from the Thames only by the width of the street. From his bedroom window, Whistler could contemplate Battersea Bridge, then made of wood, and Chelsea Church while on the opposite bank factory chimneys loomed out of the evening gloom like Byzantine minarets. At night, he could see the lights of the Cremorne Gardens. His neighbour, Mr. Greaves, was a barge-builder, a man who became famous in the neighborhood for ferrying Turner back and forth across the river at the latter's request. Whistler asked him to do the same for him.

On a river barge, at dusk or dawn, they would make for Battersea Bridge or for the Cremorne area. Sometimes, they stayed out for most of the night while Whistler produced sketches on brown paper with chalk and took notes. The drawings could be summarized as simple orientations with indications of brightly-lit areas. The work would be finished from memory once the artist was again on terra firma. The nights ended at the house of the Greaves family or with Dante Gabriel Rossetti, the pre-Raphaelite painter who lived nearby, or with the poets George Meredith and Algernon Swinburne. All of them had the same love of the bohemian life and of Japanese art which had begun to be popular in England and France after first having been the rage in Holland. Whistler and Rossetti shared a liking for blue-and-white Chinese and Japanese porcelain. They bought drawings by Hokusai (as Monet and the Goncourt brothers were doing in France). James decorated the walls of his house with oriental fans against matching backgrounds though he favored a lack of elaborate ornamentation at a time when other artists favored a riot of bric-a-brac. Whistler's re-interpretation of Japanese art made him consider he was taking the right direction by abandoning Courbet's Realism. He chose simple subjects, was inspired by the white spaces left in woodcuts and tried to reproduce the effects of colors that had hitherto been unexplored. In this spirit he created the paintings *Lange Lijzen. The Gold Screen, The Balcony,* and *La Princesse du Pays de Porcelaine,* canvases which had nothing in common with the "exotic realism" of Alma Tadema or Holman Hunt. For him Japanese art was a mere pretext, a means to an end. The other paintings in the series have titles which reveal his true preoccupations, such as *Red and Rose, Caprice in Purple and Gold, Harmony in Green and Flesh Color, Rose, and Silver.* The painting *La Princesse du Pays de Porcelaine* is a portrait of Christine Spartali, daughter of the Greek consul in France, whom he had met at the home of his friend Ionides. Whistler had arranged everything – the fan, the dress and the carpeting.

8. *Caprice in Purple and Gold: The Golden Screen.* 1864. 50.2 x 68.7 cm. Freer Gallery of Art, Smithsonian Institution, Washington.

The sittings lasted until the model fell ill. The artist then used another model mainly for the body, but visited the convalescent girl mainly to make a sketch of her face. Rossetti offered to exhibit the painting in his studio, which was frequently visited by buyers. It was a good idea, because a collector soon became interested in buying it if the painter were to agree to change his signature. The artist refused (the canvas was bought shortly thereafter by F. R. Leyland) and drew a lesson from this episode by modifying his signature. Henceforward, the signature would consist of his initials inside a cartouche which would later be changed to a butterfly. This insect was not chosen by chance and was very carefully positioned from the first rough sketches so as to balance with the composition of the painting. Whistler would also use the butterfly to sign etchings, letters and invitation cards.

The frames of his early paintings were decorated with motifs in the Japanese taste, including the butterfly and blue or red designs on a gold background chosen to harmonize with the dominant colors in each painting. He would later use plain gold frames edged with several fine lines of fluting. Whistler was one of the first artists to give picture frames the importance they deserve; the artist would never exhibit an unframed canvas.

In 1865, he exhibited *The Little White Girl*. Jo Heffernan, his favorite model, is shown leaning against a mantel shelf, holding a fan with her face reflected in the mirror over the mantel. The painting was considered by numerous contemporary artists as one of the most important of the century and Swinburne composed a poem to celebrate it, entitled *Before the Mirror: Verses Beneath a Painting*. After its exhibition at the Royal Academy, *The Athenaeum* criticized the painting, regretting that Mr. Whistler's only interest in women was to turn them into "the most bizarre bipeds." The article nevertheless recognized some merit in some of the painter's other works and remarked "a subtle beauty of color" in *The Gold Screen*, as well as "an almost mystical delicacy of tones". *Old Battersea Bridge (Brown and Silver)* also received praise. This canvas is painted in shades of gray with a splash of red in the background to indicate the houses. The work marks a clear transition between the paintings made on the Thames and the *Nocturnes* which would succeed them. In September, James took Jo to Trouville and met up with Courbet who was vacationing in Deauville at the country seat of the Count de Choiseul. Here they met the young Monet for the first time. The couple returned to London in November.

In early 1866, Whistler decided to take a trip to Valparaiso, Chile and embarked at Southampton on a steamboat leaving for Panama. The trip was noteworthy for an earthquake and the shelling of Valparaiso by the Spanish navy. The town, which stretches around a bay, was lit up by the light of the setting sun and the explosions of the shells raining down upon the city and ships caught in the sea-roads. This unique spectacle first gave Whistler the idea of painting at night, and he produced three views of the port. On the return trip, he got into a fight with a waiter who spilled food on his suit (and whom he nicknamed "the Marquis of Marmalade").

James was happy to return to London since the trip had been long and tiring. To freshen up his ideas, he decided to redecorate the house. The dining room was painted in two shades of blue, the woodwork being darker than the rest. The walls and ceiling were embellished with purple fans. The studio on the first floor was painted gray. He also painted a folding screen. The central panel shows Battersea Bridge with the Chelsea parish church in the background and a moon under a blue sky. The stair treads were covered in Dutch metal and the artist slept in a Chinese bed…

The simplicity of the decor and the harmony of shades of color were most unusual for the period. The unity of color rested the eyes as did the lack of ornamentation which was another manifestation of Japanese influence… The drawing-room was painted in flesh pink with white and pale yellow woodwork. Two large panels in the hall were adorned with paintings of two majestic sailing ships. The dado in the hall was decorated with pink and white chrysanthemum petals on a gold background. Yet this home, like all the others he lived in, would never be completely finished. Wherever he lived, Whistler gave the impression of being on the point of moving and the corridors were always littered with trunks.

In January, 1867, the French Gallery in London exhibited two of the paintings Whistler had produced during his trip. The first, a very wide canvas, depicted a view of the port of Valparaiso after the sun had set. The ships are at anchor, most of their sails furled. The critics defined the painting as a poem in color. Whistler amended the expression, claiming that this was the poetry of painting. Another view of Valparaiso exhibited was in fact one of the earliest paintings in the *Nocturnes* series, and he would later rename it *Nocturne in Blue and Gold: Valparaiso*. Daylight still illuminates the painting but it is already foggy and silvery and the moon is out. The spatial relationships are ambiguous and details disappear to be replaced by outlines of the main shapes, creating a special atmosphere which would be impossible to conceive of during the day. The ships cease to be ships and melt into a blue haze. Painted by daylight, the three planes of the picture would have separated into the embankment, the sea and the sky. Whistler explained his predilection for the night by asserting that he awaited the moment at which nature redesigns itself.

In that same year, *At the Piano* was accepted by the jury of the Paris Salon which had rejected it eight years earlier. Whistler left for Paris for the Universal Exposition, that extraordinary international and cosmopolitan event at which Manet and Courbet each had their own pavilion. Here he met his brother-in-law, Haden. The men quarrelled and Haden found himself thrown into a storefront window. James appeared in court and was already known to the judges because only a few days previously he had administered a thrashing to a stonemason. In that previous matter, thanks to the good offices of an American church minister, a friend of his late father, Whistler managed to escape punishment by apologizing to the court, but this time he was not so lucky.

When the affair was made public, it was considered an extension of the "Marquis of Marmalade" incident. Upon returning to London, Haden threatened to resign from the Burlington Fine Arts Club if Whistler, also a member, was not expelled. The club expelled Whistler despite the opposition of Dante Gabriel Rossetti.

Musical terminology was often used by artists of the period. Whistler judged it particularly appropriate for describing his paintings. The French poet Théophile Gautier used the same vocabulary to describe *Symphony in Verses*. Whistler was conscious of the need to study the Old Masters but purely with the aim of understanding their individuality. In his correspondence with Fantin-Latour, he explains his ideas about his white-on-white studies, which he put into practice in the three paintings expressing the harmony of shade and line. He disagrees with Courbet because he knows now that art does not consist in reproducing what one sees but in using the materials offered by nature in order to create something new. He often speaks of stylization, of harmony and of symmetry.

Whistler gradually embraced what would become one of his main ideas in painting, namely that a dominant color must always be used to determine the tonality of the whole. He proposed painting six canvases, each one named for a symphony of color. These *Six Projects* show to what extent Whistler was working around a single theme, symphonic and musical variations of color.

Symphony in Green and Violet remains one of the favorite paintings of those who enjoy the oriental flavor in Whistler's art. Struck by the musical cadence of color, Swinburne contributed the verbal equivalent of Whistler's strokes of the paintbrush: "The main chords struck are without doubt certain varied harmonies of blue and white though not without an interlude of brilliant and tender tones of floral red and violet." Swinburne, conscious of the colorful vibrancy of the paintings, remarked on their graceful, feminine charm. He was struck by the marine imagery, "Between the dark, damp steps and the pillars of the pier, the gentle, sparkling sea can be seen, without spray and completely blue." On the subject of the *Variation in Blue and Green*, representing a group of women on a balcony, he writes: "These women who look far across the sea, the depth of this calm, wordless happiness, there where the spirit and the senses are so full of beautiful things until it seems that at the slightest breath the brimming cup of pleasure will break or overflow and the chalices of the senses will pour out their wine of delight." Swinburne's recourse to musical imagery is a reminder that before painting the *Nocturnes*, Whistler had been very taken with the idea of visual melody.

Henceforward, he would define his works as "harmonies obtained by using infinite variations on a limited number of colors." He was inspired by writers, as well as by composers such as Claude Debussy, Reynaldo Hahn, Camille Saint-Saëns and Maurice Ravel.

Discouraged by the public's attitude to his painting, Whistler gained fame through his engravings. He was patronized by Mr. Leathart and Mr. Leyland (calling the latter "the Medici of Liverpool"), Mr. Hurt, Mr. Alexander, Mr. Rawlinson, Mr. Anderson Rose, and Messieurs Jameson, Potter and Chapman. New art galleries and independent exhibitions were springing up in London to escape the intransigence of the Royal Academy and satisfy the demands of the middle classes which now had enough power to begin to displace royalty and the nobility as far as the purchase of works of art were concerned. Whistler was one of the first painters to paint at night when from dusk to dawn shapes are enveloped in a blue and mysterious obscurity. Hiroshiga, the 19th-century Japanese artist, had used the theme extensively in his woodcuts. Whistler did not imitate Japanese technique, though he borrowed a few ideas and tricks to use in the composition of his paintings, such as horizons placed very low or very high, foliage in the foreground and the signature. The Japanese theory of drawing which he adapted enabled him to attain a certain form of purity by eliminating numerous elements of detail and revive classic techniques from western painting. He wanted his work to be included in the mainstream of art. To Whistler, nowhere did the night seem as beautiful, even in Valparaiso or Venice, as it did in London where the plays of diurnal light on the Thames redesigned space and form. The eye became lost, then adapted to a new vision of the world thus transformed. The painter was charmed by the blue-and-pink darkness which gave the river and the landscape a quality of fantasy, rediscovering the miraculous beauty of nature. He spent long nights observing, then in the daytime he would lock himself into his studio in order to reproduce the night-time visions on canvas.

9. *Nocturne in Blue and Gold: Valparaiso Bay.* 1866. 29 x 19 in. (75.6 x 50.1 cm). Freer Gallery of Art, Washington.

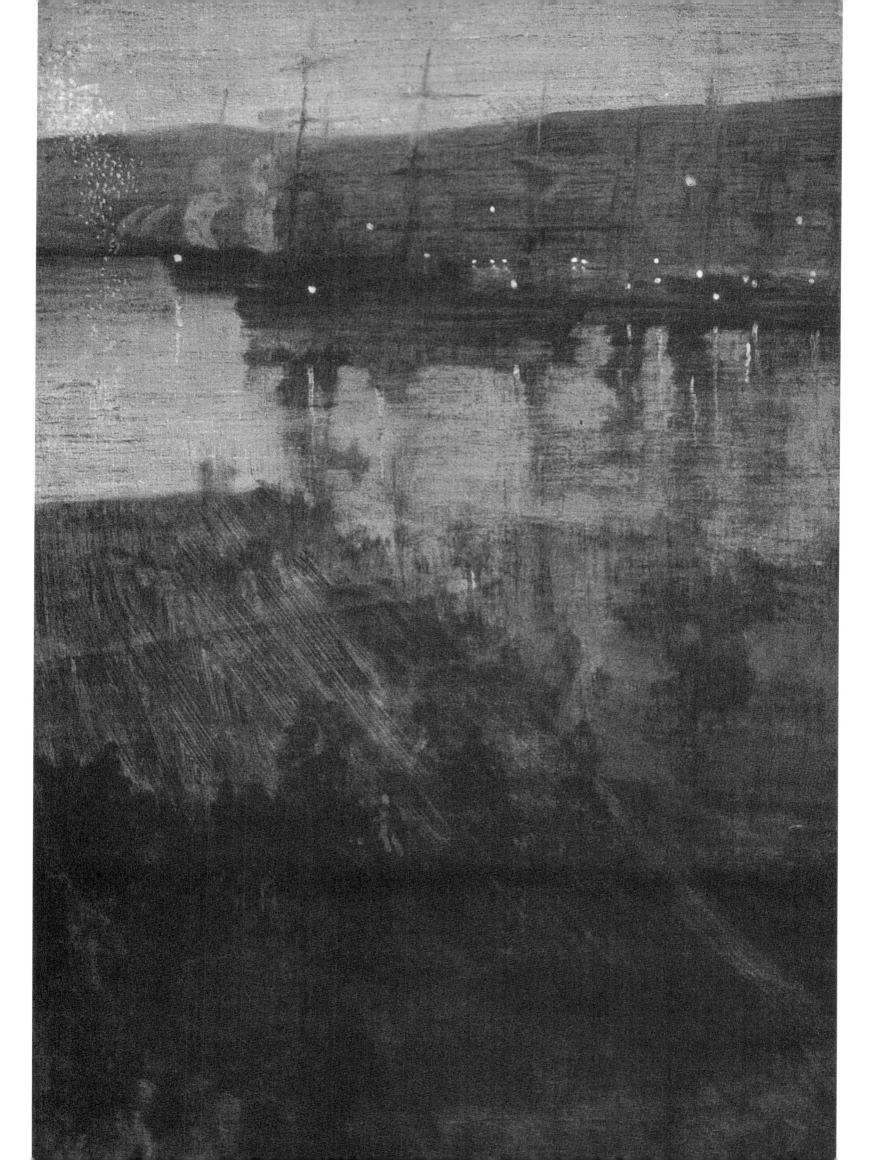

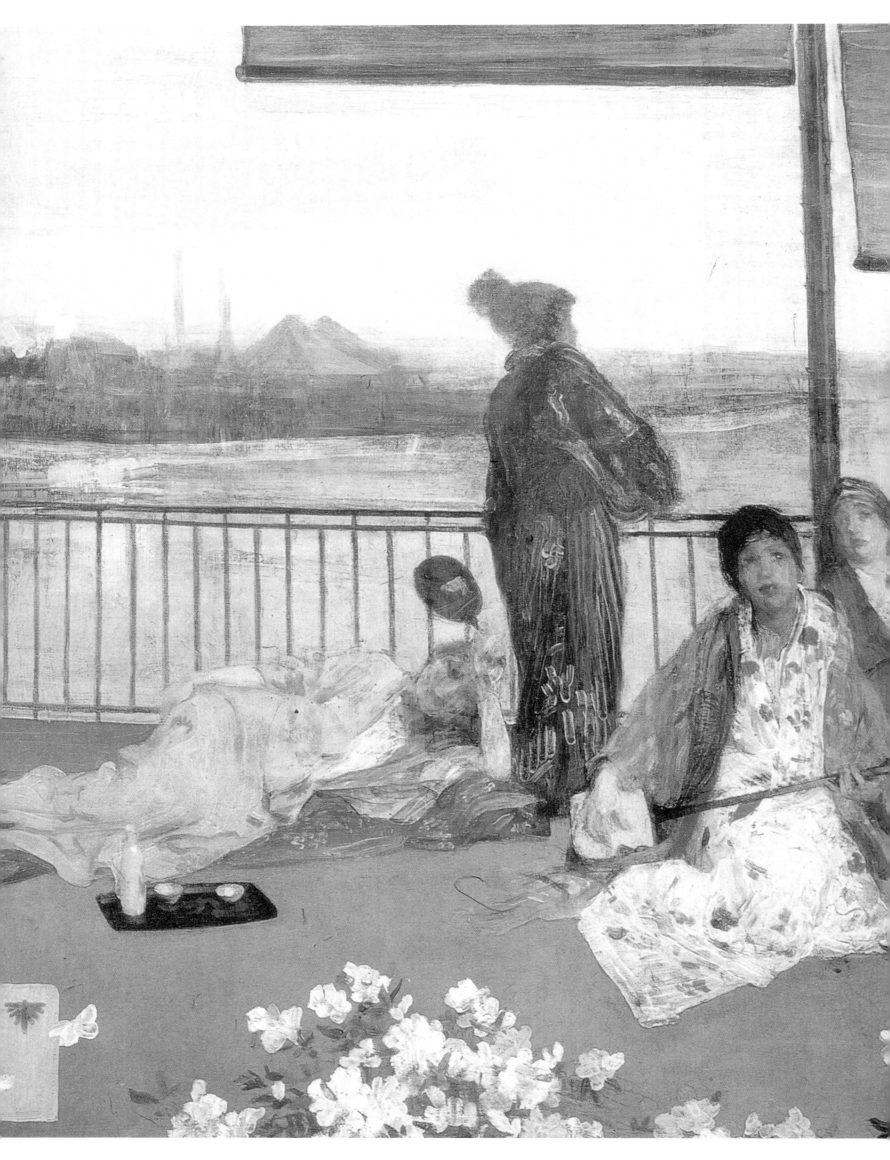

Whistler sought to understand the mysteries of the night, took notes and tried to produce colors on the spot in the darkness but was unable to do so and contented himself with merely making directional sketches. To overcome this problem of memorizing the night-time colors he put his memory through special training. He needed to paint nature. If Whistler said that nature embarrassed him that is because it rarely offered him the elements for a work of art.

The English public, who were accustomed to painters' minute "realist" detail considered the *Nocturnes* as mere sketches lacking a subject. In fact, these paintings were extremely difficult to design. The *Nocturnes* series represents the illustration of one of Whistler's favorite theories, "A work can only be successful if all trace of effort has disappeared." Nothing could be removed or added, a touch more or less would deprive the works of their charm. As if by magic, the blurred elements take their place with precision, contrasting with the blank spaces. The night envelops the universe in its mysterious charm. The lights are different, the vague outline of a building looms up out of the gloom.

The East and the West come together, lights are reflected in the water and trace golden threads. Phantom ships lurk, immobile, in the obscurity and the trails of fireworks fall into the foggy air, sprinkling their multicolored sequins like golden rain, the ultimate touch in a painting blessed by a celestial shower.

Whistler wrote, "And when the evening mist clothes the riverside with poetry, as with a veil, and the poor buildings lose themselves in the dim sky, and the tall chimneys become campanili, when the warehouses are palaces in the night, and the whole city hangs in the heavens, and fairyland is before us then the wayfarer hastens home; the working man and the cultured one, the wise man and the one of pleasure cease to understand, as they have ceased to see, and Nature who, for once, has sung in tune, sings her exquisite song to the artist alone, her son and master – her son in that he loves her, her master in that he knows her." Whistler's contemporaries thought that the *Nocturnes* were a sort of practical joke, just like the holes in Henry Moore's sculptures and the incongruous eyes in Picasso's faces.

Twenty years later, the *Nocturnes* series would be recognized and celebrated. It produced such an effect on the public that a fine night would be termed "a Whistler." The painter confirmed that he did not want to paint the night but to reproduce its effect.

Thanks to the Greaves brothers, who prepared his canvases and colors Whistler's techniques are known. Whistler would shape his paintbrushes after having used a candle flame to soften the glue which held the bristles. He mixed his colors using turpentine and linseed oil diluted in a mixture of copal and mastic. He would arrange his colors on a rectangular 24 x 36 inch palette, with grooves to hold the paint tubes and paintbrushes. This palette constituted the top of a table containing a large number of tiny drawers. The *Nocturnes* were painted in very absorbent canvas or on wood panels. In these paintings, the dominant color is blue, so the artist painted on a red ground or used a piece of mahogany.

The blues placed over the red thus gained in intensity. In other paintings the background is coated with a warm black, especially those featuring fireworks. The canvas was first coated with a lead deposit. When the sky is gray and the night is dark, he used a gray canvas (only once did he paint a *Nocturne* on a white background). This prior choice of medium made it possible for him not to have to overload the canvas at a later stage.

10. *Variations in Flesh Color and Green: The Balcony.* 1867-1868.
24 1/8 x 19 in. (61.4 x 48.8 cm).
Freer Gallery of Art, Washington.

The sky and the water were created with a few strokes of the paintbrush. Testing for the right tint took a long time but once the correct color had been obtained, the artist was able to complete a *Nocturne* in a single day. Once the precise colors had been found, he would place them in saucers and cover them with water to keep them until the next session. Some canvases were dried out in the studio, others were placed outside on the roof to dry.

The complete series of the *Nocturnes* covered the period from 1866 through 1877. In the case of the painting *The Solent*, Whistler created an almost monochrome composition. It is almost impossible to tell where the sky ends and the water begins. All the subtlety of the composition lies in the gap between the ships, the balance between their shapes and the strip of land, the rather unusual placing of these minimalist shapes in the rectangle of canvas. The brush strokes convey the fluid nature and constantly changing texture of the water.

The painter is obsessed by the idea of using the smallest number of decisive strokes. This is a concept drawn from the oriental masters. The ships were drawn in a single line, the lights a mere dot. The *Nocturne in Black and Gold: Entrance to Southampton Water* (1872-1874) helps to reveal the secret of Whistler's compositions. He reproached Turner with having been the only painter "Who alone has dared to do what no artist would ever be fool enough to attempt... paint nothing less than the sun." He considered his predecessor as his rival and used the moon in the same way that Turner had used the sun.

The *Nocturnes* are based on a precise geometrical rule. The painter used horizontal lines to divide the surface of the canvas into three equal sections, then proceeded in the same way to divide it into three vertically. One of the horizontal lines is used to determine the horizon, and one of the two vertical lines is the logical axis serving as a landmark around which to arrange the various pictorial elements. In this painting, the masts of three ships in the moonlight are all "attached" to the same imaginary line. There is a point of intersection between a vertical and a horizontal line around which the elements are grouped and this is termed the focal point. In this case, it is the moon. The same layout principle is used in *Nocturne in Blue and Silver: Battersea Reach*. Two dominant horizontal lines are the distant shore and the ship in the foreground. The central line passes from the stern of the ship and touches the pointed shape on the bank.

A single diagonal line determines the focal point of the painting. A vertical mast suddenly changes direction, thus a diagonal line intersects the horizontal and vertical. This change of rhythm is faintly echoed in the two masts on the right, though they are at a slightly different angle. These geometrical shapes are softened by the poetry of the composition. The edges of the shapes merge with the moonlit sky and with the water. The outlines are vague and constantly changing. They alter ceaselessly as the eye moves over the picture discovering new aspects.

The result was confusing for an unaccustomed public and in two exhibitions a *Nocturne* was hung upside down, not intentionally but simply in error. In several of the *Nocturnes*, three-quarters of the surface of the paintings are a wash of color animated by the texture of the canvas. The paint was diluted to the consistency of a watercolor and applied lightly, then scraped away in order to form the thinnest layer of color, thus enabling the weave of the fabric to show through, and create thousands of points of light that reflect the night. Whistler revealed an amazing range of greenish, brownish, yellowish and bluish grays.

11. *Whistler in his Studio.* 1865-1866.
24 x 18 in. (62.9 x 47.6 cm).
The Art Institute of Chicago.

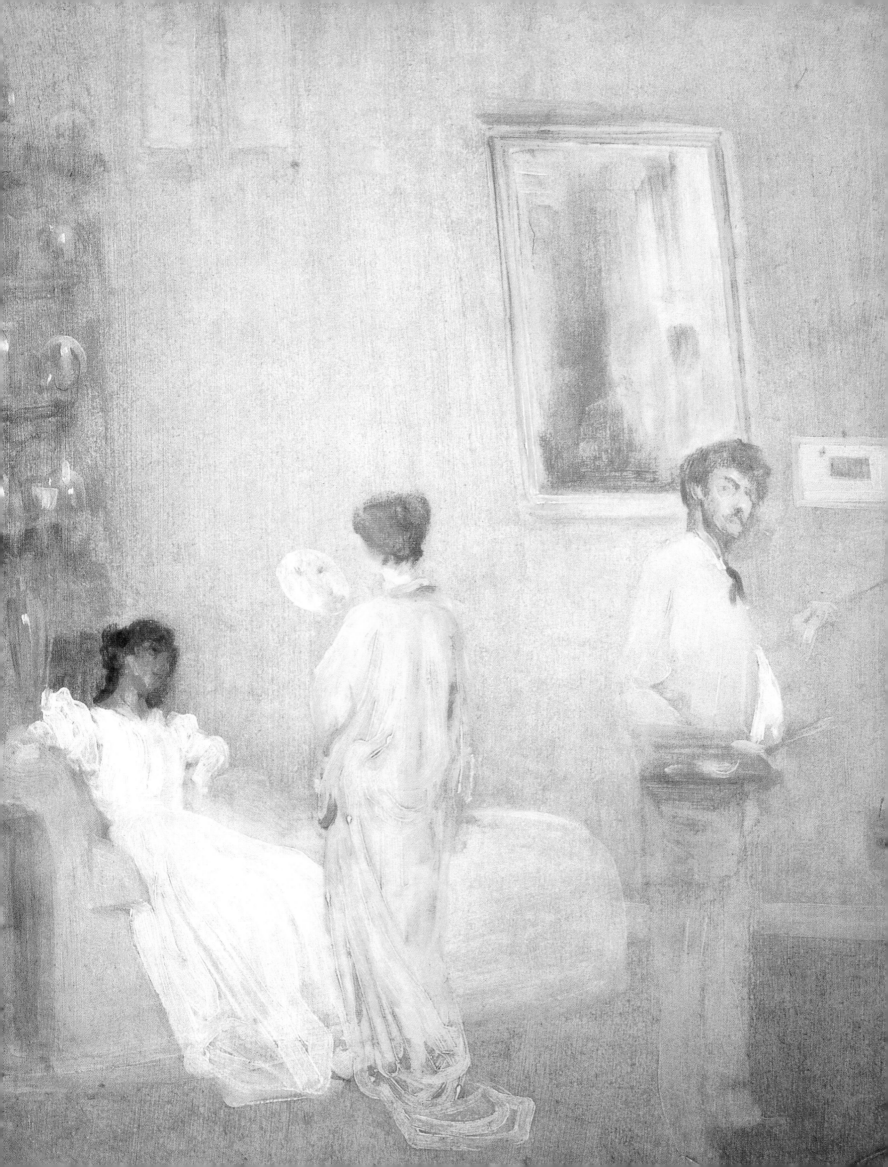

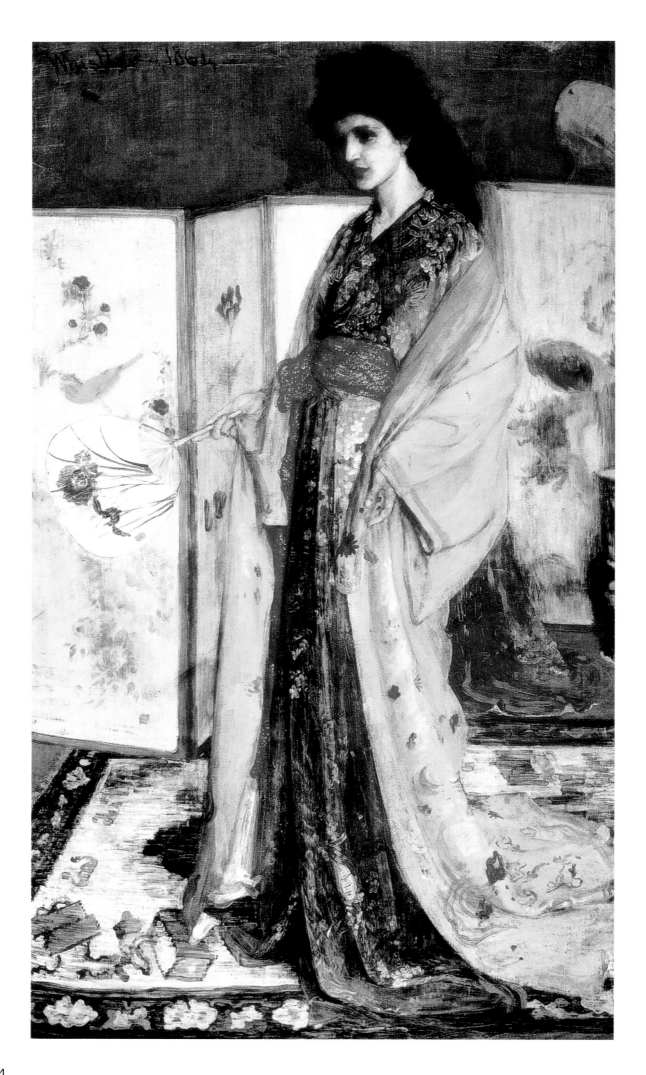

The technique whereby the paint is diluted into a wash and applied with a paintbrush, then scraped is a solution to the problem posed by painting the "vibrant darkness" typical of the *Nocturnes*, and the portraits which Whistler later painted.

Darkness accentuates three-dimensional space and the perception of the atmosphere. Whistler made the following comment about *Nocturne in Gray and Gold: Chelsea Snow* published in "The Red Rag" in *The World* in 1878: "My picture of a Harmony in Grey and Gold is an illustration of my meaning — a snow scene with a single black figure and a lighted figure, placed there because the black was wanted at that spot. All that I know is that my combination of grey and gold is the basis of my picture. Now that is precisely what my friends cannot grasp. They say, 'Why not call it *Trotty Veck* and sell it for a round harmony of golden guineas?'".

Whistler told another of his friends that all he would have had to do was to write under the picture: "Father, dear father, come home with me now!" for it to become "the picture of the year."

Night-time, more than daytime, gave Whistler the opportunity to test areas of light and shade, of colors designed like disembodied forms playing the role of abstract elements. The night itself seems to denude shapes of their literal significance and deprive them of detail. A café becomes a combination of illuminated rectangles broken by bands and splashes of shade. The snow and the water are a lighted space, just like the sky and the water in the *Nocturnes* on the Thames. Whistler's painting, like Japanese art, is an art of space. Space has an intense reality and determines the power of the composition.

Some of the *Nocturnes* verge on the abstract. The night is never really black; it is living and changing, shade is never the exactly the same wherever it happens to fall. Whistler said that his paintings are "entirely the result of harmonies obtained by using the infinite tonalities and variations of a limited number of colors." The series was much admired by the French literary avant-garde. The art critic James Laver wrote of it that "Whistler's art, which had drifted so far away from the main current of French painting, was for many reasons particularly likely to appeal to the *littérateurs* of the *Symboliste* movement."

Indeed the blue-green colors seem to withdraw from the viewer, as against the warm colors which appear to advance toward the viewer. The *Nocturnes* force the viewer to try and enter into the picture, to penetrate the fog; this is what Whistler wanted from the viewer: "In my paintings, there is no ease of brushwork, nothing that is designed to surprise and astonish, but simply the gradual emergence of beauty.

It is this beauty which reveals itself in my canvases and not the way in which I achieved it. If one were to remove a stroke, or add another, the night would be denuded of all its mystery." George Moore, a novelist and critic, was one of the few to recognise the daring and apparent simplicity of his friend's painting.

In *Modern Paintings* (1893), he wrote, "Mr. Whistler's nights are the blue transparent darkness which are half of the world's life… a little less (in the picture) and there would be nothing." Whistler had a strongly developed aesthetic taste which he put into practice in his daily life (something which Oscar Wilde would later emulate).

When one considers the English mentality of the period, the *Nocturnes* series was a rare example of audacity and a man of Whistler's temperament was needed to dare to do it.

12. *Rose and Silver: La Princesse du Pays de Porcelaine.* 1863-1864. 78 x 45 in. (199.2 x 114.8 cm). Freer Gallery of Art, Washington.

Walter Greaves, who helped the painter, explained that the painter "prepares his paintings like the Venetian old masters, that is to say with one color which contrasts with the colors to be added on top of them."

He himself explained, "the sky is gray, and the water is gray, and, therefore, the canvas must be gray." The spontaneity of the final result was the consequence of meticulous preparation. A careful choice of background color not only unified the tonality of the painting but accelerated and simplified the work involved.

In 1872, his friend Degas wrote to Tissot, "Give my regards to Whistler who really has found a personal note in this well balanced expression and this mysterious mixture of earth and water." *Symphony in Gray: the Thames, Early Morning* is an abstract view of Battersea, facing Whistler's house in Chelsea on the other side of the river.

The palette is monochromatic, anticipating Whistler's later observation that "color exists at its strongest once the heavy curtains of the night have started to draw back and the beauty of light has been revealed." Here, the artist paints the light rather than color. Although the night has evaporated, the colors of nature, already reduced by winter fog, are even more attenuated by the penumbra. Whistler's grays are of particular interest to oriental art experts. The art historian Ernest Fenollosa thought that Whistler's grays throbbed with imprisoned colors. He noted, "The ancient Chinese school perceived color as a flower growing in gray dirt, but the only example I have seen of that theory in European art is in Whistler's work."

Other oriental elements included the division of the canvas into horizontal strips and the geometrical butterfly signature inside a rectangular cartouche similar to that used in the seals on Japanese woodblock prints.

A little cloud of white smoke on the right is consciously balanced by the signature cartouche in a touch of Japanese asymmetry. Whistler had discovered the importance of blank space. At night, nature redraws the landscape, and in the thick veil that is formed it creates vast empty spaces which are to be found in the kakemono panels. Sometimes, the artist was forced to penetrate the ambiguities of space when, darkness or diffused light blotted out the distinctions.

The methods used by Whistler to paint the *Nocturnes* were as unconventional as the paintings themselves. A craftsman who printed many of Whistler's lithographs tells of a walk with the artist, when "he stopped suddenly, pointed at a group of distant buildings, an old ruin at the corner of a street, the windows and storefronts showing their golden lights through the foggy dusk. Whistler looked at them and since he had nothing with which to make notes or sketches, I offered him my notebook.

He replied, 'No, no, don't move.' After stopping for a long time, he stepped back, turned, and took a few paces back; then turning his back on the landscape which I was still looking at, he said to me, 'Now we'll see if I have learned it properly', and gave me a complete description of the landscape just as one recites a poem that has been learned by heart." (Jacques-Emile Blanche wrote that Whistler was considered to be 'the Mallarmé of painting.') A critic wrote about *Nocturne in Silver and Opal: Chelsea*, "The suspended bridge seems to advance toward us, then fade away into the foggy dusk at the moment when the lamps are lit."

Arthur Severn, a friend of the painter, says, "He would look steadily at a pile for some time; then mix up the color, then holding his brush quite at the end, with no mahlstick, make a downward stroke and the pile was done.

13. *Symphony in White, No 3*. 1865-1867.
20 x 30 1/8 in. (52 x 76.5 cm).
The Barber Institute of Fine Arts,
University of Birmingham, U.K.

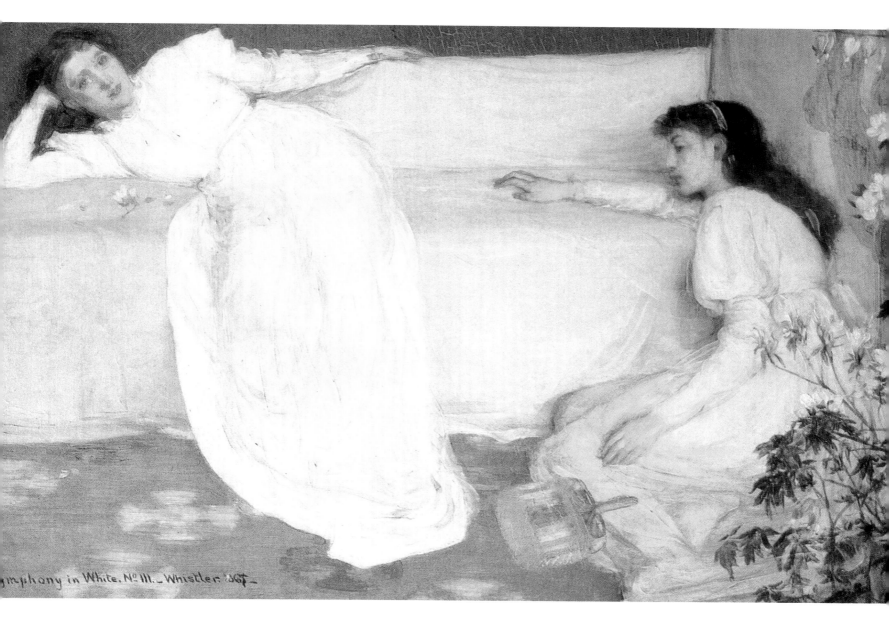

Symphony in White, No. III — Whistler 1867

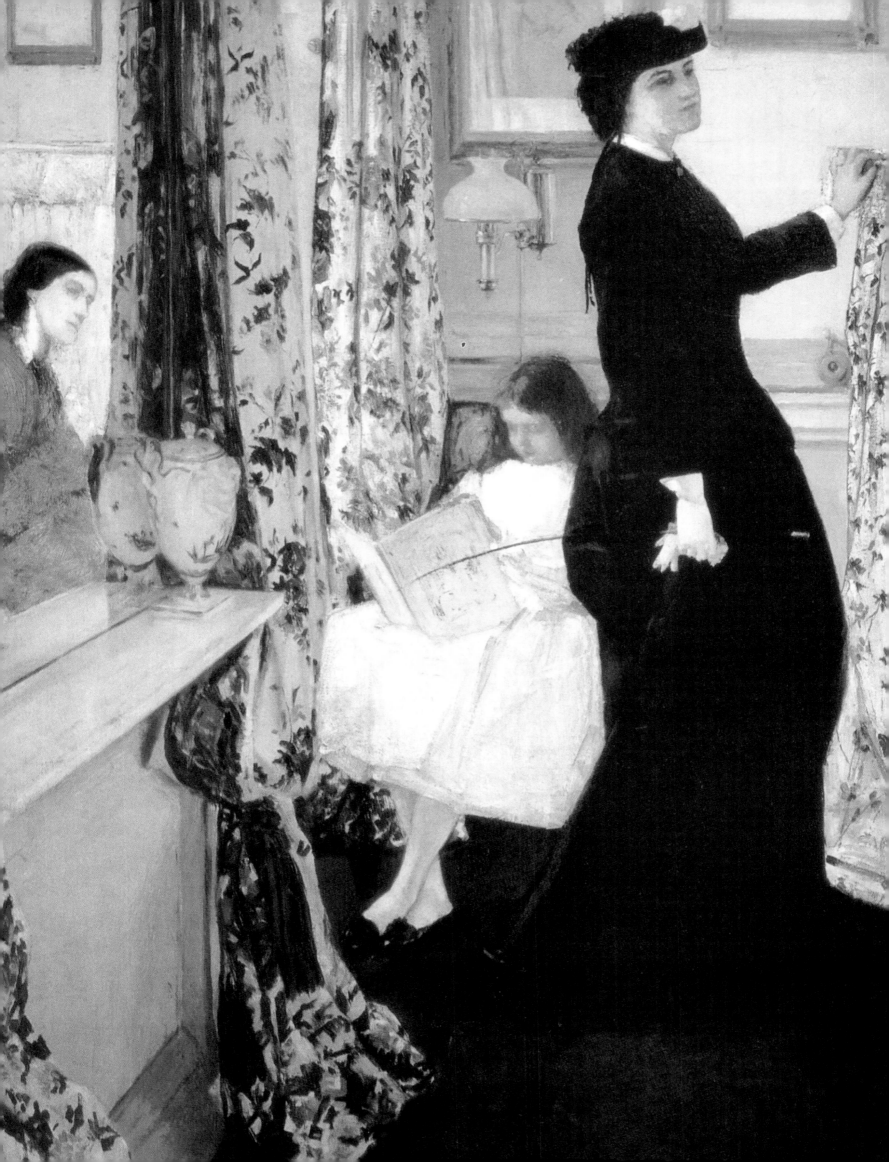

I remember once his looking very carefully at a handsome cab that had pulled up for some purpose on the bridge, and in a few strokes he had got the look of it perfectly." The completion of the *Nocturnes* series with the depictions of the Cremorne Gardens enables us to understand how Whistler subscribed to the great tradition. "Who today remembers the gay Cremorne?," wrote the novelist Thomas Hardy. Whistler paid a great deal of attention to these London pleasure gardens. He found a very special music in his night-time perambulations. He wrote, "Just as music is the poetry of sound, so painting is the poetry of vision, and the subject has nothing to do with the harmony of sound or of color."

This concept is perfectly illustrated in the series of paintings devoted to Cremorne. At the time, the artist was capable of encapsulating in words the equivalent of his painting, "In the lemon-colored wing of the pale butterfly with its delicate splashes of orange, he sees before him the grand gilded halls with their elegant saffron-colored pillars, and one learns how the drawing which one sees at the top of the walls can be traced in delicate tones and repeated at the bottom by darker nuances." He littered his prose with metaphors of color as he created his pastels with little dabs of color. Whistler attacked the general opinion of his day which took it for granted that the greatest accomplishment of art is to tell a story.

He was particularly annoyed with art critics who in his view were responsible for the false notions which the public had of painting. He wrote, "A painting is more or less a hieroglyph or the symbol of a story. Apart from certain techniques which he can arrange to do in any case, the art critic considers a work from a literary point of view... In his writing he treats a painting as if it were a novel, a story or an anecdote and naturally he completely fails to see its artistic merits or demerits, and in doing so he degrades art by comparing it to a method designed to create a literary effect... He finds invention in the difficulty of a theatrical production and noble philosophy in a few details of philanthropy, courage or virtues suggested to him... During this time, all the poetry of the painter remains completely invisible to him. The surprising invention which could have succeeded in creating a perfect harmony between form and color, this exquisite thing, he does not perceive." Nature alone was not art, "telling a painter that nature must be taken as it is to tell an artist that he has the right to sit on a piano," wrote Whistler. Only the artist can read the secrets of nature and translate them into art: "He looks at her flower not with an enlarging lens that he may gather facts for the botanist but with the light of the one who sees in her choice selection of brilliant tones and delicate tints suggestions of future harmonies [...] In all that is dainty and lovable, he finds hints for his own combinations and *thus* is Nature ever his resource and always at his service, and to him is nought refused."

Ernest Fenollosa understood the nature of synthesis of the creative process of the painter: "It is the exploration of this rich universe of combination [...] which for Whistler became the sole purpose of his life." Like Baudelaire, James Whistler rejected Realism as a negation of the imagination. For him, the act of creation was more important than the subject chosen.

"Let us take *Portrait of my Mother* exhibited at the Royal Academy under the title *Arrangement in Gray and Black*," he wrote. "Well, for me, this is an interesting painting as a portrait of my mother but what interest does the public have in the subject of the portrait?" Swinburne immediately criticised this comment by affirming that the inconsistency of the polemic rendered it useless and maintained that Whistler, while having denied the concept of the

14. *Harmony in Green and Rose:*
The Music Room. 1860-1861.
37 5/8 x 27 7/8 in. (95.5 x 70.8 cm).
Freer Gallery of Art, Washington.

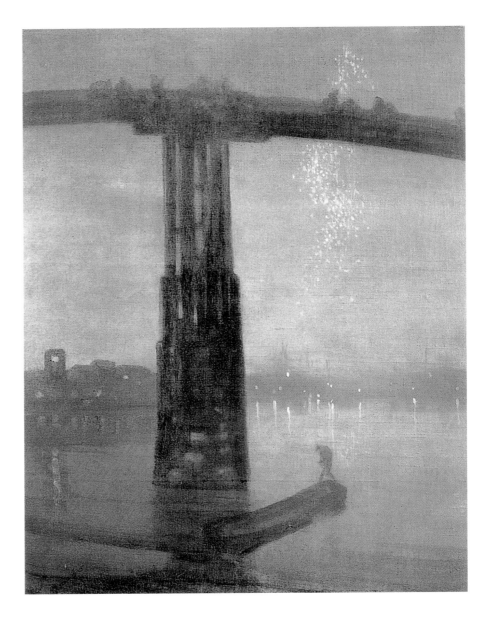

subject, could nevertheless not escape from it. He detected in the *Arrangement in Gray and Black* "the expression of a living character, the intensity of a pathetic power which gives this noble work something of the solemnity which belongs to a tragic or elegiac poem."

Whistler affirms that the subject is translated into the beauty of form. This does not mean that it is lost. Baudelaire noted, "The best way to understand a painting would surely be as a sonnet or an elegy. We have recently noted that French avant-garde artists seek contemporary subjects which could symbolize the spirit of their age."

In 1863, Baudelaire published an article in the Paris newspaper *Le Figaro*, entitled "The Painter in Modern Life."

Modernity to him meant "the ephemeral, the fleeting, the contingent, the half of art of which the other half is the eternal and the immutable." He explained that the aim of the painter in modern life "is to extract from fashion any element which it could contain within history, to distill the eternal from the transitory" because for him beauty represented both of these: "It is the result of changing fashions, of the manner of sensing what is typical of the different eras." He tells his readers that "each era has its own look and gesture." His preoccupations are the same as Whistler's and those

40

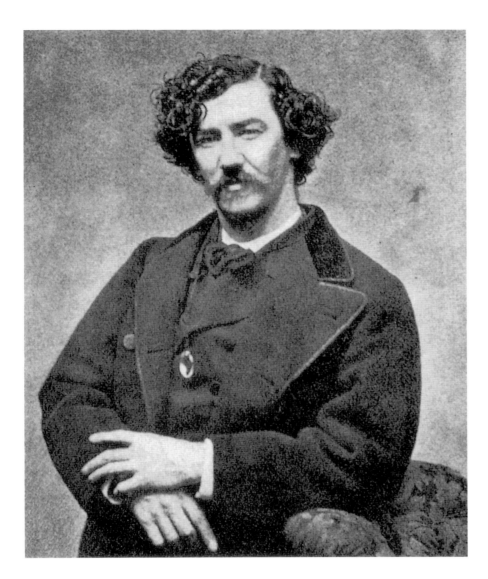

artists who he befriended in London and especially in Paris – Manet, Monet and Degas, who are busy grasping their own impressions of light. At the time when Whistler chose to live beside the Thames, Chelsea represented bohemian life, it was the equivalent of the Paris Latin Quarter. For more than a century, Chelsea was a riverside enclave reserved for artists and writers, with such famous residents as Thomas Carlyle, Charles Dickens, William Turner, William Morris, Dante Gabriel Rossetti, John Everett Millais and Oscar Wilde. Whistler's choosing to paint views of Chelsea is similar to the choices made by the Impressionists in France.

Chelsea had changed little since the previous century but in the late 1870s it was to be profoundly altered by modernization and the encroachment of the city. Prior to this transformation, the quays were lined with grain stores, gardens and 14 wooden bridges across the Thames.

Cremorne Gardens was one of the last of the London pleasure gardens. It lay on the edge of town, a place to which Londoners used to come to amuse themselves. The need to build new housing had become more and more pressing and would play a decisive role in the destruction of this garden, which was a victim of urban renewal. Cremorne was a vast open space in the middle of a neighborhood which had been overcrowded for too long.

16. Whistler, photographed by Etienne Carjat. Paris, 1864.

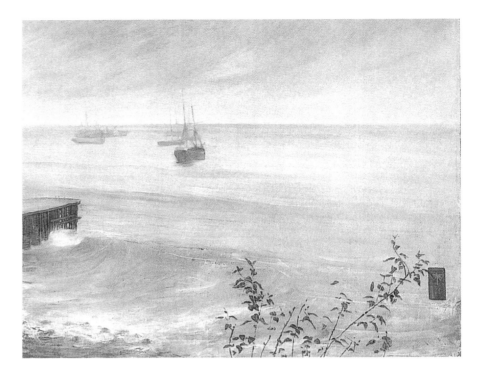

Whistler has left us a valuable legacy in his record of Cremorne Gardens, created as they were on the verge of extinction. These are modern historical paintings reminiscent of the work of Watteau and Gavarni as well as that of the French modernists. The painter was determined to leave us with a feeling for the atmosphere created by this pleasure ground before it disappeared forever.

Whistler was himself part of the world of high fashion and high society, and it will be seen that Whistler's representations of the Cremorne show him to have taken up the Baudelarian challenge which required that a painter depicts modern life.

Only an artist could transform such a prosaic neighborhood into art. A contemporary photograph probably taken from the tower of Chelsea parish church offers us a view of old Battersea Bridge and the trees of Cremorne Gardens which stretch along the riverside. The *Nocturne in Blue and Silver: Cremorne Lights* depict almost the same scene as the photograph but most of the details have disappeared, replaced by an evocative suggestion. Seen though the veils of mist, the lights of the Gardens attracted Whistler into what he described as a "fairy-land." Although the lights were only the reflection of a popular amusement park, Whistler transformed them into eternal works of art before the gardens closed forever.

The *Cremorne Gardens* series consists of seven oil paintings created between 1872 and 1877. The owner of Cremorne Gardens was taken to court concerning the dilapidation of some of the facilities in the park (in fact this was a pretext by the London authorities to recover the land) and his license was not renewed. The garden was soon sold off as parcels of land. Cremorne was right by the river and had been a private estate until it was bought by Charles de Bérengé, a nobleman of French and Prussian extraction. De Bérengé opened the Stadium, a sports club in 1830. This park offered "manly" pursuits, such as sailing, swimming, fishing, shooting, gymnastics, football, cricket, wrestling, military drill, skating, horseback riding, in short all the daring athletic pastimes of the man-about-town. Sports festivals and galas were held there, thus creating the fashion for such events which were

17. *Symphony in Gray and Green: The Ocean.* 1866-1872. 31 x 39 in. (79.5 x 99 cm). Frick Collection, New York.

eventually to be typical of the Gardens until Whistler's time. Furthermore, de Bérengé was experienced in handling fireworks and in 1836, he organized a fireworks display. Thus one of the major themes of the *Cremorne Gardens* series, the fireworks, had been one of its great attractions since its inception. In 1837, de Bérengé obtained a license for permitting musicians to play and he built a dance floor, one of the other activities to be depicted by Whistler. In 1839, de Bérengé added a bowling room, a crystal grotto, a circus, a theater, puppets, gypsy tents, and a Chinese theater. The place had become the sort of amusement park which Whistler visited thirty years later.

De Bérengé died in 1845, and the park was then opened to the public. The existing amusements were supplemented by a banqueting hall which could accommodate a thousand people and a theatre at the southern end of the park which overlooked the river.

A pagoda was built to house a Chinese orchestra; "It is most charmingly decorated […] surrounded by a huge circular stage designed to be used as an open air ballroom, and it is said to be capable of offering great freedom of movement to four thousand dancers at the same time."

Ten years later, a journalist admired the Chinese stage with its wrought ironwork including the emerald and ruby cut-glass ornaments on the chandeliers which produced the most extraordinary effects. Other features of the building are described in the sale catalogue for Cremorne Gardens. The pavilion had a circumference of about 300 feet. It was edged with ornamental iron pillars and encrusted with more than four hundred mirrors framed in black.

At the upper part of the pagoda, where the orchestra played, there were seventeen gasoliers. Details of the stage appear in the work of Walter Greaves. Whistler depicted the stage full of dancers in his *Nocturne in Black and Gold: The Gardens*. This painting was first called the *Cremorne Nocturne: the Dance* by Whistler.

But rather than accentuate the decorative aspect of the stage and the dance, the painter preferred to suggest the presence of these elements by the bright light falling on the wrought iron structure and illuminating the clothing of the dancers. The anonymity of the silhouettes suggests the movement of dancing.

In 1857, Cremorne was expanded. A miniature replica of the city of Berne, Switzerland was built, as well as a Swiss chalet and a covered riding school. Two theatres were then added as well as numerous other attractions. Cremorne also became famous for its restaurants where one could dine lavishly. The Gardens were noted for their theatrical and musical performances. When Whistler frequented them, he would certainly have attended a performance of a work by Offenbach. A typical program from the 1870s gives an idea of what an evening spent at the Gardens had to offer:

6:00 p.m.	Instrumental concert
7:00 p.m.	Hungarian dancers with the Royal Theatre Comic singers and dancers.
	Ventriloquism and mime
8:00 p.m.	The Boisset family of acrobats
9:00 p.m.	At the puppet theater: operettas
10:00 p.m.	Comic ballet at the Royal Theatre
	Big firework display by Wells
11:00 p.m.	Concert until closing time.

The other pleasure gardens, such as Vauxhall and Ranelagh, were frequented by the upper classes but no place in London served as was the exclusive purlieu of the aristocracy. Cremorne seemed to be a pleasure garden aimed at the middle and lower classes, as this program would suggest, although it had known better days.

To publicize the Gardens, the management of Cremorne would plaster the walls of London with advertisements. During an ascent by balloon in 1861, four thousand leaflets were used both as ballast and as publicity bombs, scattered all over London to lighten the ascent.

It was easy to get to the Gardens by water. A landing was built at the Thames side entrance in about 1850. The dock and gate which led to the pier are shown in a view by Walter Greaves. One could take a boat from all the jetties between London Bridge and Cremorne thus combining the visit with a pleasant riverboat ride.

There was a boat every five minutes. On land, buses served the Gardens from various parts of town. The buildings of Cremorne were new when the infrastructure of Vauxhall, the rival establishment, was in ruins. Vauxhall was temporarily closed for rebuilding in 1857, before closing forever two years later. Its rival took the name of the Royal Cremorne Garden. A journalist wrote, "This is a much gayer place than Vauxhall, its ancestor. When the weather is fine, several thousand people come to the Garden in a single evening and the fireworks organized quite early conclude the entertainments offered in this very popular place."

The parks had long been considered as the favourite place for the flourishing of fantasy and dreams. Whistler thought it important to depict the Cremorne Gardens in abstract terms because the traditional elements of the park no longer had much to offer to the public. The weight of tradition is important in understanding the work. Whistler incorporated oriental techniques into The *Cremorne Gardens* series, and Chinese motifs are numerous.

The figures in *The Balcony* are wearing oriental dress. Who knows whether they are perhaps listening to the Chinese orchestra in Cremorne Gardens? The woman who is leaning over and looking to her right may perhaps be seeing the trees which shaded Cremorne and projected their reflections into the river, at the western edge of the district. Whistler did not need to take a boat or a bus to get to the garden from his house in Cheyne Walk, but the proximity is not only explained by the interest he had in the Gardens.

He began painting the subject in 1872, almost twelve years after moving to Chelsea. The same themes that interested the French painters are to be found in his work. All were conscious of the powerful attraction of the parks and places of amusement, excellent places in which to observe the lives of fashionable people.

A French visitor to London wrote, "I have been told that fifty thousand people gathered at Hyde Park on days when the orchestra was playing. It would be difficult to find a better occasion for observing the various elements of which elegant society is composed."

In 1847, Cremorne Gardens boasted a magnificent entrance erected at the riverside and modelled on the gate of the Mabille Garden in Paris. The gateway can be seen in a painting by Walter Greaves and in an abstract pencil drawing by Whistler. The painter was determined to produce a night view showing the brightly-lit lamps and the silhouettes moving toward the entrance.

18. *Crepuscule in Flesh Color and Green: Valparaiso*. 1866. 22 x 29 in. (58.4 x 75.9 cm). Tate Gallery, London.

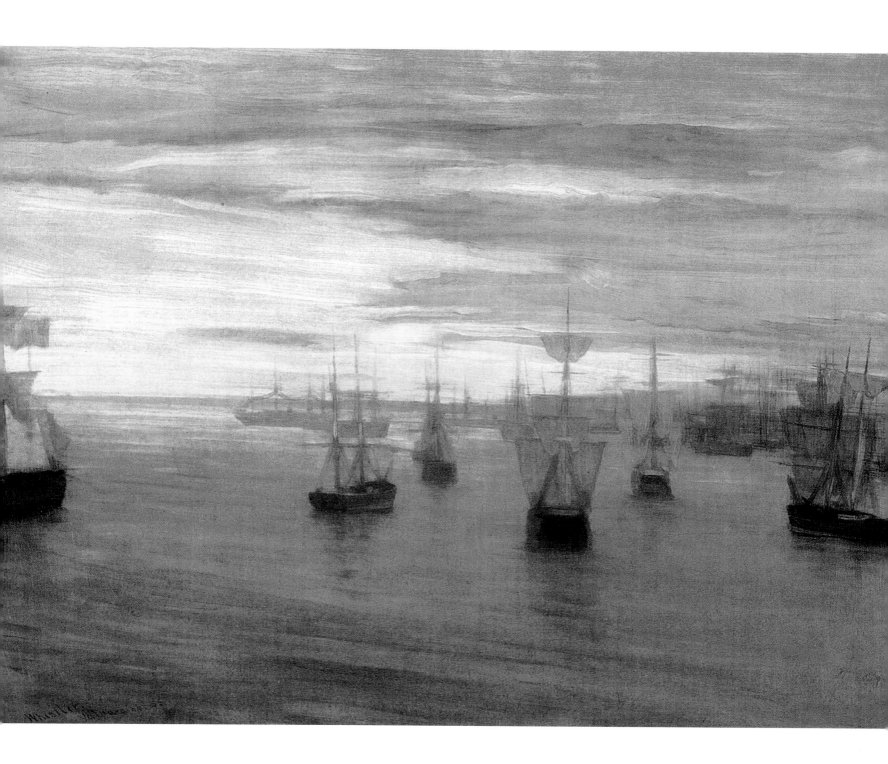

Another attraction of French origin at Cremorne was the Versailles Promenade. The program for the opening of Cremorne in 1860 promised an oriental circus copied from the existing circus in Paris, and two years later, Cremorne presented another novelty, Delamarne's flying balloon (known as *L'Esperance*).

A poster announced that the balloon had come directly from the Luxemburg Gardens in Paris, where it had been on display.

Whistler was attracted by the same centers of interest as his French contemporaries, namely, the popular singers and fireworks, which can also be seen in lithographs by Degas.

Manet, Degas and Renoir painted numerous scenes in cafés and fashionable restaurants. Whistler happened to prefer the Gardens at night rather than the daylight scenes of the French artists. Renoir, on the other hand, included the faces of his friends in his paintings while the American artist only painted outlines, thus taking the role of a stranger observing contemporary life but detached from it. In this respect, there is a clear relationship between Whistler's painting and Baudelaire's writing.

The latter wrote: "For the idler as for the impassioned spectator, it is a great joy to be able to be part of the multitude, to be in the crowd and the flow of movement, in the middle of the fleeting and the infinite, to be in the center of the world and yet to remain hidden from the world, such are some of the lightest pleasures of these independent, deeply interested and yet impartial natures which are hard to put into words. The spectator is a prince who always enjoys being incognito."

Whistler brings us into the gardens and through a dense and veiled atmosphere, the spectator shares the atmosphere of the place. B. Selman stated in 1805 that many distinguished people frequented Vauxhall, but he recognized that a sizeable proportion of the crowd consisted of demi-mondaines and, he continued, Vauxhall was extremely elegant but he was convinced that this was a very successful school of corruption.

Whistler conveys the same message in his *Nocturne: Cremorne Gardens No 3*. We can discern a couple who appears to be hastily leaving one of the theaters or restaurants.

The man is wearing a top hat and an evening cape while his companion wears a fashionable white dress. In the same way, *Nocturne in Black and Gold: The Gardens* offers us an almost lascivious view of the dancing on the Chinese stage though everything is implicit, anonymous, as clandestine as the type of relationship one might have pursued in Cremorne Gardens. The covers of the musical scores are revelatory of the tolerance of the public in relation to public licentiousness. The words of numerous waltzes and quadrilles were based on the amorous activities to which people devoted themselves at Cremorne.

A visitor of the period remarked, "Here, no one pays attention to what his neighbor is doing."

The threat to morality represented by Cremorne Gardens caused discussions among the ownership and in other sections of the community. In 1857, the Chelsea Association petitioned for the annual permit for the Gardens to be refused. The Gardens were attacked and mocked in cartoons.

Over the next fifteen years, the opposition grew in intensity and profited from various tragic accidents connected with ballooning and other spectacular attractions organized by the Gardens.

19. *Variations in Blue and Green.* 1868.
18 x 24 3/8 in. (46.9 x 61.8 cm).
Freer Gallery of Art, Washington.

Stricter controls were urged. In 1873, Canon Cromwell, principal of St. Mark's College, headed a list of petitioners opposing a renewal of the permit for the Gardens. He was particularly incensed at the women of easy virtue who could be encountered there.

A pamphlet written in 1876 by a cleric satirized the pleasure gardens in telling terms. In 1877, Cremorne's operating license was refused, and the structures on the grounds were dismantled and auctioned off.

Immediately afterward, the land was parceled off for construction purposes. This public garden, so convenient for dalliance, did not escape Whistler's attention nor his source of inspiration which categorically denied the pious equation which Ruskin advocated between morality and art.

Whistler's mistresses from 1850 through 1870 regularly appeared as models in his paintings and engravings and he considered the belief that a nation must live virtuously otherwise art would perish as an example of supreme pretentiousness. "Another virtue is in our own choice," he added, "In no way can we influence art."

Whistler's series of paintings of the Cremorne Gardens redefines historical painting by suggesting things rather than representing them directly and with complete Realism. Although Whistler lacked the means to be independent, he maintained against everything his position regarding aestheticism.

His elaborate dress, his spectacular lock of white hair, the elegant topcoat, his cane and the monocle he affected, even the succession of mistresses were part of a code of foppishness which belonged to the long tradition traceable back to figures such as Beau Brummel and Beau Nash in the late 18th and early 19th centuries.

For half a century, James Whistler continued to shock his critics and the artistic establishment even after a bitter struggle for acceptance by them. His butterfly signature was the choice of a dandy, the tail of the creature being the visual expression of Whistler's written commentaries. Baudelaire noted "whether these men are called exquisites, macaronis, beaux, lions, or dandies they are all born from the same belly, they all share a characteristic streak of opposition and rebellion."

Whistler's aggressive dandyism was a means to an end just as his passion for a sharp retort kept him constantly in the eye of the press. For Baudelaire, dandyism was the final spark of heroism in a climate of decadence, and he said, "Dandyism emerges mainly in periods of transition when democracy is not yet all-powerful and the aristocracy has only just begun to stumble and fall.

In the confusion which reigns during these periods, some men are ill at ease socially, politically and financially but all are rich in original energy and can conceive the idea of establishing a new sort of aristocracy, one which is all the more difficult to destroy since it is based on the most precious and durable faculties and on divine gifts of a type which hard work and money cannot gratify."

Twenty years after Baudelaire published these observations, Whistler announced, "All that it remains for us to do is to wait until at a sign from the gods, the Chosen Artist comes among us." Whistler considered himself to be this messenger of the gods.

The *Cremorne* series was an anticipatory salvo, and an important one, against the Old Regime of Realism in painting. *The Falling Rocket* is much more than "a pot of paint flung in the public's face." It was an incendiary cocktail thrown by an aesthetic terrorist.

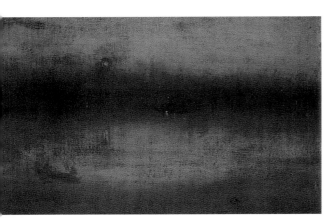

The artist's choice of subject is perfectly appropriate, dictated not only by the contemporary significance of the place described, but also by the traditional significance generally attributed to fireworks, which for centuries were likened to warfare. These Chinese inventions were used not only during battles but also to represent battles in performances. Among the Japanese woodblock prints found in Whistler's studio after his death, one was a Shotonsai woodblock print entitled *Fireworks on a Bridge*, and dated 1857.

Fireworks retained their martial connection even when they reached the West. "Fireworks or artificial fires" were used as a spectacular political instrument in France in the 17th and 18th centuries. Artists and architects created elaborate productions which included the firing of rockets, both fixed and mobile, in order to commemorate the main events in the history of a nation. It is important to remember that such events were only symbolized.

The spectators were to some extent having an abstract experience when they witnessed firework displays. This stylization which was continued in paintings and engraving was an attempt to retain a trace of fleeting events. Fireworks have changed little through the centuries and the spectators in the 1870s saw displays similar to those of the preceding century. A printed leaflet accompanying a display in the Cremorne Gardens in 1856 gives us an idea of the pyrotechnical composition which Whistler might have witnessed. "The representation of a Chinese pagoda formed of diamond, yellow and white lights terminating in four half-suns in contrasting positions which eventually meet.

A double vertical Catherine wheel decorated with all the colors of the rainbow and transforming itself into a twelve-pointed star formed of lights in a diamond shape and ending with a double sun with forty-eight rays.

A wonderful piece called the revolving sun begins with a colored wheel then changes into a strange shape with an octagonal center surrounded by alternating shades of green, scarlet and purple and ending with a brilliant fire. Then large caliber rockets releasing amber-colored stars and golden rain."

At the time when Whistler would have been watching the firework displays at Cremorne, the main pyrotechnic technician was a man called G. Wells. "As the night advanced, the temple of fireworks received its elect. Mr. G. Wells justified his position as the most remarkable pyrotechnic artist with a succession of amazing devices."

It may well be supposed that it was Mr. Wells who lit the fuse of the rocket immortalized in Whistler's painting *Nocturne in Black and Gold: The Falling Rocket*. Applause is the natural response to the experience of light, smoke and sound of a firework display but, as the printed program of 1836 states, a written interpretation can give the performance added and greater significance.

For example, a spectator could read that Guillache was a type of firework representing a watch mechanism which ended in the form of a sunburst. The program helped the spectator to make the symbolic leap from the watch to the sunburst.

Whistler ought perhaps to have supplied an explanatory text to his painting *The Falling Rocket*, in order to define to his contemporaries the goals he was pursuing. But it might reasonably be supposed that they would not have reacted any better, the ideas of the painter being so far ahead of his time.

21. *Nocturne in Blue and Silver: Battersea Reach*. 1872-1878. 15 4/5 x 25 1/5 in. (39.4 x 62.9 cm). Isabella Stewart Gardner Museum, Boston.

22. *Bust of Whistler.* Joseph Edgar Boehm, 1875. National Portrait Gallery, Smithsonian Institution, Washington.

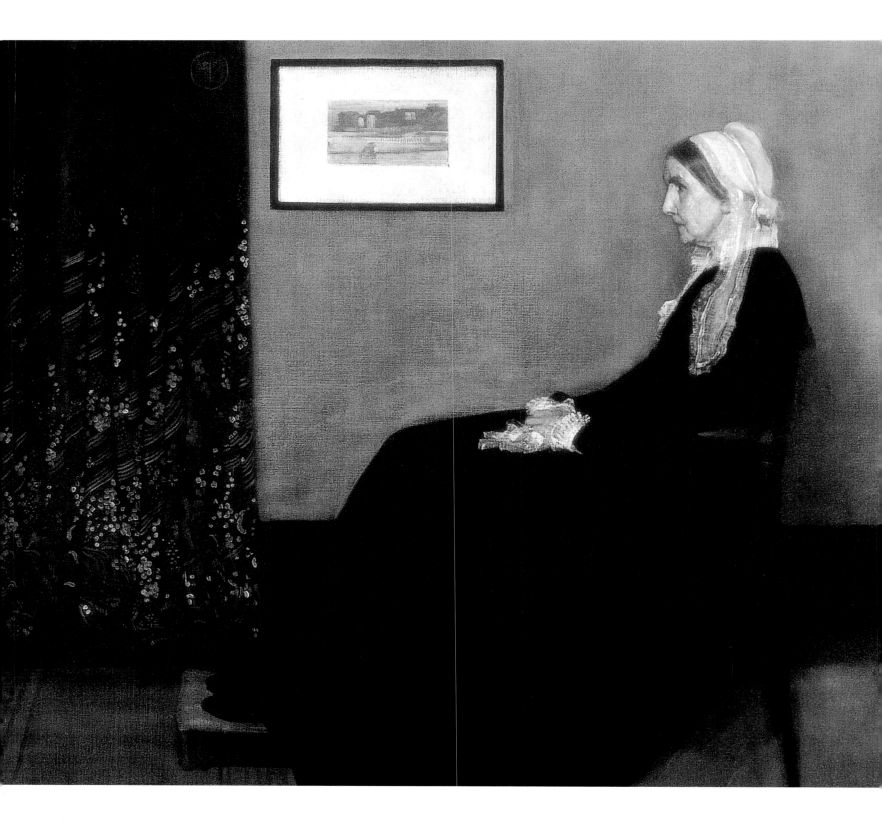

HARMONY OF GOLD AND ANGER, THE PEACOCK ROOM, THE RUSKIN TRIAL (1872-1880)

Degas wrote, "in our beginnings, Whistler, Fantin and I were on the same road, the road from Holland. Go and see a small picture, a scene of a woman dressing herself by Fantin, Whistler and I could have signed it…" Whistler and Degas left the traditional, well-signposted road to take the steeper paths. Their techniques were similar, though. Whistler literally wore out his canvases by scraping and obliterating the same image dozens of times. Degas would draw and redraw the same image, throwing away sheets of paper one after another, introducing a subtle variation of themes. The experimenter is destined to fail more often than to succeed. Whistler took a solitary road, defying any classification. He had shocked the world of painting and artistic concepts of the time, and his influence was decisive. The emotive reaction provoked by his *Nocturnes*, his *Arrangements* and his *Variations* would stand out in history.

As Duret wrote of the *Nocturnes*, "He had reached a limit which could not be exceeded. He had attained that extreme region in which painting has become vague and by taking one more step one would fall into absolute indeterminism where one no longer had anything more to say to the eyes." On the steep path he had chosen to take, Whistler encountered fragments of the travel notes made by his predecessors (Watteau, for example). For the painter, this was first of all a discovery of Japanese and Chinese art. He said, "The only fidelity of the artist is to paint according to his own vision." Academic painters paint anecdotal and realistic scenes, and Whistler was not capable of being the sole attacker of such an establishment. On the other hand, he was a master of guerrilla warfare. Henry James, who was one of his admirers, wrote to him, "You have done too much of the exquisite not to have earned more despair than anything else." The public and the critics were determined not to see further than the end of their noses. Whistler was merely an innovator but they considered him an eccentric. Few people saw him in his studio, a place where the act of creation was too often a fight with despair. Another friend, William Rothenstein, described an evening with Whistler: "Climbing the stairs, we found the studio in darkness. Whistler lighted a single candle. He had been gay enough during dinner, but now he became very quiet and intent, as though he forgot me.

Turning a canvas that faced the wall, he examined it carefully, up and down, with the candle held near it, and then did the like with some others, peering closely into each. There was something tragic, almost frightening, as I stood and waited, in watching Whistler; he looked suddenly old, as he held the candle with trembling hands, and stared at his work, while our shapes threw restless, fantastic shadows, all around us. As I followed him silently down the stairs I realised that even Whistler must often have felt his heart heavy with the sense of failure."

23. *Arrangement in Gray and Black: Portrait of the Artist's Mother.* 1872. 57 7/8 x 64 5/8 in. (145 x 164 cm). Musée d'Orsay, Paris.

Obsessed by the need to destroy these failures, Whistler even hated looking at some of his work. He would say of one of his portraits that it was damnable, that it "could have been done by my worst and most incompetent enemy…

There must be no record of this abomination!" Toward the end of his life, he would bring to London the whole contents of his studio in Paris and would methodically burn the drawings and paintings which did not completely satisfy him. Sometimes he could not face the pain of such destruction. Sickert recounts a poignant moment on the way to dinner at the end of a day's painting. As they walked down the street, Whistler suddenly halted. "You go back," he said to the young painter. "I shall only be nervous and begin to doubt again. Go back and take it all out." While the old man waited below, Sickert climbed the stairs and carefully wiped away the picture with a rag and gasoline.

His working method, which consisted of painting and repainting until he was satisfied, was an agony of self-doubt. "It's always the same – work that's so hard and so uncertain," he wrote to Fantin-Latour. "I am so *slow*. When will I achieve a more rapid way of painting… I produce so little because I rub out so much." The most intuitive of painters wanted to be guided by the most systematic of artists.

The technique of perfecting a painting is an attempt to resolve a seemingly insoluble problem, namely how to give a work created in several hours from life a deliberate essence. The way in which Whistler had ordered his mind made it possible for him to attain results. He forced himself to eliminate any trace of conflict visible on the canvas. One can sometimes see brush strokes, but one has no idea how many times they were erased and recommenced. His reputation is based mainly on the portraits and the *Nocturnes,* which he produced in the years 1860-1870. Using very liquid paint, he created a wash of color consisting of decisive paint strokes.

The contemplation of a *Nocturne* or a portrait by Whistler requires one to "immerse" oneself in the painting. The subtleties will only become apparent to the spectator after attentive and prolonged contemplation. For the portraits, Whistler painted models as he saw them in the light of dusk at the end of a winter afternoon.

The outlines of the silhouettes are blurred. "As the light fades and the shadows deepen, all petty and exacting details vanish, everything trivial disappears, and I see things as they are." What emerged was an impalpable continuity of color, the impression that the whole picture consisted of tinted smoke. "In a mature work of art," said Rudolf Arnheim, "All things seem to resemble each other. Sky, sea, ground, trees, and human figures being to look as though they were made of one and the same substance, which falsifies the nature of nothing but recreates everything by subjecting it to the unifying power of the great artist."

Whistler's studio offered no visual distraction. For each painting the choice of color was often articulated in closely related neutral tones of gray, ochre, brown and black prepared in advance, rather than mixed on the palette as the work progressed. Minor adjustments were made by wiping, scraping and mixing on the canvas itself. Knowing that everything depended on a bold, decisive attack and that the chances of victory were slim, Whistler left the least possible room for chance. The canvas was tinted with a veil of color which had to envelop and harmonize with the colors to come. Then he would sound the attack. He would quickly make two chalk marks on the canvas, representing the top and bottom of the outline; he would stand back, seize a large paintbrush and attack the surface with big strokes, sweeping the canvas, holding out the gigantic brush at arm's length far from the canvas so that he could envisage the painting as a whole. A few moments later, he would walk back across the room

24. *Nocturne in Black and Gold: The Fire Wheel.* 1872-1877. 21 x 29 in. (53.3 x 75.5 cm). Tate Gallery, London.

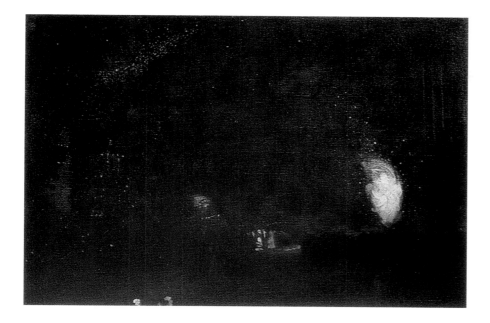

to survey the battlefield, reassemble his forces and prepare for another attack. The layout of the pictorial elements was completed in one or two hours in a series of forays. These then became briefer, the brush strokes smaller, the attacks less violent, less broad. The completion of the portrait was then a matter of light touches here and there, interspersed with pauses for observation.

The artist would slowly bring the brush up to the canvas, change his mind and pick up another brush, seeking the exact tool with which he would be able to provide the finishing touches. The canvas was not worked on more than fifty times in three hours of posing, each brush stroke removing a veil from the design. Then once the final brush stroke had been placed and the portrait was apparently perfect, the model, tired after long hours posing, would watch in horror as the artist took a rag and began to rub it all out! Whistler had seen some minor imperfection, invisible to anyone but himself, and insisted on starting over. Many models were so disgusted that they left and never came back. No one will ever know how many portraits were abandoned or destroyed.

In Whistler's first exhibitions, the artist gained new notoriety because portraits such as these had never been seen before, the effect achieved was so different from that produced by other painters. A legend was born: Whistler was able to grasp the soul of his models which one can feel very clearly, ready to "emerge" from the picture to come and join us. Oscar Wilde was inspired by Whistler when he wrote his novel *The Picture of Dorian Gray*.

Whistler wanted to succeed with portraits of mature people, without exotic touches. One of the first of these was that of his mother. He mentioned it in a letter to Fantin-Latour as early as 1871. He wanted to create a perfect harmony between the lines and colors of the painting. The painter was inspired by Velasquez and Canova's painting *Napoleon's Mother*. Whistler called his painting *Arrangement in Gray and Black: Portrait of my Mother*. It was highly praised by Swinburne, and Thomas Carlyle commissioned his own portrait after having seen it. Whistler also began the portrait of Miss Cicely Alexander, advising her on the type of muslin to use for the dress she is wearing. The same color scheme was used, green and gold were predominant and gave unity to the painting. It took seventy sessions to complete it. The result enchanted Mrs. Alexander who commissioned portraits of her other children. To paint Cicely's sister, May, Whistler asked permission to paint in the room in which the picture would be hung, in order to ensure that it matched the color scheme.

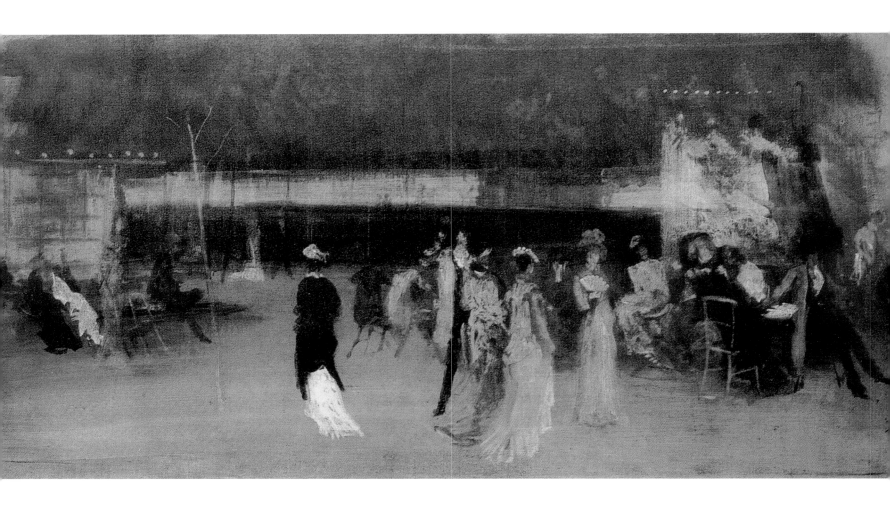

Private commissions began to flow in. F. R. Leyland commissioned his portrait, and that of his wife and children. Whistler paid several visits to Speke Hall, the mansion near Liverpool which was the home of the Leyland family.

The large painting of Eleanor, the first of the *Young Girls in Blue*, is a study in black. James worked to create an impression of depth between the subject and the background. In the painting depicting Mrs. Leyland, the artist has posed his model in front of a blossoming almond branch. He chose a pink-and-white dress to harmonize with her auburn hair. During the many posing sessions, Mrs. Leyland saw the picture take shape and assumed that a few hours would be enough for it to be finished... But the next day, to her horror, she found the canvas had been wiped out. The whole thing had to be started over.

Faced with the difficulties of exhibiting on the "traditional" circuit, Whistler decided in 1874 to hold a one-man show at the gallery owned by Greaves, the Flemish Gallery, in London. Thirteen large portraits were exhibited, as well as several *Nocturnes,* three of the six *Projects* and about fifty etchings. Perfectionist that he was, Whistler created the interior design of the rooms himself. The pictures were well-spaced against a background of gray fabric. He even designed the invitation cards which were decorated with a butterfly. The opening was the occasion for an enjoyable party but the criticisms were unfavorable. His method of painting and the titles of the paintings themselves were so extraordinary!

The painter decided to respond to an article which appeared in a minor publication called *The Hour.* In this way, he pursued his goal of informing the wider public about his aesthetic views choosing to respond only to those articles which best answered his intentions. He called this "making history."

In any case, it must be admitted that the critics brought out the worst in him. It was no rare sight in the public skirmishes he had with them to see him bursting into maniacal laughter as strident as the cry of the peacock. The painter loved to receive fellow artists after his own heart and men of taste, but mere idlers were sent off to do the shopping or post letters. He loved the company of women because the mere fact of watching them develop gave him an aesthetic pleasure. He loved to watch them move and this often gave him the idea for a new painting. In 1871, James Tissot took refuge with Whistler and painted some *Views over the Thames*. Critics would often come to the studio but the articles always mentioned the man and not his work. His words of wisdom were repeated, he was accused of "building the universe on his private life," to which the artist would reply, "Ha! I've had no private life for a long time!"; in a word, he was fashionable. Giving only as good as he got, he then took pleasure in ripostes and was delighted when he hit home against the enemy.

Whistler would often visit his neighbor, Lord Ribblesdale and read him letters from the critics, on which he would comment. The luncheons and dinner parties hosted by Whistler at the house in Lindsay Row were famous. Walter Greaves recounts the preparations for one such repast. "There was great agitation. Mrs. Venturi would lend her pots and pans, Mrs. Leyland her butler.

At the last moment, she brought in some muslin curtains. Whistler was terrified; during the party, a short-sighted person almost sat down on the Japanese bath in which he grew water-lilies." The painter liked to interject "saws" into the conversation, little phrases which were as irrelevant as possible. He also liked elegant humour and tried to inject his reunions with enjoyment.

He inaugurated his famous Sunday lunches where, wrote George Broughton, "one discovered the originality of the artist and his work." Nothing like it had been seen in London. There had been dandies before him, but this was something different! He supervised the decor, designed the invitations and took a great deal of trouble over the organization. His guests were in a strange land as soon as they crossed the threshold. The tableware, the cooking, the goldfish in a bowl, the warm colors of the walls, the color scheme, rare blooms, all of it was so exotic. The painter himself made the buckwheat cakes. In general, about twenty guests would attend, friends, painters, patrons, aristocrats, and journalists. They would arrive on Sunday, invited for midday but the habitués advised them not to appear before two o'clock or they would risk having to suffer hearing Whistler singing away in his bath on the other side of the wall. That is what happened on the day on which Mr. Howell was due to attend in the company of about fifteen other guests, between midday and 1:30 p.m. Suddenly, there was the sound of running water.

Whistler made his appearance at 2:00 p.m., dressed all in white, smiling and gracious. He was so delightful and charming that he made the guests forget their two-hour wait. He had the gift of drawing attention to himself and eclipsing others through his conversation, to say nothing of the fascination of his monocle and his white lock of hair. His hands were delicate, slender and nervous and his gestures expressive; he would mark a pause in the conversation before laughing, and would sketch during the meal. He had a monstrous cheek.

One day, he arrived at a dinner so late that the hostess reproached him with, "We were beginning to be hungry," to which he replied, "Well, that's a good sign!" As an added distraction he played in a successful play, *Under the Umbrella*. The *Daily News* even spoke of his talent as an actor. In October, 1874, he exhibited the *Nocturne in Blue and Gold No. 3* and *Nocturne in Black and Gold: the Falling Rocket* at the Dudley Gallery. Only the Belgian Alfred Stevens expressed a liking for these paintings. Apart from that, the event passed unnoticed.

25. *Cremorne Gardens, No. 2.* 1872-1877. 27 x 53 3/8 in. (68.5 x 135.5 cm). The Metropolitan Museum of Art, New York.

Whistler undertook new portraits but for the moment, our dandy was experiencing financial difficulties and creditors threatened to seize them. Rather than abandon his paintings, he slashed them with a knife. The debt Whistler was unable to pay was a very small one. Lord Ribblesdale or any of his other friends would happily have advanced him the amount but Whistler said nothing and asked no one for anything. After these events, he painted *The Fur Jacket, Arrangement in Black and Brown*. The painting depicts Maud Franklin, a model who had begun to take an important place in his life.

The pose was dignified, the long folds of her dress were created with majestic sweeps of a brush loaded with color. The shape was deeply in shadow, it was claimed that the representation was of a ghost. On the subject of another painting for which Rosa Corder was the model, Jacques-Emile Blanche wrote that Whistler had conceived the idea for the painting seeing Rosa Corder wearing a brown suit as she passed in front of a black door.

The wealthy philanthropist Frederick Leyland continued to befriend the artist. When he bought a house in London, in fashionable Princes Gate, he asked Whistler to design some of the interior decoration. The artist chose pale brown and gold as the color scheme for the hall. Leyland owned Whistler's painting *La Princesse du Pays de Porcelaine*, which was to be hung in the dining room at 49, Princes Gate. The rug in that room was very brightly-colored and the artist suggested that it was incompatible with the painting, so Leyland agreed to cut off the border of the rug. Whistler started work, spending days on ladders and scaffolding, or reaching out in a painter's cradle. He had invented a very individual method of dealing with the problem of working under the ceiling, by using brushes fixed to the end of fishing poles! The Greaves brothers, who were commissioned to gild the room, were sprinkled with gold dust by the end of the day. They would start work at 6:00 a.m. so that by evening all they could think of was resting, "their eyes were so full of sleep and of peacock feathers." The main theme of the room was the peacock, and the artist used two decorative details to create a pattern based on the "eyes" in the peacock's tail and neck feathers. The woodwork was patterned in blue on a gold ground, and the walls were painted in gold on a blue ground.

The artist claimed that the two peacocks which he had painted facing the wall on which the picture *La Princesse du Pays de Porcelaine* had been hung symbolized poor and rich, and illustrated his relationship with his client. One of the peacocks is clutching a roll of gold coins, the other is extending its wings, its feathers ruffled in an angry pose. Mr. Jeckyll, the artist who had started the decoration of the room before Leyland had asked Whistler to take over became mad with rage when he saw what Whistler had done to his work. He went home and painted his wooden floor gold. Shortly thereafter, he was incarcerated in a mental hospital. This did not stop Whistler from holding receptions at the house in Princes Gate in order to brighten his long and arduous labors. One day, Leyland discovered that Whistler had painted over all the leather hangings in the room. When the work was almost completed, Whistler demanded a fee of £13000 ($52,000); Leyland protested and only sent him £6250 ($25,000).

The symbolic premonition embodied in the two peacocks was to be fulfilled. Their friendship which had lasted for several years was not strong enough to reconcile the two men. Leyland agreed to pay the rest on condition that the artist leave his house. But Whistler would only agree to do so when the two peacock panels were completed. "This is where Leyland will sit at table, his back to my Princess; he will always be facing the apotheosis of art and money." Leyland kept the room intact, despite the obvious satire. It now symbolizes the quarrel which parted the two men.

26. *Whistler in the Cremorne Gardens (The Dancing Platform).*
Henry and Walter Greaves, 1866.
Museum of London.

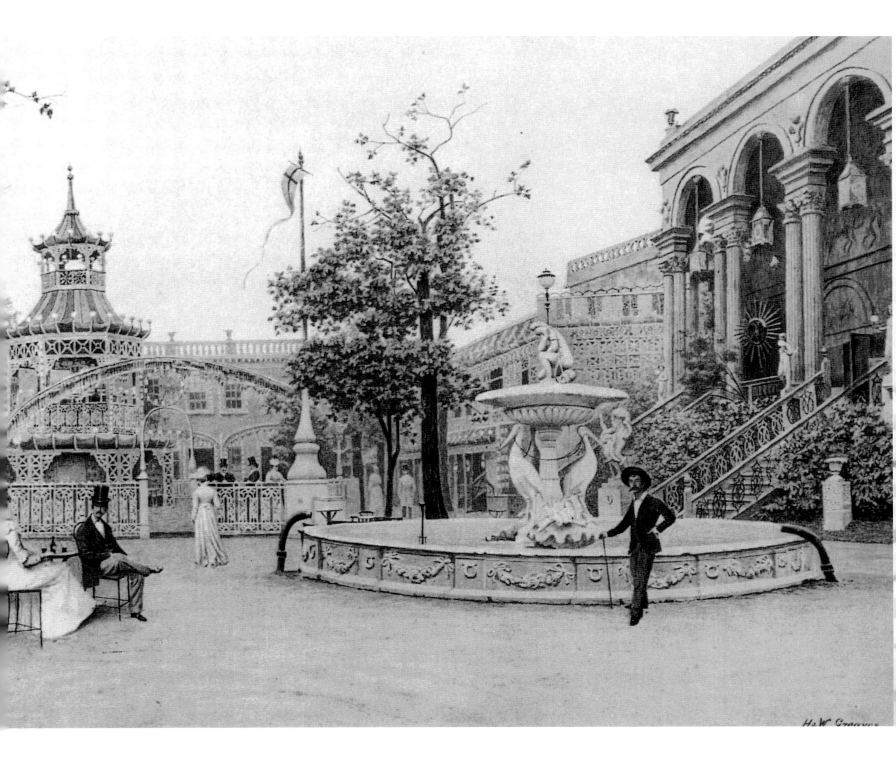

Whistler's attempts to exhibit his paintings nationally, in parallel with the Royal Academy had always failed hitherto. It was in reaction to the Academy's tyrannical attitude that Sir Coutts Lindsay founded the Grosvenor Gallery in 1877. The first exhibition included Whistler's *Nocturnes*, one of which was *The Falling Rocket*. The painter also designed a decorative panel for the room, a pale blue and silver frieze representing the moon in its different phases set among stars. The *Times* mentioned, "Mr. Whistler's corner in which the music strange *Nocturnes* is to be heard." On July 2, as a result of this exhibition, John Ruskin, the passionate intellectual and foremost art critic, violently attacked Whistler in his magazine *Fors Clavigera*. Ruskin had been responsible for the success of the pre-Raphaelites and his convictions defended values which were moral as well as aesthetic. Ruskin claimed that nature was the only reason for art and a painter must reconstruct scenes from life as closely as possible. When he saw the *Nocturnes*, he was filled with hatred of Whistler. England stuck firmly to its traditions, and Ruskin considered himself to have been vested with the mission of defending its values. Ruskin had been a faithful friend and ardent defender of Turner's, whom he had known during the last ten years of the painter's life. In 1843, he had been one of the first to admire this "sublime painting of thought and impressions." There is thus no other way of explaining except as a dramatic mental deterioration, unfortunately confirmed by numerous attacks of dementia, why upon the artist's death Ruskin went so far as to destroy a large number of the painter's drawings on his own initiative.

In fact, he was unaware of the fact that Turner had regularly visited brothels in order to draw the delightful creatures he found there in suggestive poses. When Ruskin found boxes of these erotic drawings, he burned every one of them.

Ruskin believed in his own infallible judgement. When he saw *The Falling Rocket*, he wrote, "I have seen and heard much of cockney impudence before now, but never expected to hear a coxcomb ask two hundred guineas for flinging a pot of paint into the public's face." Whistler was at the Arts Club when he encountered these lines in the publication. "That is the first time I have been attacked in such a vulgar manner," he stated. "Isn't this libellous?" inquired Broughton. "That is what I intend to find out," replied the artist.

The painter was outraged by the criticism, both as an artist and as a man, and he decided to take proceedings for libel against John Ruskin. There was an immediate consequence – the commissions stopped abruptly. A Mr. Robinson, who dared to buy a *Nocturne*, was the butt of jokes. While awaiting the trial, the artist worked on a series of watercolors for a catalog of blue-and-white Nankin porcelain forming the collection of Sir Henry Thompson. In 1878, Whistler published a design for the interior decoration of a house he was having built at Tite Street, Chelsea, by the architect, E. W. Godwin. *The American Architect and Building News* of July 27, 1878 described it thus: "Since Mr. Whistler, a painter from Baltimore, decorated the famous Peacock Room at Princes Gate for Mr. Leyland, he has enjoyed equal fame as an artist of furnishing and wall coverings as that which he had acquired in more elevated art forms. He is currently building himself a house in London, a house which naturally will look like no other, and in the construction of which he has no doubt thought to react against the popularity of Queen Ann-style red brick façades with their balconies and drawbridges."

One of the rooms in this house is called the "Gold Button Room." Whistler also called it "Harmony in Yellow and Gold." The mantelpiece stretches along a section of yellow-colored wall which blends with the rest of the furnishings in the room which were of yellow mahogany, of a pale rather unusual color, very different from the common reddish mahogany.

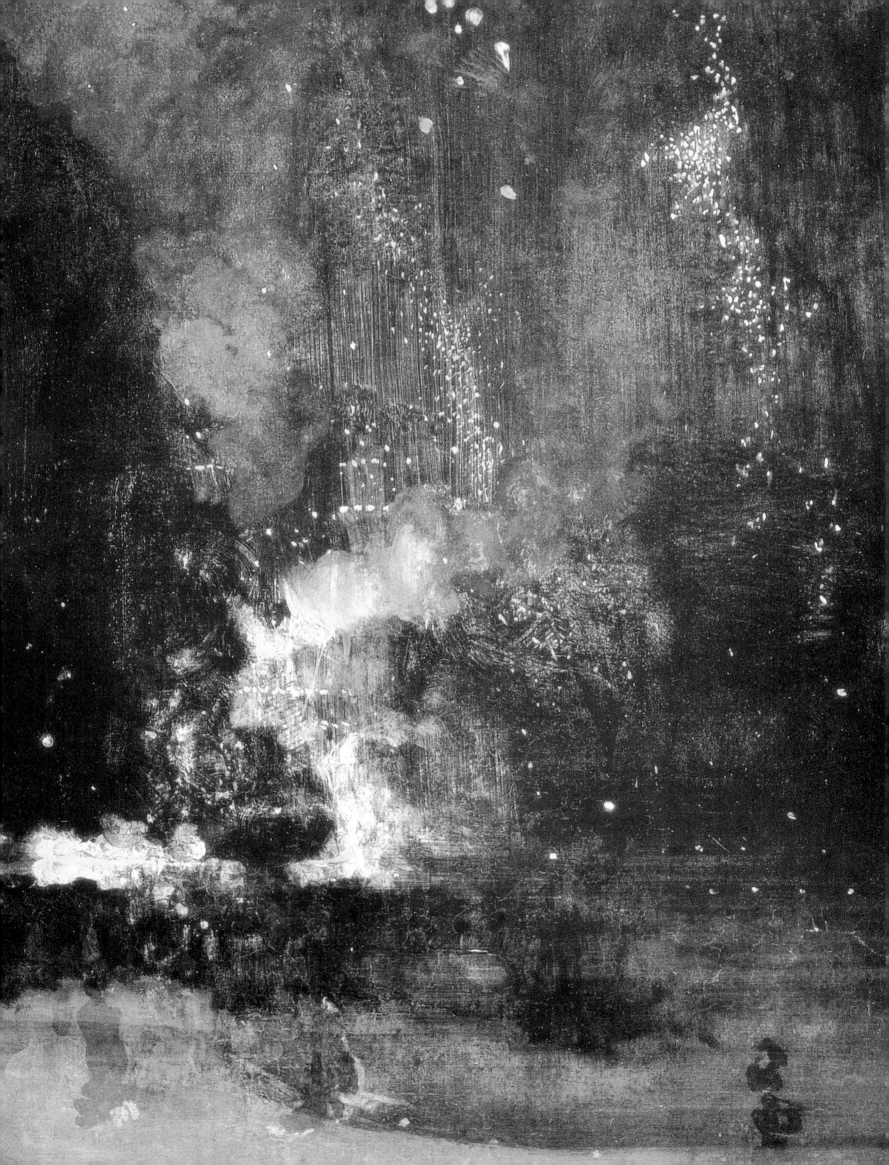

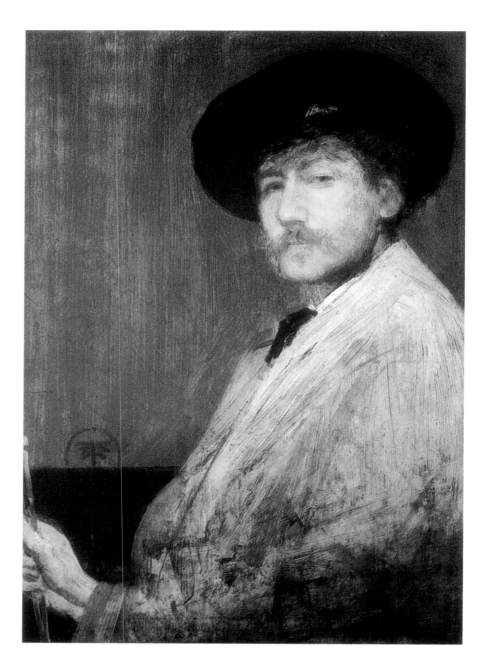

Whistler also installed a yellow-brick fireplace. A sideboard with triangular shelves was ornamented with red-and-yellow Kaga porcelain. The whole decoration of the room was a gradation of shades of yellow on yellow or gold on gold. The peacock theme reappeared at least in the form of the "eyes" in the tail and neck feathers. The table legs were of brass and the furniture rested on a yellow-brown velvet rug. The armchairs and couches were upholstered in a very warm, pure yellow velvet, darker than that of the walls, and fringed with yellow. The shape of the couch indicated Japanese influence, which is also discernible in the whole decor of the room though almost imperceptibly.

Whistler became famous for his interior decoration. He would prepare color schemes for interiors and started a painting by considering where it would be hung, so that one consideration inevitably influenced the other. While he traveled this path alone, a knight errant, Europe was embracing the Art Nouveau style with its themes of extravagant arabesques and curlicues. In England, William Morris strove to offer minute, repetitive patterns which tyrannized the eye. Art had never looked so much like bric-a-brac. Whistler, on the contrary, purified shapes and colors.

He had hardly settled in at the White House in Tite Street when he had to deal with financial difficulties. The newspapers were also full of gossip about his private life. The engagement between the painter and Frederick Leyland's sister-in-law was abruptly terminated. Despite the sums of money loaned by friends (including J. Anderson Rose, his lawyer, Mr. Blott and Mr. Greaves), Whistler was forced to pawn the Carlyle portrait and even *Portrait of My Mother*.

On November 25, 1878 the libel action opened in the Exchequer Chamber in Westminster, "in which Mr. James Abbott McNeill Whistler, an artist, seeks to recover damages against Mr. John Ruskin, the well-known author and art critic." The whole point of the case was to know whether an artist has the right to paint things as he sees them. As for Ruskin, who had been suffering from mental illness since 1870, he was a vain man who had already written disparagingly of Velasquez and Rembrandt. This was a good sign for Whistler, who thought he would be able to topple the great arbiter from his pedestal.

The *Times* and the *Daily News* published reports of the trial on 26 and 27 November, 1878. Lady Burne-Jones stated that Ruskin awaited the trial impatiently although his doctor had forbidden him to attend the hearings. On the opening day, the court was packed, so sensational was the case. Whistler's attorney opened the case and quoted the Ruskin article. Whistler was called to the witness stand. He explained that of the four *Nocturnes* exhibited at the Grosvenor Gallery, two had been sold in advance, the *Nocturne in Blue and Gold* had been sold to a Mr. Percy Wyndham for $5500 and another to Mr. Graham in exchange for another commission worth 1000 guineas (about $4000). He had presented the third painting to Mrs. Frederick Leyland. The only painting which remained unsold was the *Nocturne in Black and Gold: the Falling Rocket*. Ruskin was incensed by the fact that Whistler had asked 200 guineas for this painting. Questioned as to whether since the publication of Ruskin's article he had difficulty in selling it, the artist replied that he had had to reduce the price. The portraits of the actor Henry Irving and of Thomas Carlyle were shown to the judge and jury as documentary evidence.

Whistler commented, "I have perhaps meant rather to indicate an artistic interest alone in the work, divesting the picture from any outside sort of interest which might have been otherwise attached to it. It is an arrangement of line, form, and color first, and I make use of any incident of it, which shall bring about a symmetrical result. Among my works are some night pieces, and I have chosen the word Nocturne because it generalizes and simplifies the whole set of them." At that very moment, *Nocturne in Black and Gold: The Falling Rocket* is shown to the court, upside-down. Cross-examined by the Attorney-General, Ruskin's attorney, Whistler explained that the painting was "a night piece and represents the fireworks at Cremorne."

ATTORNEY-GENERAL: Not a view of Cremorne?

WHISTLER: If it were called a view of Cremorne, it would certainly bring about nothing but disappointment on the part of the beholders (*Laughter*). It is an artistic arrangement.

ATTORNEY-GENERAL: Why? Do you call Mr. Irving an arrangement in black? (*Laughter*).

The judge ordered Whistler to answer despite his attorney's formal protest. The latter replied to the Attorney-General that it was the painting and not Irving himself which was the arrangement.

WHISTLER: These were impressions of my own.

28. *Arrangement in Gray: Portrait of the Painter.* 1871-1873. 29 x 21 in. (60.3 x 46.6 cm). The Detroit Institute of Arts.

I make them my study. I suppose them to appeal to none but those who may understand the technical matter.

Whistler added for the benefit of the special jury that it would be easy for them to go and view the paintings which had been deposited at the Westminster Palace Hotel.

ATTORNEY-GENERAL: I suppose you are willing to admit that your pictures exhibit some eccentricities. You have been told that over and over again?

WHISTLER: Yes, very often! (*Laughter*)

ATTORNEY-GENERAL: You send them to the Gallery to submit them and invite the admiration of the public? Did it take you much time to paint the *Nocturne in Black and Gold*? How soon did you knock it off?

WHISTLER: I knocked it off possibly in a couple of days – one day to do the work, and another to finish it.

The case was interrupted in order to enable the jury to view Whistler's paintings at the Westminster Palace Hotel. *Nocturne in Black and Gold: The Falling Rocket* was then shown again to the court.

ATTORNEY-GENERAL: What is the peculiar beauty of this painting?

WHISTLER: It would be impossible for me to explain it to you, I am afraid, although I think I could it to a sympathetic ear.

ATTORNEY-GENERAL: Do you not think that anybody looking at that picture might fairly come to the conclusion that it had no peculiar beauty?

WHISTLER: I have strong evidence that Mr. Ruskin did come to that conclusion.

ATTORNEY-GENERAL: Do you think it fair that Mr. Ruskin should come to that conclusion?

WHISTLER: What might be fair to Mr. Ruskin I can't answer. No artist of culture would come to that conclusion.

ATTORNEY-GENERAL: You offer that picture to the public as one of particular beauty, as a work of art and one which is fairly worth 200 guineas?

WHISTLER: I offer it as a work which I have conscientiously executed and which I think worth the money. I would hold my reputation upon this as I would upon any of my other works.

Whistler having completed his evidence, William Michael Rossetti was then called to the witness-box. He had a difficult task because he was a friend of both Whistler and of Ruskin.

However, in this instance, he was firmly on Whistler's side. In reply to a question by Serjeant Parry, Whistler's attorney, about the *Nocturne in Blue and Silver*, Rossetti replied, "I consider it an artistic and beautiful representation of a pale but bright moonlight."

SERJEANT PARRY: What was your judgement of the works in the Grosvenor Gallery exhibited by Mr. Whistler?

29. *Harmony in Gray and Green: Miss Cicely Alexander.* 1873. 86 x 39 in. (218.4 x 99 cm). Tate Gallery, London.

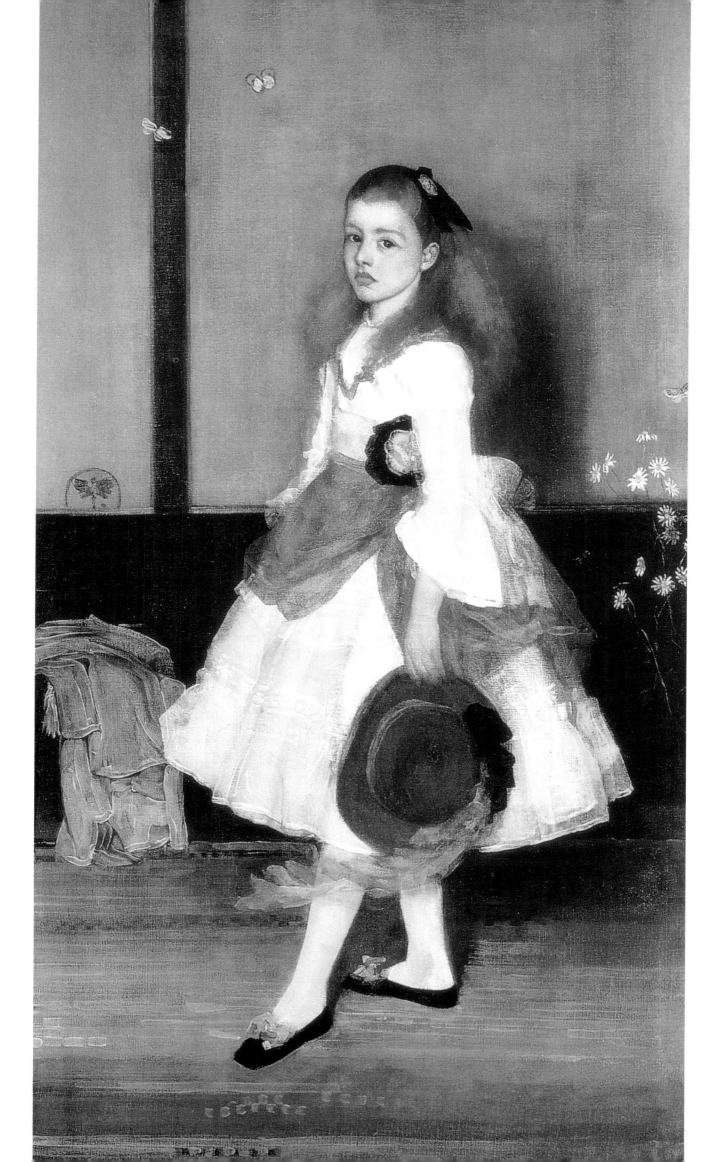

ROSSETTI: Taking them altogether, I admired them much, but not without exception.

After close questioning, Rossetti finally admitted that *The Falling Rocket* was not one of the paintings he particularly admired.

ATTORNEY-GENERAL: Is it an exquisite painting?

ROSSETTI: No.

ATTORNEY-GENERAL: Is it very beautiful?

ROSSETTI: No.

ATTORNEY-GENERAL: Is it a work of art?

ROSSETTI: Yes it is. It is a picture painted with a considerable sense of the general effect of such a scene as that, and it is painted with a considerable amount of manipulative skill.

ATTORNEY-GENERAL: Is 200 guineas a stiffish price for a picture like that?

ROSSETTI: I think it is the full value of the picture (*Laughter*).

It was then the turn of Albert Moore. He declared that Whistler's paintings were beautiful works of art and that no other painter could equal them. He described *Nocturne in Black and Gold* as "marvellous," seeing it as a consummate example of art. He was asked if there was anything eccentric about it. He replied that what was taken for eccentricity in Whistler was merely originality. The Attorney-General then made an application to non-suit the case, but the judge, Baron Huddleston, responded that the terms which had been used by Ruskin had subjected Whistler to mockery and public derision and that they were of a libellous nature.

The complaint ought thus to be submitted to the jury to decide and the Attorney-General proceeded to try and persuade the jury that Ruskin's criticisms did not exceed the bounds of permissibility. His summation began with a paean of praise to Ruskin. He then proceeded to ridicule the evidence of the witnesses, ending on a derogatory note regarding Whistler and his work. The Attorney-General went on, saying "without fear of contradiction that if Mr. Whistler founded his reputation on the pictures he had shown in the Grosvenor Gallery, the *Nocturne in Black and Gold*, the *Nocturne in Blue and Silver*, his *Arrangement of Mr. Irving in Black*, his representation of the ladies in brown, and his symphonies in gray and yellow, he was a mere pretender to the art of painting." Edward Burne-Jones was the first witness for the defense. He affirmed, like Ruskin, that painting required careful work and considered the *Nocturne in Blue and Silver* as an unfinished work but, he added, the color was remarkable. He then agreed that *The Falling Rocket* was not a work of art and that it certainly was not worth the price the artist was asking for it. It was then the turn of W. P. Frith, a member of the Royal Academy and an ally of Ruskin's, and then of Tom Taylor, the *Times* art critic, both of whom said broadly the same thing.

Serjeant Parry then remarked that Ruskin's attorneys were treating Whistler as an impostor. He declared, "After hearing the evidence, can it be said that this is a fair criticism of Whistler's works?" Ruskin had not supported his assertion by evidence, "and had not condescended to give reasons for the view that he had taken. No, he had treated them with all the contempt that he treated Mr. Whistler. He said, 'I, Mr. Ruskin, seated on my throne of art, say what I please upon it, and expect all the world to agree with me.' Mr. Ruskin is great as a writer but not as a man. As a man, he had degraded himself. The tone of Mr. Ruskin's mind …was personal and malicious …Mr. Ruskin's criticism upon Mr. Whistler's pictures is almost exclusively in the nature of a personal attack.

30. *Annabel Lee*. 1870. 13 x 7 1/8 in. (32.5 x 17.8 cm). Freer Gallery of Art, Washington.

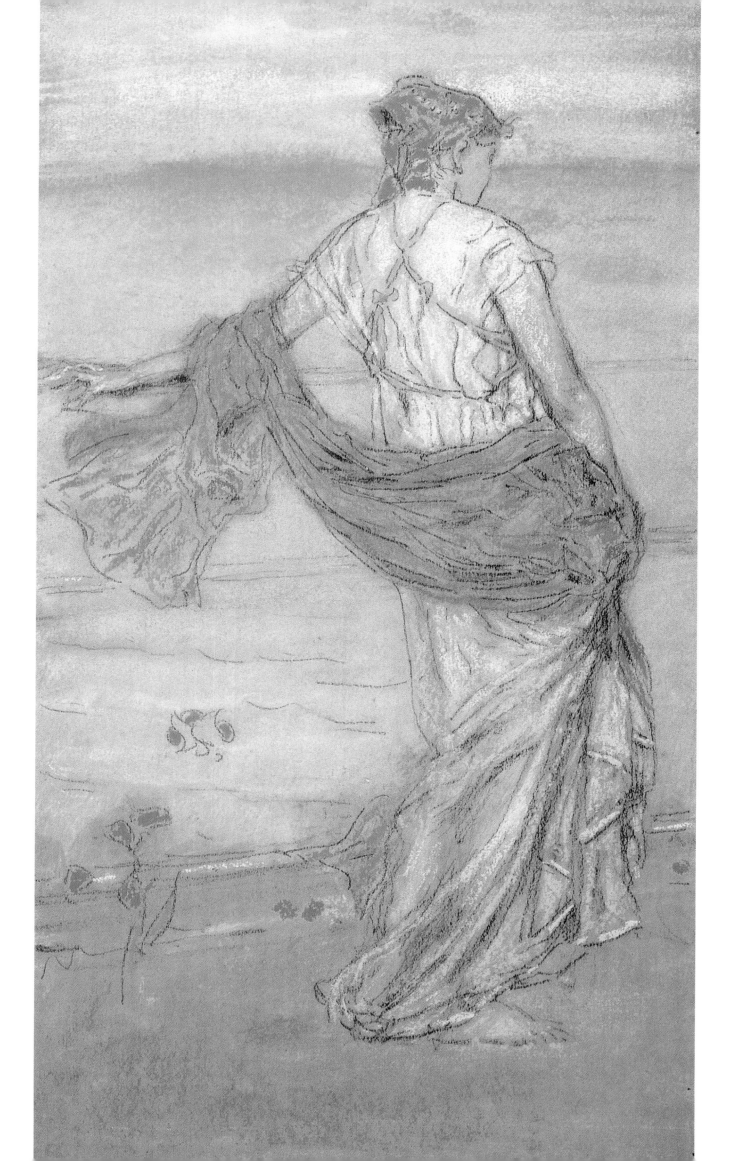

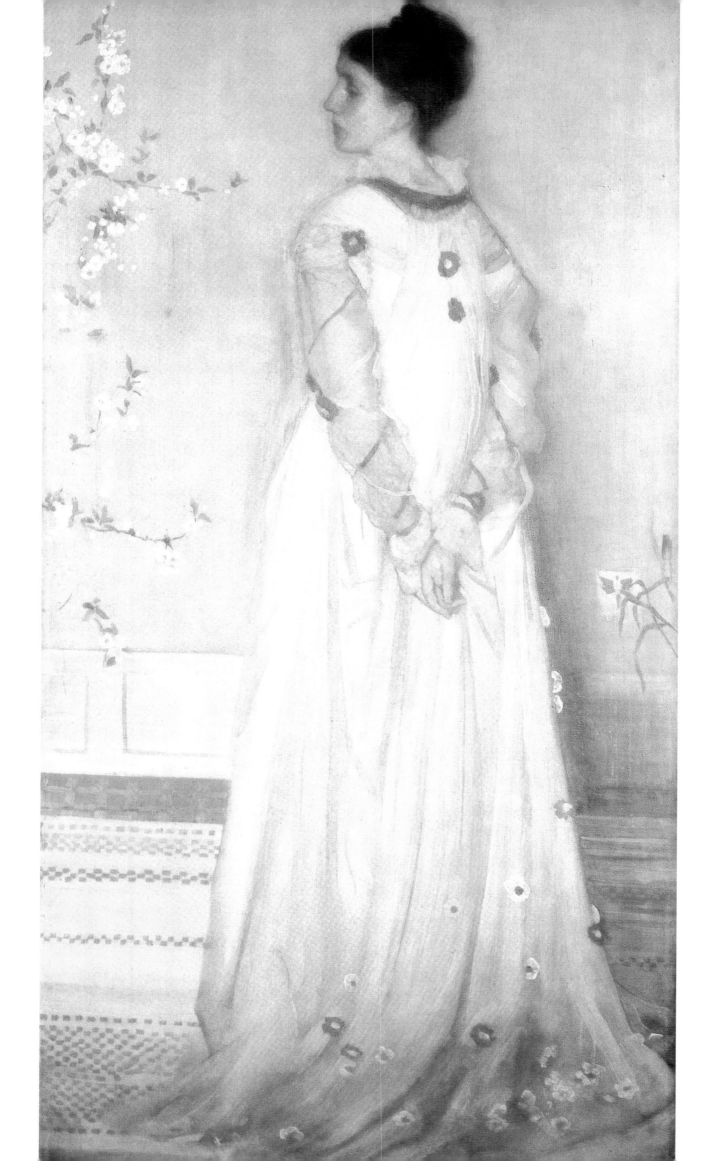

While all fair criticism of art was allowable, a pretended criticism of art which is really a criticism upon the man himself, which was calculated to injure him, and which was written recklessly and for the purpose of holding him up to ridicule and contempt, was not allowable.

Mr. Ruskin had gone out of his way to attack Mr. Whistler personally and must answer for the consequence of having written a defamatory attack upon the plaintiff. Is there any difference between telling a man that he nearly approached wilful imposture and that he was a wilful impostor? Was that not defamation? This was what was called pungent criticism, stinging criticism, but it is defamatory, and I hope the jury will mark their disapproval of it by their verdict." The jury found for Whistler, but he was accorded one farthing as symbolic damages, and was not awarded costs. In December, 1878, Whistler produced a pamphlet entitled *Whistler vs. Ruskin, Art and Art Critics*, which was published by Chatto and Windus and dedicated to the painter Albert Moore. He writes in this pamphlet, "One does not become a painter by spending one's life among paintings, if that were so the policeman at the National Gallery could call himself an artist." Criticism was unleashed against him. Wedmore wrote in the August, 1879 issue of *Nineteenth Century* that Whistler's portrait of Henry Irving was a "blackish caricature of Velasquez," and that the painting of Carlyle "was a lugubrious canvas" and that the *Nocturnes* were "promising sketches." Whistler was by now deep in debt, partly due to the costs of the trial but also to his spendthrift lifestyle, and soon found his house papered with seizure orders and as was the custom in England in those days, bailiffs were moved into his home.

The painter employed his practical common sense by using them to enliven his social life. The bailiffs were present at his weekly luncheons. At one of these luncheons, Mrs. Moncrieff, noting that John, Whistler's manservant, was being helped to serve at table by three assistants, exclaimed, "My compliments, Jimmie. I see you must have come into a fortune…" "Ha, ha! You must mean the bailiffs; I'm glad to find they are good for something!"

There were other stories. Rossetti and his wife were served by the same servants but this time they were liveried. One of the guests noted that the servants seemed eager to please and appeared to be very helpful. "Of course they are," replied the artist, "They wouldn't leave me for anything in the world." At another luncheon, all the painter's furniture had been numbered prior to seizure when one of the bailiffs announced, "Luncheon is served." Whistler confided in his guests, "These are remarkable individuals, you will see how admirably they serve at table. This will not stop them from selling tomorrow morning and no less admirably every last one of the chairs on which you are sitting." Another time, Mrs. Edwin Edwards was dining with three bailiffs seated at table, while the painter's friends were removing paintings by the back door. One day, a bailiff asked for wages in order to feed his wife and children. Whistler replied to him, "Well, do what I do, send in a bailiff!"

On May 7, 1879, Whistler's debts were valued at £4640 while his assets amounted to only £1824; it was bankruptcy. Whistler went to see one of his creditors who also happened to be a friend and making circular motions with his cane, indicated that he could add his name to the list of creditors in the bankruptcy proceedings. The friend tried to settle for a smaller amount but the artist was adamant and flew into a rage. At the creditors meeting, Whistler blamed Leyland, who was present, as the archetypal capitalist. In three paintings, he caricatured the man to whom he attributed his downfall. The first of these paintings is called *The Love of Lobsters: Arrangement in Rats*. A lobster is depicted wearing the same type of frilled shirt that Leyland sported.

31. *Symphony in Flesh Color and Pink: Portrait of Mrs. Frances Leyland.* 1873. 74 5/8 x 37 in. (189.5 x 96 cm). Frick Collection, New York.

"He whom the gods wish to render ridiculous they first dress in a frilled shirt!" The second was called *Mount Ararat*. It represents Noah's Ark stranded on a hilltop with tiny figures all dressed in frilled shirts. The third, and the cruelest, is entitled *The Gold Scab* (or *Eruption in Frilthy Lucre*). This is not a typographical error for Filthy Lucre but a deliberate play on the words "frill" and "filthy." The picture shows a demon, his body covered in leprous eruptions in the shape of gold pieces, who is playing the piano while seated atop the White House, Whistler's erstwhile home.

The White House was sold on September 18, 1879. The artist was allowed to destroy his unfinished works prior to the liquidation sale. Other paintings were grouped into lots. The sale catalog lists such works as the studies for the *Six Projects*, a sketch of Valparaiso, a *Cremorne Gardens* painting, and the *Young Girl in Blue: Portrait of Miss Eleanor Leyland*. The collection of china, the engravings and paintings were all sold on February 12, 1880. "Sale by order of the courts. By order of the liquidators. Catalogue of china, furniture, paintings and works of art having belonged to J.A. McN. Whistler; provenance of the seizure performed at the White House, Fulham; including numerous items of Chinese porcelain; an oil painting by Whistler, *Connie Gilchrist Jumping a Rope*, entitled *Young Girl in Gold: A Satirical Portrait*, called *The Creditor* by Whistler, pencil drawings, etchings, chests and miscellaneous other articles." The friends and art dealers who were in the habit of buying his works were present at the sale.

The total amount fetched by the goods was derisory. The china, crystal and bronzes were bought by Thomas Way, Oscar Wilde, Dowdeswell and Howell. The Fine Arts Society bought the Japanese screen which was used as a background in *La Princess du Pays de Porcelaine*. The painter's admirers bought the Japanese bath, and the paintings entitled *The Creditor* and *Connie Gilchrist*. Way bought the bust of Whistler by Boehm for 10 guineas. Wilde bought a sketch of the French actress Sarah Bernhardt for five guineas. He later got the actress to sign it (the drawing was bought back by Whistler ten years after the sale, when Wilde himself became insolvent). Whistler's personal souvenirs were sold and his letters ended up in second-hand bookstores.

Oscar Wilde and Whistler had met some time before the trial. In 1878, Wilde was 24 years old and still studying at Oxford. When he came to live in London, he decided to become an art critic and to worship beauty. His name was on every lip. He was imbued with the theories of his Oxford professors. Oscar found that he had met his match, since Whistler had managed to devise a unique "look" for himself and was overflowing with original aesthetic ideas. He advocated a renaissance in art. The men had much in common – the same need to shine in society, the same lifestyle which led to their downfall, even the same taste for daring paradoxes.

Wilde was a socialist at heart and dreamed of doing good works. Like Whistler, he enjoyed his social life and cultivated his image. Whistler at the time was feared and admired, an outstanding figure in the contemporary world of art. At first he was flattered by the admiration of this brilliant young student who would spend hours in his studio and attended his Sunday luncheons. It was here that Wilde invented the character of Basil, a gifted painter who produced the portrait of a dissolute young man by the name of Dorian Gray, who was in fact based on Count Robert de Montesquiou. The most far-fetched rumors about Whistler's paintings were to inspire the fantasies of Oscar Wilde's novel *The Picture of Dorian Gray*. Whistler was alleged to have captured the souls of his models, or so it was rumored in London. If Wilde had become as friendly with another writer, he would soon have been taken for a plagiarist. Whistler was charmed by the conversation, verve and attitudes of the poet.

32. *Harmony in Blue and Gold: The Peacock Room.* 1876-1877. *La Princesse du Pays de Porcelaine* is hung over the mantelpiece. Freer Gallery of Art, Washington.

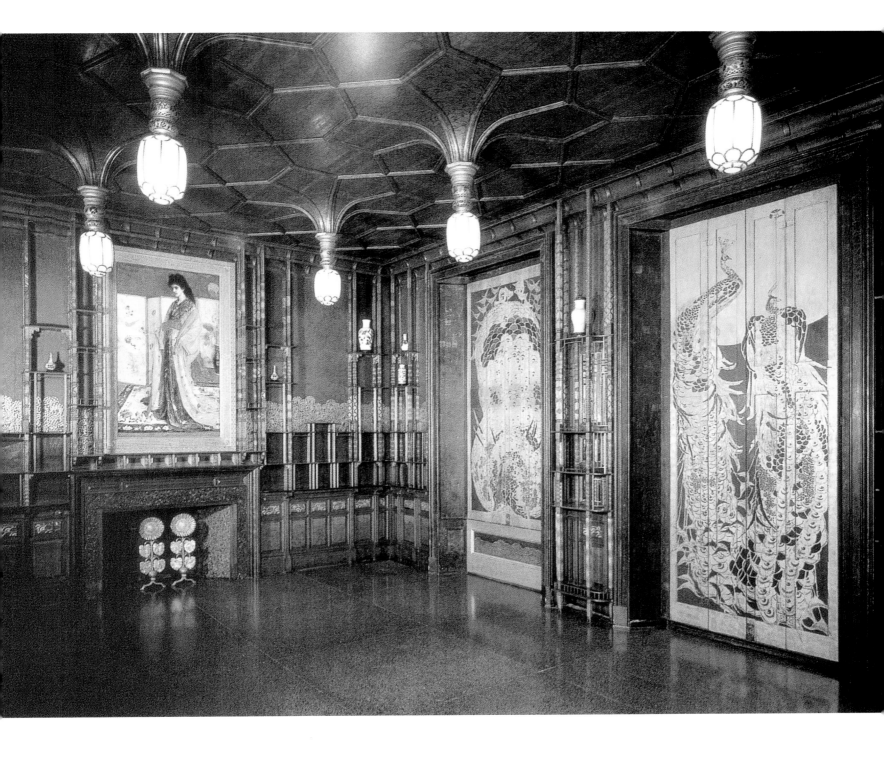

The two men became favorites of London's gossip columnists, who amused themselves by comparing them. It became a popular game. They could never be imagined without each other and yet, basically their characters were completely at odds. This enthusiastic friendship was to go badly wrong and would eventually become a tacit agreement of mutual aggression.

The quarrel lasted for several years. What had brought it about was Whistler's testing the artistic taste of his chronicler. Wilde had a shallow polish beneath which he hid a lack of reasoning and a lack of taste. Wilde was very good at adapting other people's ideas. Whistler, however, would not tolerate the presence in his studio of anyone who did not have an intelligent approach to his artistic views. Those who did not offer proof of this open mind were considered to be hostile. Whistler realised that "Wilde had no more sense of painting than of the cut of his clothes." He also reproached him with drawing too frequently on his "intellectual background." This was a similar phenomenon to the relationship which united and disunited Montesquiou and Proust. It was the special talent of these two writers which incorporated other people's work and revived it with their own originality. Wilde was intoxicated by his success; he wasted his time and produced little. Whistler held the snobbish view that aesthetics had nothing to say to the middle classes, while Wilde favored, "Art in everyday life." M. H. Ward, that art critic of the *Times*, came to a Whistler exhibition and exclaimed at the sight of one of his paintings: "That is good, it is of the first order, a delicious morsel of color, but you see," he said indicating another painting, "This one is bad, the drawing is defective, it is bad, bad…" "My dear sir," interrupted Whistler, "learn never to say that one painting is good and another is bad, never! Good and bad are terms you should not be using. Say rather, I like this one, I do not like that one. You will thus remain within the limits which are permitted to you. And now, come and have a whisky because I'm sure you will like it." Wilde was delighted and exclaimed, "I should love to have said that!"

"You will, Oscar, you will…", responded Whistler.

For the moment, the painter was thoroughly disgusted with England, and he decided to settle in Venice (1879), a trip he had contemplated several times. He found the city beautiful "when the sun shines on the polished marble and the warm tones of the brick and plaster." He visited the Scuola di San Rocco and stood on the watchman's chair to be able to look more closely at a Tintoretto. He preferred the golden harmonies of the Peacock Room to the effects created by the golden domes of St. Mark. "It's always old history," he wrote to his mother, "The dawn finds me at work and so does the night." As in London, Whistler was not interested in the great monuments normally chosen by painters, except in the case of the *Nocturne* whose theme is St. Mark's. He took up residence at the bottom of the Riva degli Schiavoni, where a whole panorama of Venice is laid out.

The windows of his apartment overlooked the Salute neighborhood, the Doges' Palace and the church of San Giorgio. It was from here that he produced his pastels and etchings of the Riva and the lagoon. He made three more *Nocturnes* in watercolor before abandoning this genre for good ("paintings which no one understands," he declared). He socialized a lot because throughout the year, Venice was invaded by artists and celebrities who would stay for long periods of time. Any Londoner would receive a tongue-lashing from Whistler. Opinions were divided as to his true financial position. Some certified that he was forced to eat "cat food and cheese parings." Others affirmed that the dandy was hosting dinners and luncheons on Sundays where there was always good fare, and which were as good as the London events.

33. Photograph of John Ruskin.

34. *Arrangement in Gray and Black, No. 2: Portrait of Thomas Carlyle.* 1872-1873. 67 3/8 x 56 in. (171 x 143.5 cm). Museum and Art Gallery, Glasgow.

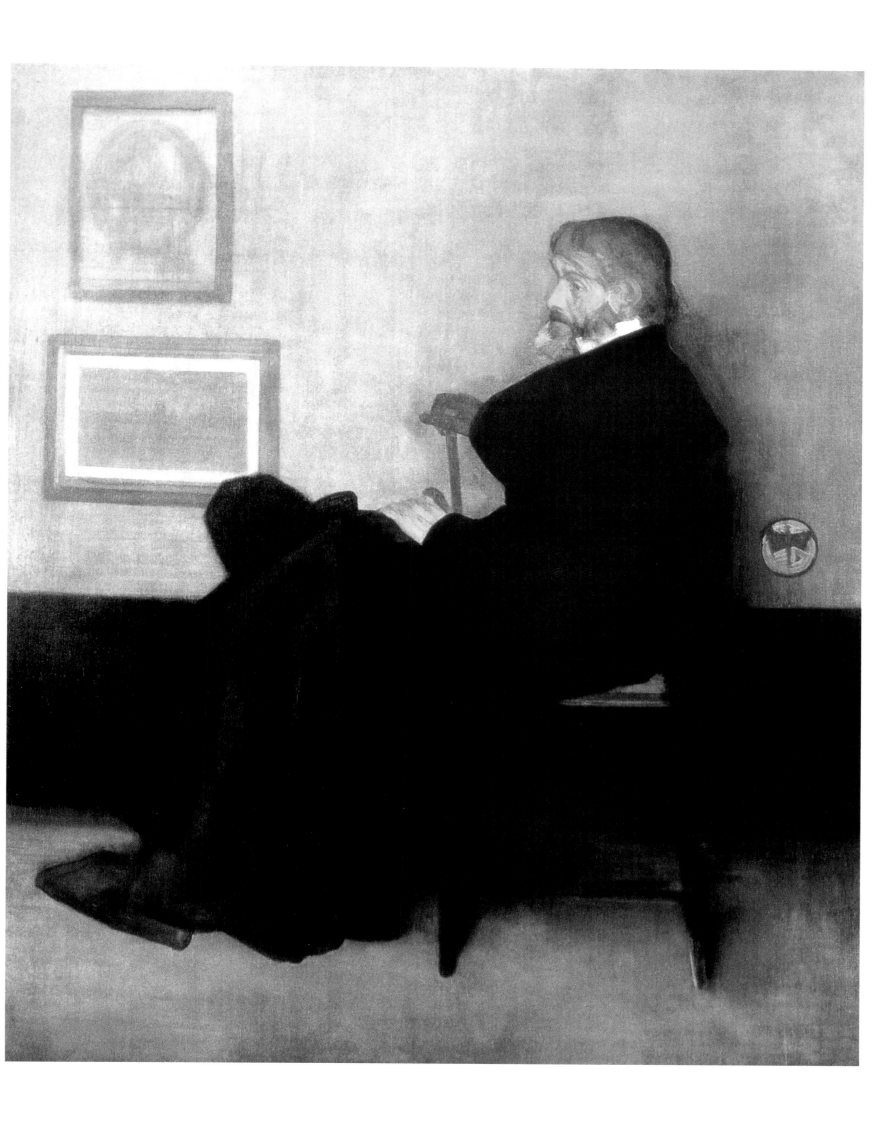

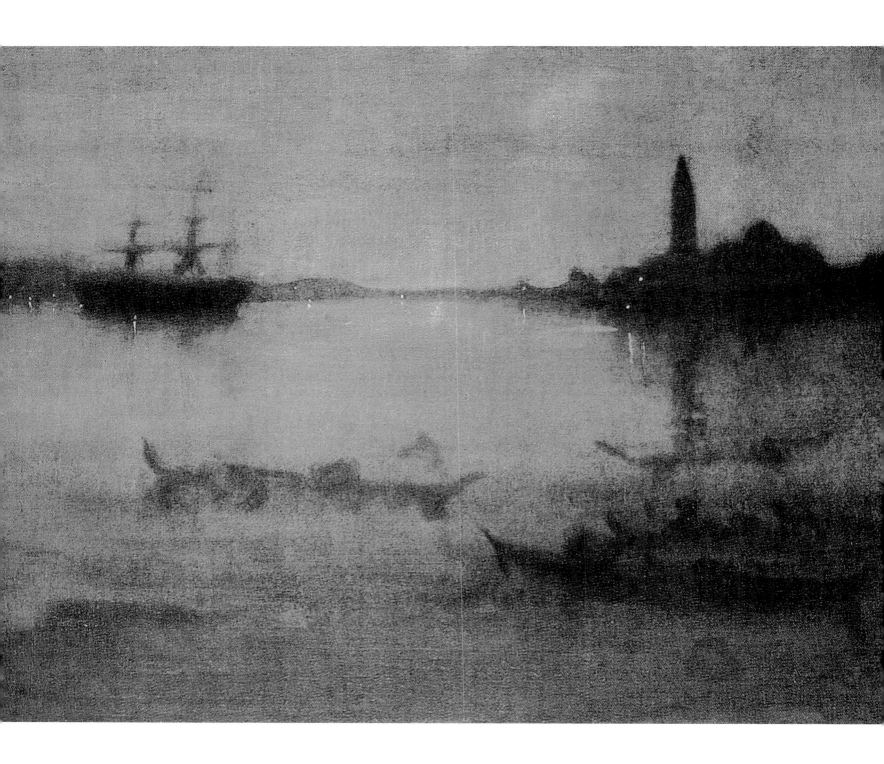

Whistler passed his days in excursions to the Venice Lido and trips to Chioggia and to Murano... These trips which are today so inexpensive represented a considerable investment in those days. When the artist Wolkoff claimed to be able to imitate Whistler's pastels so closely that it would be impossible to tell them from the real thing, James bet him "a champagne dinner" that he would not be able to do so. On the appointed day, all the artists met at the Casa Jankovitz. They were able to recognize which of the pastels were Whistler's even mixed in with those of Wolkoff... Seeing the artist Bunney in the process of producing a view of St. Mark's for Ruskin, Whistler stuck a note to his back reading, "Pity the poor blind man!"

Another time, under the scorching summer heat, Whistler was leaning out of his window and saw several stories below a goldfish bowl on the balcony of his landlady against whom he bore an old grudge. With a line, as if he were fishing, he caught the fish, fried it, then used the line to replace it in the bowl. He merely had to watch discreetly from his window for the return of the landlady.

He and a friend once turned up at the Academy Bridge, which one had to pay to enter. He happened to have a broken wristwatch of which one hand turned at breakneck speed. He placed the watch in his eye like a monocle, and the watchmen let the pair through, believing that he was afflicted with the evil eye. A year passed, and the time finally came to leave Venice. For his departure, a coal barge was rented, which was decked out like a floating garden, garlanded with flowers and orange and red Japanese lanterns. He assembled his friends and said to them. "You really have been very good to me all the time I have been staying here, and I want to show you my gratitude... Yes, I've thought about it a lot..." He then examined woodcuts which he had signed, chose one which had been badly printed and cut it into pieces, giving a piece to each of them.

His pastels of Venice are classic in their technique, having no superfluous detail which would distract the eye from the subject of the painting. He drew in black pencil on brown, blue and pink cartridge paper and added a few colors. The Venetian series exhibited in London would cause a revival in the use of pastels. The artist copied Rembrandt's technique for etchings and retouching of prints.

He used what he called his "secret," the Japanese method, which made it possible to place the subject in exactly the right spot thanks to a sketch made prior to engraving the plates.

The technique he used was to determine on the canvas, copper plate, or any other medium the point at which the main part of the subject would be placed, taking account of the fact that this must give the impression of being contained within the painting. The theory which led him to incorporate flowering branches or branches which seemed to bend into the picture and thus extend the subject out beyond the frame would be abandoned forever in Venice.

Henceforward, composition would have to provide the interior of the picture with the same impression of distance as was felt by the painter or engraver toward his subject. Once the crucial center part was placed, Whistler would work on the edges without losing sight of the whole which he would constantly return to work upon until the composition was in complete harmony. The result was amazing. What is obtained is a drawing or painting which is "finished from the beginning" with large areas left blank or filled with details.

In oil painting, on the other hand, Whistler had to go on the offensive and sometimes contradict his theory where by he claimed an artist must never compensate for a mistake by later increasing or reducing the size of any of his canvases. He did this, in fact, for *Old Battersea Bridge*.

35. *Nocturne in Blue and Silver: The Lagoon, Venice.* 1879-1880. 20 x 26 in. (51 x 66 cm). Museum of Fine Arts, Boston.

36. *Stormy Sunset, Venice.* 1889. 7.5 x 11
 3/8 in. (18.5 x 28.3 cm). The Fogg Art
 Museum, Harvard University.

37. *Arrangement in White and Black:
 Portrait of Maud Franklin.* 1876.
 75 x 34 in. (191.5 x 90.8 cm). Freer
 Gallery of Art, Smithsonian Institution,
 Washington.

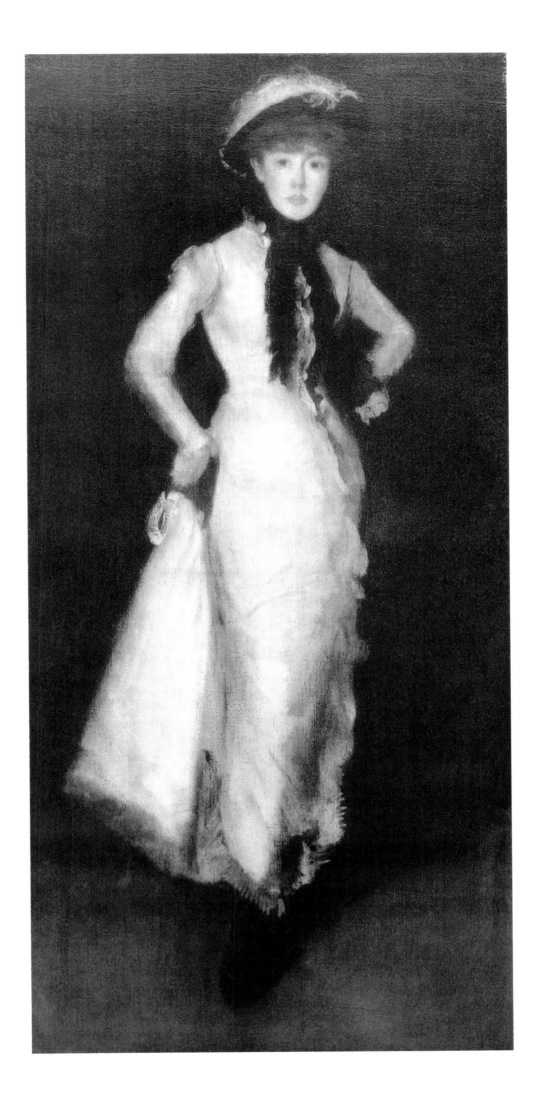

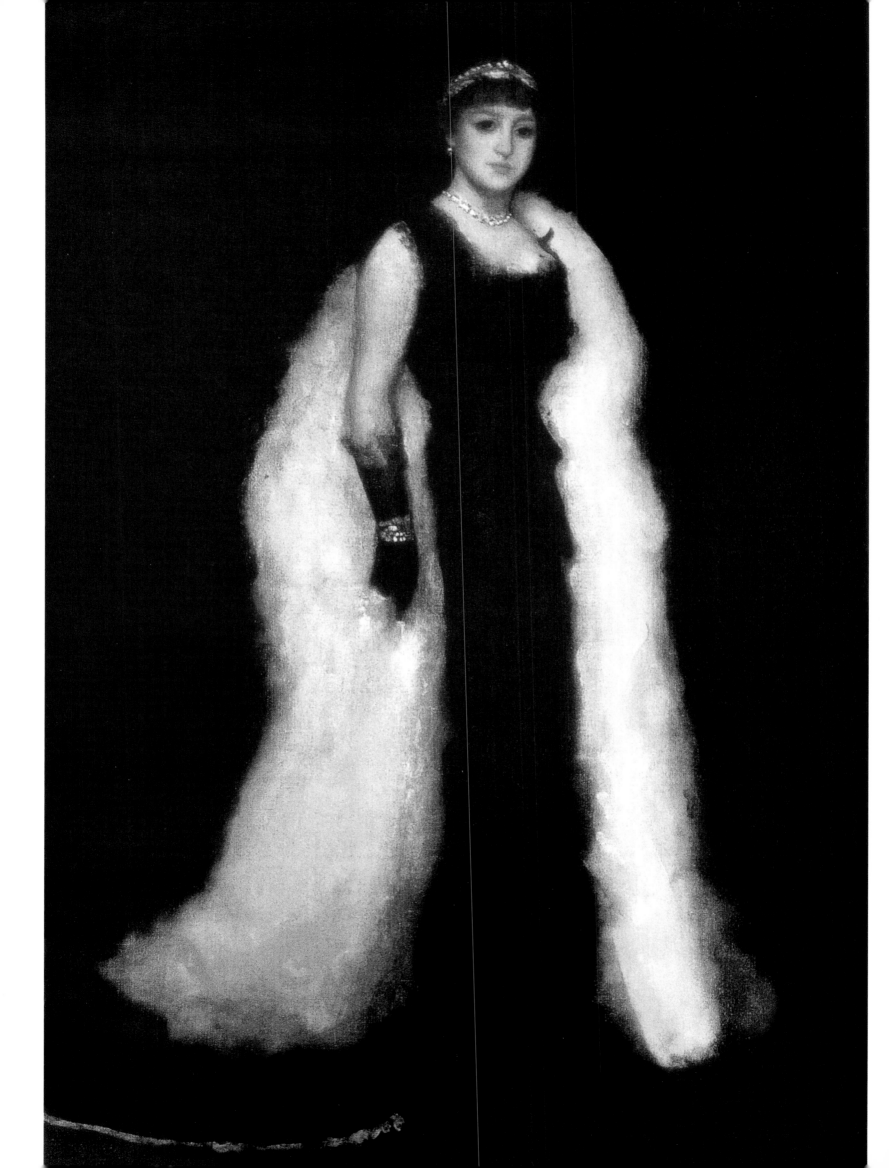

THE PORTRAITS

Whistler decided to return to London in late November, 1880, despite the unfavorable and ignominious conditions of his return. The painter was more determined than ever and had lost none of his pugnaciousness, however. The strident and vengeful cry of the peacock would soon return. Knowing that success would depend largely on the work he had done in Italy, he devoted himself to printing his Venice etchings. These were exhibited at the Fine Art Society in December. The critics returned to the attack. The magazine *Truth* wrote, "Another crop of Mr. Whistler's little jokes." The *World* considered that the subject had been treated superficially. The painter saw himself portrayed in turn as either a joker or a phoney. The influence of the Ruskin trial was still present in the critics' minds. The artist appeared to remain impervious but in fact when he was in this state, it meant he was preparing "a dirty trick." He devoted himself to the preparations for an exhibition of the pastels he had produced in Venice; the pastels were also displayed at the Fine Art Society. He designed frames for his pictures and took charge of the interior decoration of the gallery, creating an "arrangement in brown and gold." The architect and interior designer E. W. Godwin was one of the few to appreciate the beauty. "First a low skirting of yellow gold, then a high dado of dull yellow-green cloth, then a moulding of green gold, and then a frieze and ceiling of pale reddish brown. The frames are arranged on the line; but here and there one is placed over another. Most of the frame and mounts are of a rich yellow gold, but a dozen out of the fifty-three are in green gold, dotted about with a view to decoration, and eminently successful at attaining it." (*British Architect*, February, 1881). On the day of the opening – January 29, 1881 – the exhibition was crowded. Millais' reaction to the pastels was to exclaim, "Magnificent! They do not lack impudence but they are very beautiful all the same!" He wrote a letter to the painter who was very touched by it. Whistler attended the exhibition, as mordant as ever. When a visitor asked the price of a pastel and exclaimed, "Sixty guineas, but that's enormous!" the painter replied, "Enormous? Sixty guineas? Not at all! I assure you that it took me no less than half an hour to create this pastel!" Criticism was unleashed against this "transatlantic impudence."

Nevertheless, the exhibition was an unexpected success and was extended until the end of February, when Whistler learned of the death of his mother. Since 1876, she had been living in Hastings for her health and her son had kept in touch by letter informing her of his successes and struggles. He spent a week in Hastings, tormented and full of remorse. A few months later, James busied himself recovering the paintings which during his troubles had been left with Mr. Greaves.

38. *Arrangement in Black, No 5: Lady Meux.* 1881-1882. 76 x 51 in. (194.2 x 130.2 cm). Academy of Arts, Honolulu, Hawaii.

He sent the Philadelphia Academy the *Portrait of my Mother*. The painting returned to England in 1882 after having been shown in various exhibitions where it was on sale at a price of $6000, but no one had been willing to pay this price. The etchings, on the other hand, were well-received in America by societies of engravers in New York and Philadelphia. The painter's fame had been spread by painters who had met him in Venice and were now back home. They proclaimed their admiration for his ideas and his work. Private collections were started. *The Young Girl in White* was shown at the Metropolitan Museum of Art where it would stay for several years. In May, the artist rented a studio at 12 Tite Street, near the White House which he had to leave due to his bankruptcy; the new owner became worried; the legendary disposition of the artist made him fear reprisals. The Tite Street studio was decorated in yellow. Howell claimed one had the impression one was entering an egg.

Whistler bought back his china and silverware, and the Sunday lunches recommenced, as in the old days. He once again moved in society and appeared to be trying to attract attention to himself by every means. His enemies, renewing their attacks through the press, actually contributed to his revival. He had been the first to invent a new way of being an "artist" which translated itself into a desire to make his exhibitions into total works of art by supervising all the elements from the decoration of the hall to the invitation cards for the vernissage. He created the "happening" long before Montesquiou, Jean Cocteau, or Salvador Dali. He became malicious, enjoying exercises in spiteful barbs which left an indelible impression on those at whom they were aimed. Extravagant and joyful, he protected himself against the stupidity of his critics and chose to envelop himself "in a sort of misunderstanding."

From now on, all his attackers would be treated to retorts in the form of letters to the press. His letters were artistically pointed barbs, all with the same aim, that of wounding his adversary. Alan Cole, a friend, found him in 1882 "in a new beige overcoat and a cane of inordinate length." Another of his great friends, the influential art critic Théodore Duret, recounts how at that period, commissioning a portrait from Whistler was considered a courageous act, a dangerous adventure even. Lady Meux nevertheless defied opinion and commissioned such a portrait. She was to be the first client in a long series of portraits, because the artist also aroused passionate advocates for his cause.

The painting of Lady Meux is one of the best examples of Whistler's portraiture. It consists of a harmony of color, "an arrangement in white and black", a very powerful image set against a dark background. Lady Meux's black dress contrasts with the white fur edging of her coat. The richness of the tones is unequaled. Seeing the canvas at Whistler's studio, Duret stated that there was something "mysterious and fantastic about it." A new legend was woven around the portraits.

That of Lady Meux seemed to be "spiritualized" through her presence, her haughty air, the strength of her personality in the space contrasting with the ghostly impression left when viewing the whole painting. Desnoyers and Huysmans declared they had never seen anything like it. The painter, satisfied for once with his work, called it his "beautiful lady in black." Lady Meux was also pleased with it and ordered a second portrait, which at first was entitled *Harmony in Rose and Flesh Color* but was subsequently renamed *Harmony in Rose and Gray*. There is a third unfinished painting as well as several pen-and-ink sketches of Lady Meux.

39. *Harmony in Pink and Gray: Portrait of Lady Meux*. 1881-1882.
75 x 35 5/8 in. (190.5 x 90.5 cm).
Frick Collection, New York.

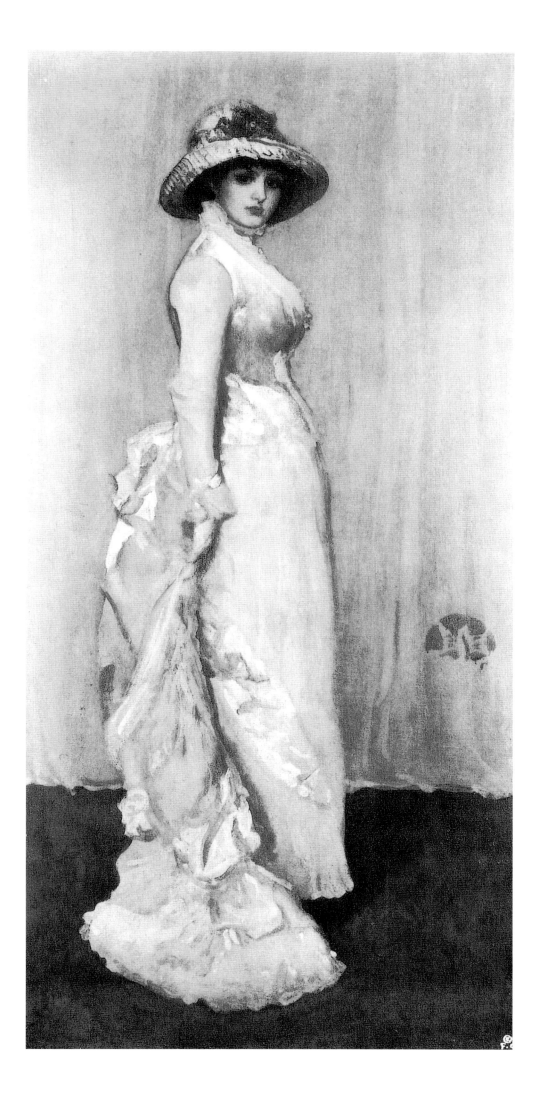

Whistler then devoted himself to completing the portrait of Sir Henry Cole, which had been begun several years previously. The sittings lasted from February through to April, 1882 the date of Cole's death. Whistler tried to complete the painting from memory. For reasons which are unclear, the painting was never finished. Nor were those of his friend Eldon, Lily Langtry, actress and sometime mistress of King Edward VII, *Arrangement in Yellow* featuring Miss Maud Waller, with a blue-on-blue effect, and a painting of Lady Archibald Campbell, the famous actress, all of which were later destroyed.

Lady Campbell recounted the incident as follows. "Whistler had made me sit for a year or two for many different studies. His original idea had been to paint me in court dress. He made a sketch but the pose was too tiring […] and he had to give up the idea. One of the studies he made of me shows me dressed as Orlando… This little canvas seemed quite good to him. He also produced a painting under the title *Lady in Gray*, the predominant color of which was silver-gray.

If memory serves me it was a masterpiece of drawing which wonderfully conveyed the impression of movement. The canvas was very tall; I was shown descending a staircase; the general effect was striking. This painting was almost finished when I had to leave London and this interrupted the sittings. Upon my return, he asked me if he could paint my portrait in the dress I had been wearing when I went to see him. This painting was later exhibited under the title *The Lady in a Yellow Buskin*… I think Whistler only needed a few sessions in order to complete it. When I went to visit him shortly before his death, I asked him what had happened to the *Lady in Gray*. He replied laughingly that he had destroyed it."

Lady Campbell was herself full of capriciousness, believing her beauty gave her privilege, and she had demanded that some changes be made to the face. The artist, who would normally never have acceded to such a request, gave in this time and tried to satisfy her, but her requests for change persisted and in the end he became tired of them. The relationship deteriorated, there was a quarrel, and Lady Campbell stormed out of the studio.

Duret managed to catch her at the last moment, as she was actually sitting in her cab. He tried to calmed her down and persuaded her to return to finish the sitting. The painting was completed and today the figure and face of Lady Campbell can be admired as she buttons her glove, an unusual and distinctive pose. The colors are applied to an arrangement in black. The critics only perceived an ugly color scheme of dirty, drab tints. One of them claimed that the portrait showed a lady rushing to catch the last train in a smoky tunnel of the London Underground (in those days the trains were pulled by steam locomotives).

Duret, who was also a great friend of the Impressionists, helped French critical opinion change its mind about Whistler. In April 1881, he published an article about the painter in the *Gazette des Beaux-Arts*.

In *Arrangement in Gray and Flesh Color*, Whistler has placed a rose-colored lady's cloak over his subject's arm and a red fan in his hand to pick out the gray background of the painting. Whistler believed men should always be painted in modern dress as Baudelaire had advocated. Duret gives us a description of how the artist worked. "He would begin by sketching out in pencil on the canvas the broad lines of the painting to place the subject in the setting. He would start painting immediately, using the colors which would be the final tones. Even by the end of the first sitting, one had a fair idea of what the finished painting would look like.

40. Sketch for *Annabel Lee.* 1896.
12 1/8 x 9 in. (30.7 x 22.6 cm).
Hunterian Art Gallery, Glasgow.

This quick way of working often made him hesitate, doubt, rub out and start over. At this stage, the work lacked detail which had to be put in later. Whistler doubted in anticipation and this is why he had difficulty in finishing a painting. His theory for achieving and maintaining a harmonious whole was that it was better to start the painting from scratch rather than rework certain parts if they were not right the first time."

Duret's portrait is a further illustration of Whistler's harmony of color. The grays and pinks complement each other and the gray background seems to be tinged with pink. Duret showed a visitor the portrait, cut a hole in a sheet of paper to cover his figure and placed it over the painting, thus demonstrating that the gray background, once isolated, showed no hint of pink. The pink is purely illusion and is proof of Whistler's knowledge of the relationship between colors.

In the winter of 1883, Whistler had a second exhibition of his Venice etchings at the Fine Art Society. The gallery was painted white and hung with yellow drapes. The floor covering consisted of pale yellow matting with matching sofas; yellow flowers were arranged in yellow vases. Even the attendants wore a yellow-and-white livery. Whistler handed out little yellow silk-and-paper butterflies. He himself was sporting yellow socks and his assistants wore yellow neckties.

Under the title of each of the paintings reproduced in the catalog Whistler added an extract from the critics. The half-title bore the legend, "Out of their own mouths shall ye judge them." The Prince and Princess of Wales visited the exhibition. The critics were unanimous in condemning the event as carnivalesque, the attendant at the entrance being dubbed "the poached egg." They were furious at seeing their judgements attached to the paintings because the juxtaposition made them look ridiculous. Wedmore, for instance, was credited with the observation, "Long ago, he was an artist of whom great things were expected." The following extract from *The Athaeneum* appeared: "It can be asserted fearlessly that Whistler's works do not contain a trace of culture." The journalists were cut to the quick and tried to depict Whistler as a buffoon in order to save themselves from ridicule. The *Times* compared his humor to that of Mark Twain. The *Daily News* found the exhibition "delightfully irritating." *Funny Folks* dubbed Whistler a second Barnum.

Whistler sent two of his *Nocturnes* to the Grosvenor Gallery, and the portrait of his mother was exhibited at the Salon in Paris. His dream-like landscapes *Nocturne in Silver and Blue* and *Nocturne in Black and Gold* were also on display there. In the latter, fireworks smear the night with blood-red streaks and sprinkle their stars in the nocturnal gloom. In *Nocturne in Blue and Gold*, the Thames emerges from the fog, and a golden moon illuminates the sleeping barges. We are back in the world of Thomas de Quincey, the visions of an opium-eater... The pale gold frames were sprinkled with turquoise blue and picked out in silver. Whistler hated the countryside because there were "too many trees."

In the winter of 1883, Whistler worked in the open air in St. Ives, Cornwall. He was more interested in the sea and water and in fact, he spent the last summer of his life painting the seas at Domburg in Holland. His paintings and drawings of Cornwall were exhibited among the *Notes*, *Harmonies*, and *Nocturnes* at the Dowdeswell Gallery in May, 1884. Once more he surpassed himself in his interior decoration of the Gallery. Always interested in color harmony, this time he matched the delicate pink of the walls with white woodwork, white chairs and pink vases containing pale-colored azaleas.

41. *Arrangement in Black: The Lady in a Yellow Buskin, Portrait of Lady Archibald Campbell.* 1883-1884. 85 3/8 x 43 in. (213 x 109 cm). Philadelphia Museum of Art.

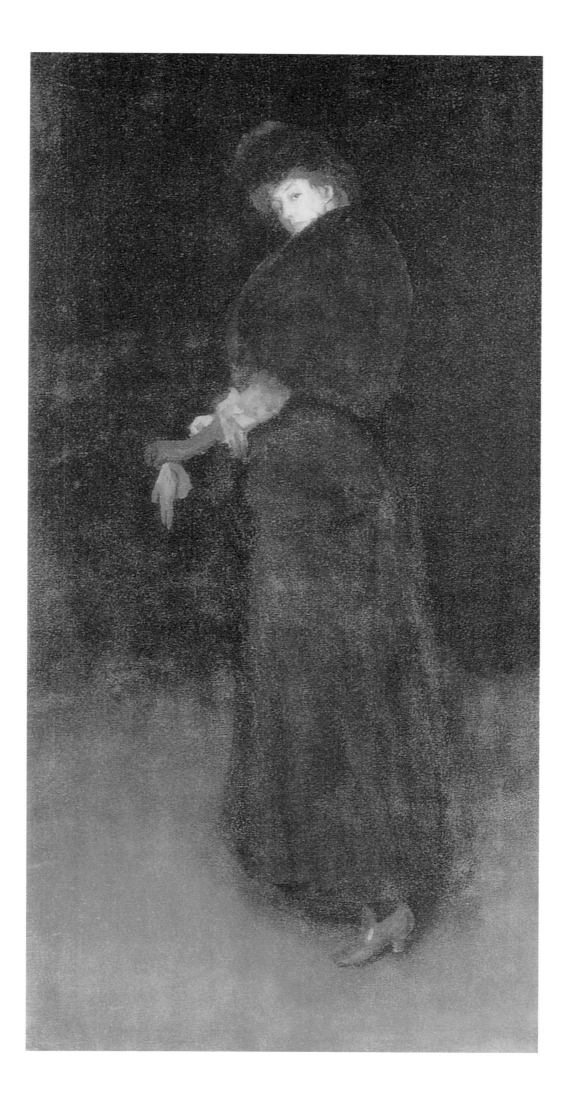

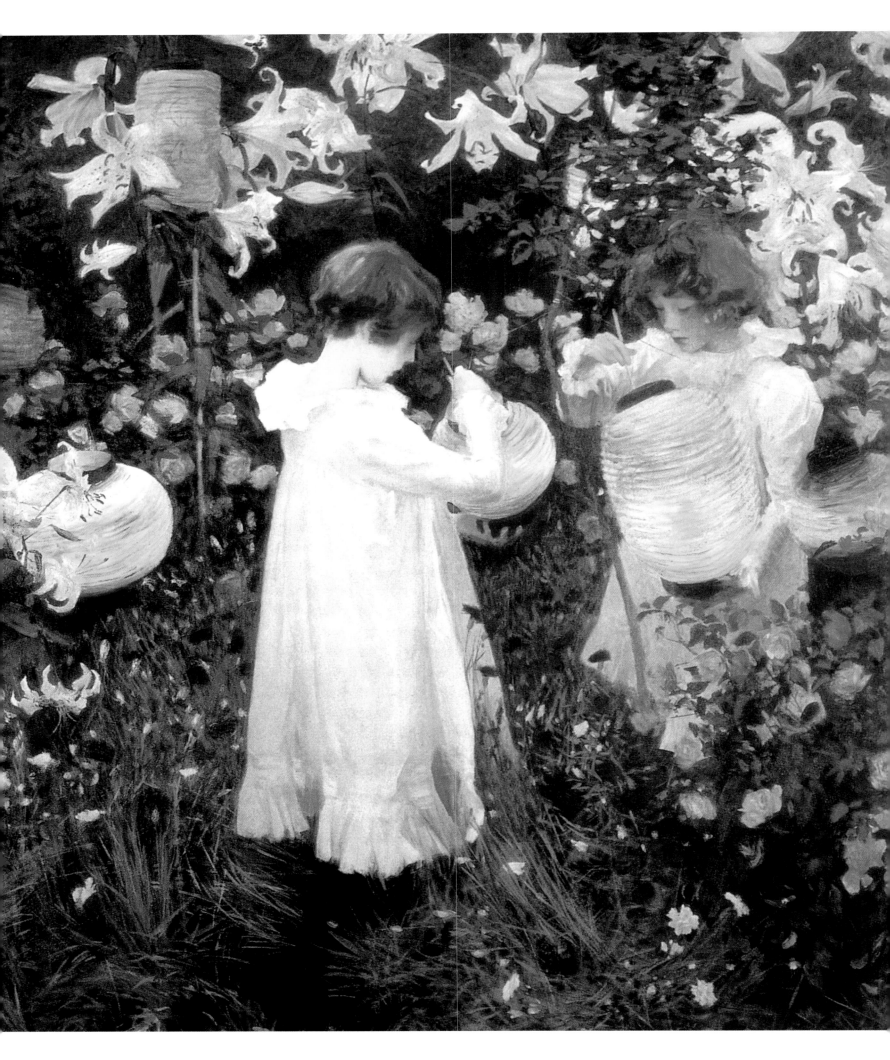

The invitation cards were decorated with a butterfly in the same shade of pink as the walls.

In 1884, Carlyle's portrait was very well received when exhibited at the Scottish National Portrait Gallery in Edinburgh.

The painting was first offered to Mr. Scharfe, director of the National Gallery in London, who dismissed it with contempt, claiming it had nothing to do with painting. George K. Halkett sent a letter to *The Scotsman* to start a fund to acquire the painting for the sum of $10,000 with the intention of donating it to the Museum.

The text stipulates that the donors not commit themselves by their subscriptions to agreeing with the painter's theories. Whistler learned of this move and immediately telegraphed Edinburgh announcing that under these conditions, he demanded $25,000 as the purchase price. Obviously, this thunderbolt put an end to the project.

The Pennells, his biographers, describe meeting Whistler, "Dressed all in white with a long-sleeved vest and a little black tie. At first I thought I was dealing with a barman…

His eyes were shining, burning, sparkling under thick, bushy eyebrows. I perceived that Whistler was all nerves, vivacity, action." One day, in his workshop, Pennell noticed a portrait of the violinist Sarasate: "Whistler stopped me in the middle of the corridor, to judge the effect of the painting in the dark frame made for it by the door." The portraits of Carlyle and of the painter's mother are larger than lifesize and yet they look as if they are of human dimensions. In the case of Sarasate, Whistler wanted to use a smaller format, so as to show him as he would appear to concert-goers. The violinist is surrounded by the penumbra of the concert hall and there is the same depth before and behind him as there would be in real life. During the sittings, Sarasate would often play the violin and was not the slightest bit interested in the problems of painting, and even less in his portrait. He was posing on the advice of his manager, Mr. Goldschmidt, who already owned a *Nocturne* by Whistler. Whistler invited one of the Pennell brothers to luncheon: "It was a memorable luncheon in the large pale dining room, the yellow and blue room. We were served a 'marvellous' curry. After the meal, Whistler took me for a walk by the river; he showed me the statue of Carlyle and Turner's little house, and indicated his former homes in Lindsay Row, telling me the story of a great photographer who had reproduced all his pictures and views of the old parts of Chelsea which have now been demolished."

Whistler had many loyal friends whose friendship was unconditional, despite his boast, "Having a friend is beyond my means." A photo taken in the studio shows four of them with the master: Julian, Waldo Story, Frank Miles and Frederick Lawless. Dr. Lanteri and Francis James were also frequent visitors to Tite Street.

Sir Rennell Rodd told how one evening at Whistler's the host kept his guests until dawn, taking them to see the sunrise over the Thames. This seemed to them a curious, original and strange notion. Upon their return, they realised what he was trying to say in his paintings, now being certain they had discovered a world of whose existence they had been ignorant only a few hours earlier. London had split into two factions, the Ruskin camp of ageing pre-Raphaelites and the Whistler camp whose followers included fashionable society, with Wilde in the vanguard.

In 1881, Oscar Wilde had to leave for the United States and wrote to Whistler, "I dread being sea-sick…," to which the painter replied, "In that

42. *Carnation, Lily, Lily Rose*. John Singer Sargent, 1885. Tate Gallery, London.

The artist reserves his right to choose to paint those elements in nature which suit him. He composes a scene by concentrating on the shape and colors, not on the photographic details like the pre-Raphaelites who reproduce all the minutiae (thus increasing the time it took them to produce a picture; they would spend hours on a square inch or two). Whistler, on the other hand, would reduce the time he took to create a canvas, creating the composition at a single sitting, trying to grasp the subject as a whole.

Millais was afraid that young artists would be influenced by a man "who does not even know the grammar of his art." This shows how stultified the concepts of the time were, at least as far as art was concerned. The rules had not changed for hundreds of years. The painters of his generation were famous, especially the English painters who had studied with Whistler in Paris, such as Edward Poynter, Frederick Leighton, and George du Maurier.

Whistler's influence began to make itself felt among the new generation of artists after 1880. Sir Walter Armstrong, writing in *The Art Journal* in 1887 claimed that French art influence in England was attributable to Whistler and the 1867 Exposition in Paris. The Society of British Artists was a venerable institution which had lost its prestige, although for a long time it had been classified just below the Royal Academy. Founded in the early 19th century to fight the tyranny of the Royal Academy, it found itself in a difficult situation after the opening of the Grosvenor Gallery which posed a serious threat to it. The advent of Whistler gave hope of a renaissance.

But the old guard of the Society, who had remained silent when he was elected President, feared his ideas and were frightened of arousing the wrath of the Royal Academy. Whistler showed himself to be sensitive to this initial recognition but did not realise the difficulty in which the institution found itself. He thought it was time for a showdown with the Royal Academy. In exhibiting his work, the British Artists Society wanted to provide the public with something sensational.

Claude Phillips wrote in the *Pall Mall Gazette* in July, 1885, "The eccentric Mr. Whistler has gone to a neglected little gallery, the British Artists, which he will probably bring into fashion." That is, indeed, what happened, the public hastened to the exhibition. The new president passed a resolution whereby receptions would be held every Sunday in the exhibition hall so that he did not have to have people at home (sic).

He organized the annual award of two medals, one of which was reserved for landscape artists. By participating in the election of his friend, the watercolorist Mortimer Mempes, as a member of the Society he also contributed to confirming the watercolor as an art in its own right. At the Winter Exhibition of 1885, Whistler exhibited the *Portrait of Mrs. Cassatt* and *Note in Violet and Green*, a nude study in pastels which caused a furore.

A Royal Academician called Horsley, stated during a church convention that "There are people who never have enough words with which to glorify the representation of the nude by the artist.

Do they know what a disgrace it is for a woman to adopt the shameful profession of model?" Whistler made it his business to immortalize this speech in his own way. He attached to his picture a small notice reading, "*Horsley soit qui mal y pense.*" His fellow members of the British Society of Artists were horrified at such audacity. The notice soon disappeared, but everyone was aware of its contents.

44. *Chase and Whistler,* 1885. The Parrish Art Museum, Southampton, New York.

The Century published a series of portraits of men then in the limelight. John Alexander was given the task of painting Whistler's portrait. During the sittings, Whistler was constantly on the move and critiqued the work. Alexander tore up his sketch and said that as soon as he had done so, the model became as amenable as possible.

Whistler settled with his new mistress and model, Maud Franklin, in a house in Chelsea which he had painted pink and dubbed the Pink Palace. He later moved to nearby Fulham, not far from the King's Road. Whistler continued to keep himself in the public eye and give interviews. The Fulham Road studio was a huge room painted white. A few yellow rugs provided some color.

Nankin porcelain was displayed on a table and the canvasses were all packed into one end of the room. The right-hand wall was covered in splashes of color, created by pastel drawings on gray paper, semi-draped figures, and other representations... Whistler was in the habit of leaving his paintings outdoors to dry on the roof of the stables of the local Bus Company, which were just below his windows. Sometimes he would work in a white suit, as if to defy the splashes of paint. He even did two self-portraits wearing a white vest, which never left his studio during his lifetime.

Whistler wanted his work to be better known abroad and made trips to Holland, Belgium and France, and wrote extensively about his concept of painting. The texts would be presented by him in his *Ten O'Clock Lectures*. He abided scrupulously by the rules expressed in the text, as his friends had known for a long time.

As soon as Whistler had carefully edited a passage he would rush round to Alan Cole to read it to him, whatever the hour of the day or night. Mempes remembers having spent evenings pacing the floor while Whistler read him various extracts from his lectures. The artist fell ill for a few days and went to stay with his brother. As soon as anyone came to visit him, they were treated to a reading.

Whistler at first intended to publish these writings as articles in *English Illustrated*, but Lord Powerscourt invited him to Ireland in order to give the prizes at an Irish school of art.

Whistler considered that his notes were suited to such an occasion and this gave him the idea for a series of lectures. At the same time as the award ceremony, the Dublin Sketching Club was organizing an exhibition of painting. Four American artists were represented, John Sargent, William Story, Ralph Curtis, and Whistler. Never had so many of his canvases been seen outside London. The show was a success. Mrs. d'Oyly Carte, the owner of the Savoy Theatre in London, gave Whistler the opportunity of delivering his famous lecture and proved to be just as enthusiastic about it as the painter. Whistler would often visit her in the evening to talk about his projects and ask for her advice on his oratory skills.

The room chosen for the lecture was the Prince's Hall. Whistler arranged for the event to start at 10:00 p.m. He knew his lecture by heart, and Mrs. d'Oyly Carte sat in the back of the hall to check that his voice would carry. On the great evening of February 20, 1885, the hall was packed. The journalists were intrigued and wondered what they were about to hear. One of them did not know "if the eccentric artist was going to draw, pose, sing or discourse."

The *Daily Telegraph's* correspondent was expecting a farce, but in his report he wrote that "the amiable eccentric whom London has tacitly authorized to take every day of the year for April 1 revealed himself to be alert, calm and full of sangfroid, self-contained in his top hat and monocle."

Whistler had for once dressed soberly, in black on a dark background, his hat placed on the table and his cane behind him leaning against the wall.

Oscar Wilde, on the other hand, perceived the painter as "…a miniature Mephistopheles mocking the majority." Whistler kept his discourse simple so as to allow no room for the critics to attack him on trivial grounds. This first lecture was difficult for him. Anna Lea Merritt, who had attended the first lecture, recalled, "He was intimidated for once in his life! All those who attended his first lecture can bear witness to that. Faced with this distinguished audience who did not know what to expect, the orator experienced several minutes of intense stage-fright and did not use the notes he had brought with him.

As soon as the lecture began, the packed hall was won over, especially when he started talking about how London was transfigured at night." A Mr. F. Day wrote, "I went to this lecture to amuse myself. I remained to admire." The *Ten O'Clock Lecture* contains many sonorous pronouncements about art, as well as epigrams and sarcastic asides in which the enemies of the author are depicted and derided. The "dogmatic" part in which Whistler explains his views on art, which were by now hackneyed, were listened to with gravity and surprise. The public, by concentrating on his eccentricities, had forgotten that he had some very serious ideas about his art.

When the painter reached the part of his lecture in which he addressed some caustic remarks to his enemies, the public perceived that some of them were in the room, and took pleasure in the fact through their loud laughter, thereby expressing their appreciation of the orator's talents. Among the ideas expressed, the painter claimed that there was no difference between Greek marbles and fans; in fact, art emerges without being subject to human reasoning.

Art is a science which makes it possible to choose and combine the various elements in nature in order to create beauty. Its laws are immutable just like those of the other sciences. While Ruskin labored over numerous weighty tomes about "modern" painters, without ever being able to clearly express his thoughts, how could the public, impressed by the very enormity of the task, take seriously what Whistler was able to say so clearly and precisely in just a few pages? The text was sprinkled with valuable quotations, always placed with the same sureness of taste that he used to place his butterfly trademark on his paintings.

In the *Ten O'Clock Lecture*, he wrote, "Nature contains the elements, in color and form, of all pictures, as the keyboard contains the notes of all music. But the artist is born to pick and choose and group with science, these elements that the result may be beautiful – as the musician gathers his notes, and forms his chords, until he brings forth from chaos glorious harmony. To say to the painter that Nature is to be taken as she is, is to say to the player, that he may sit on the piano…

That 'Nature is always right' is an assertion, artistically, as untrue, as it is one whose truth is universally taken for granted. Nature is very rarely right, to such an extent even that it might almost be said that Nature is usually wrong. That is to say the condition of things that shall bring about the perfection of harmony worthy of a picture is rare… seldom does Nature succeed in producing a picture… To say of a picture, as is often said in its praise, that it shows great and earnest labor, is to say that it is incomplete and unfit for view… for work alone will efface the footsteps of work. The work of the master reeks not of the sweat of the brow – suggests no effort – and is finished from its beginning.

45. *London Bridge*. 1880 or 1890.
6 7/8 x 11 in. (17.5 x 27.8 cm).
Freer Gallery of Art, Washington.

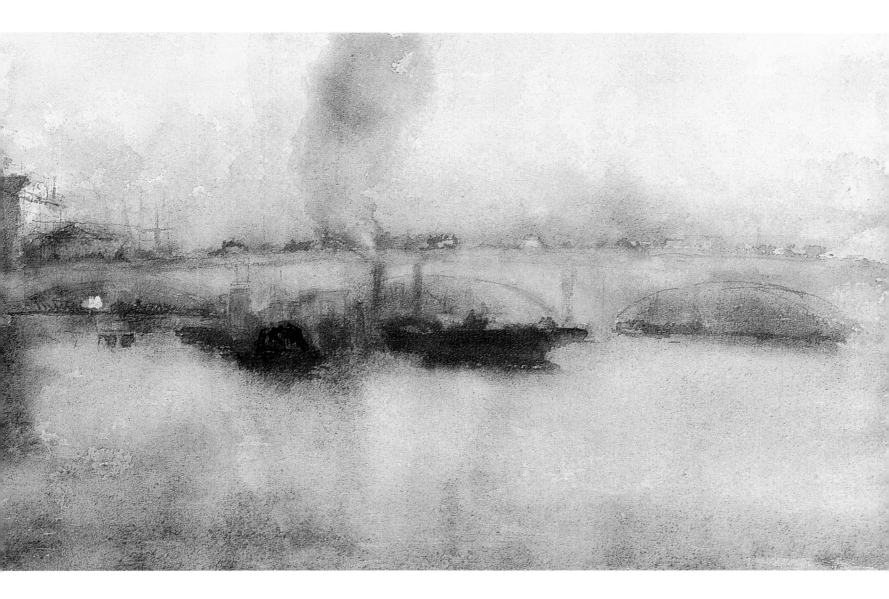

46. *Little Nude Model Reading*.
6 x 7 1/8 in. (16.8 x 17.8 cm).
Museum of Fine Arts, Boston.

The masterpiece should appear as the flower to the painter – perfect in its bud as in its bloom – with no reason to explain its presence – no mission to fulfill – a joy to the artist – a delusion to the philanthropist – a puzzle to the botanist – an accident of sentiment and alliteration to the literary man. "[Nature] is withal selfishly occupied with her own perfection only – having no desire to teach – seeking and finding the beautiful in all conditions and in all times, as did her High Priest, Rembrandt, when he saw picturesque grandeur and noble dignity in the Jews' Quarter of Amsterdam, and lamented not that its inhabitants were not Greeks.

As did Tintoret and Paul Veronese among the Venetians, while not halting to change the brocaded silks for the classic draperies of Athens. As did at the court of Philip, Velasquez, whose Infantas, clad in inaesthetic hoops are, as works of Art, of the same quality as the Elgin Marbles.

"We have then but to wait – until with the mark of the Gods upon him – there come among us again the Chosen – who shall continue what has gone before. Satisfied that, even were he never to appear, the story of the beautiful is already complete – hewn in the marbles of the Parthenon – and broidered, with the birds, upon the fan of Hokusai – at the foot of Fusi-yama."

These theories have been applied for more than a century now. Whistler revealed the beauty of the Thames and the abstract mysteries of the night. Looking at the *Cremorne* series of paintings, one can almost hear the explosions of the rockets and Catherine wheels being set off further along the shore. The murmur of the crowd, the memories of the garden are almost palpable. The men and women whose portraits he has left us are immortalized. The artist knew how to seize the moment and crystalize it on canvas. His work has the nobility of Velasquez. Whistler had the instinct and the taste as well as the good sense of the aesthete.

Oscar Wilde protested at Whistler's judgements in *The Pall Mall Gazette*. The idea that only a painter is qualified to talk about art was utterly unacceptable to him. Since he had become known as something of an art critic himself he considered himself to be personally attacked. Although the event had been well-conducted and the lecturer had been perfectly sincere, "I am convinced," he wrote, "that Mr. Whistler is one of the great masters of painting. I would dare to assert that Mr. Whistler himself absolutely shares this manner of perception. The poet is the supreme artist because he is the master of color and form, it is to the poet rather than to all others that these mysteries are revealed, to Edgar Allan Poe, to Baudelaire and not to Benjamin West or Paul Delaroche."

Whistler commented ironically on the choice of these two painters. Wilde replied by sending him this note, "Dear butterfly, thanks to the Biographical Dictionary, I found two painters named Benjamin West and Paul Delaroche who were fond of launching themselves in public into long discourses about art. Since nothing remains of their works, I conclude that all their art was spent in explanation. Be warned in time, James, and remain misunderstood. To be great is to be misunderstood."

Wilde would later say that Whistler had opened the eyes of the blind. However, Whistler was not pleased and retorted at a national exhibition with the following tirade which was published in *World*, "What does Oscar have in common with art? Except that he dines at our tables and swipes the plums from our puddings in order to go and sell them in the provinces, Oscar the delightful, the irresponsible Oscar who does not understand any more of a painting than he does of the cut of a coat, has

the courage of the convictions… of other people!" On the following day, *World* published Wilde's response. "What is so sad about our dear Jimmy is that vulgarity begins at home and ought to stay there." This feud, which began with an exchange of telegrams, ended in a book. Whistler reproached Wilde with having stolen his ideas and using them in his essay, *The Decay of Lying*, which claims that nature imitates art and that artists must detach themselves from Realism in order to immerse themselves in an imaginary world. The final episode in the seven years of conflict, was published in the form of an exchange of letters between Whistler and Wilde in *Truth* magazine. Whistler claimed that Wilde had asked him for ideas with which to embellish his own lectures. Whistler wrote, "Plagiarists ought at least to say, 'I take wherever I may find it' but Oscar's effrontery goes much further because he boasts without blushing, 'I take what *he has* wherever I may find it.'" Wilde replied, "The definition of a disciple is one who has the courage of the convictions of his master, but this is too hackneyed, even for Whistler… The only original ideas on art I have heard fall from his lips are those concerning his own superiority over painters who are much greater than him. A gentleman should not take the trouble to reply to the wild imaginings of such an ignorant and ill-mannered person, but the publication of this insolent letter leaves me no choice."

The painter retorted, "I realise that here our Oscar is at bay and is at last original and incomparable in his death throes. For once, he is not repeating the words of any author and appears in a guise truly invented by himself: that of a gentleman." Wilde's essay, *The Decay of Lying*, ends with a phrase reminiscent of a *Nocturne*: "And now let us proceed to the terrace, from which white peacocks hang like ghosts when the evening star casts its silver shadows." Later, Whistler would be equally wary of a young man named Aubrey Beardsley who showed him his drawings in the Japanese taste. "This young man is all hair, he has too much on his head, and how he is covering his paper with it." The young artist had better luck with Wilde who permitted him to illustrate his play *Salomé*.

In 1886, Whistler planned major projects with the American painter William Merritt Chase, who had arrived from New York. Chase wanted to bring him back to the U.S. to open a school of painting. Whistler was enthusiastic about the project for a while. He imagined himself arriving in New York by luxury liner, saluted by a flotilla of tugboats.

But for unknown reasons the plan never came to anything. All that remains of this meeting are the portraits which each artist made of the other. Whistler painted Chase in a frock-coat and top hat, with a long switch in his hand. He wrote, "I was kind to him. I turned him into a New York man-about-town." Chase painted Whistler in a frock-coat, a long cane in his hand, hatless, standing in front of a yellow wall. Once he had returned to the United States, Chase gave a series of lectures in which he told of his meeting with Whistler. He enthralled his listeners with tales of the originality of the dandy who dreamt of traveling in America in a white coach with yellow reins and with a black servant in a white and yellow uniform. He recalled his memories of the artist with the crazy ideas. He told of the meeting arranged one day with an American who wanted to buy Whistler's watercolors.

The prospective purchaser had invited them to lunch. Passing before a fruit store, James stopped the cab, "Quite a nice display!" he said to his companion, "I'll just go in and ask the storeowner to move the oranges."

47. *The Façade of the Grosvenor Gallery.* Illustration in *The Builder*, May 5, 1877.

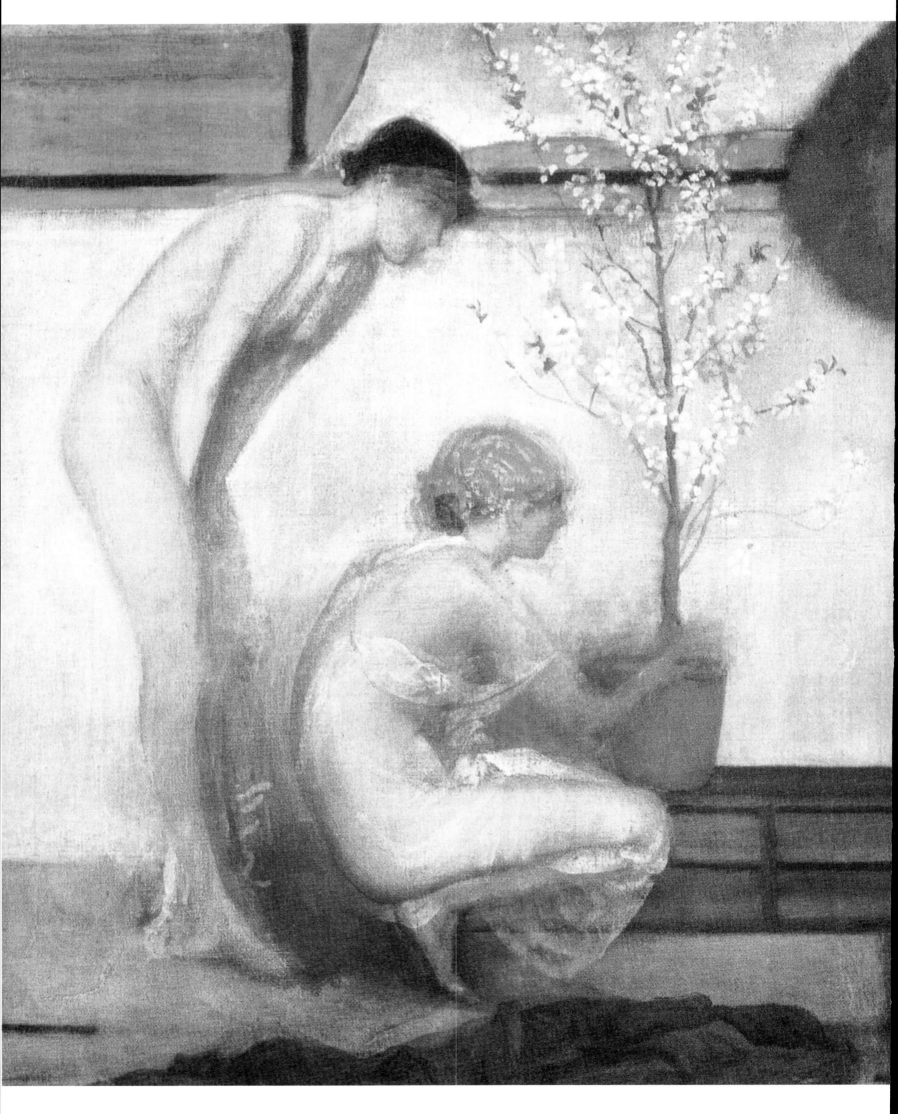

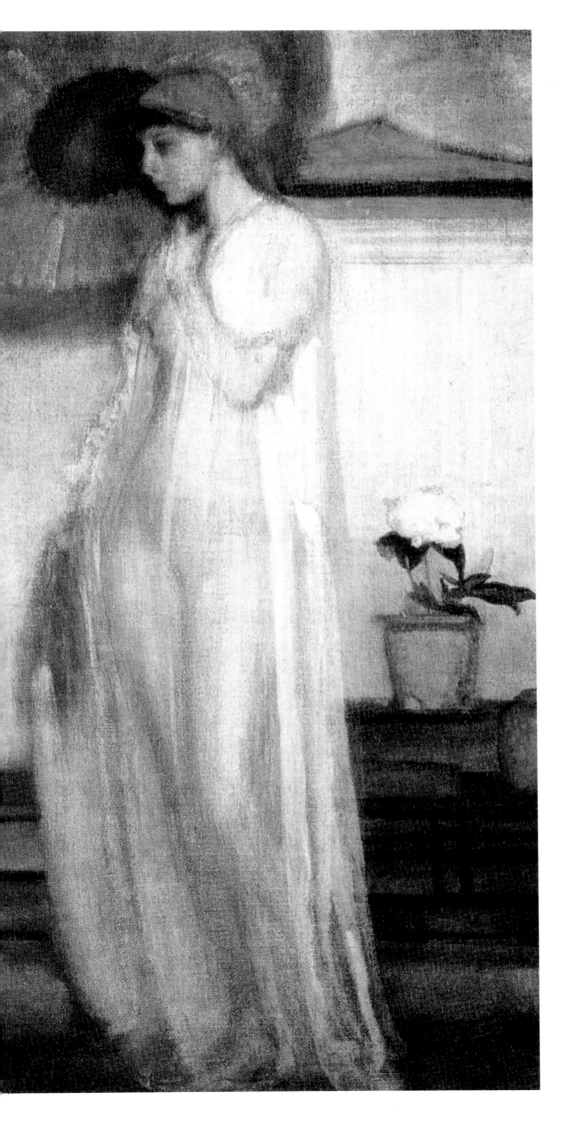

48. *Pink and Gray: Three Figures.* 1868.
57 x 73 in. (144.8 x 185.4 cm).
Tate Gallery, London.

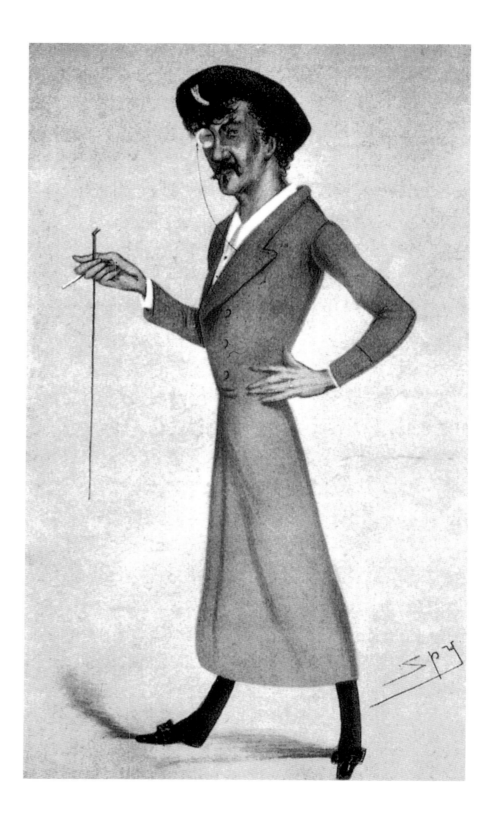

49. *A Symphony.* Caricature of Whistler by
"Spy" (Sir Leslie Ward), published in
Vanity Fair, January 12, 1878.

Then he took out pen and paper to produce a quick sketch. The collector was left to fret alone in front of his plate.

Another time, Whistler refused to part with a commissioned painting which he had just completed.

Chase was amazed and received the following explanation. "Look, my poor dear friend, you know that three-quarters of the people do not appreciate the beautiful things they are given... They spend two or three thousand dollars on a painting and then they figure that the painting belongs to them. Well, I don't mind that, but not forever! They can look at it as long as they like, then give it back!"

Whistler held one-man shows. He was also intent upon fighting the reputation which he had gained. As Degas said, "his eccentric outfits served to keep him at a distance from a mediocre public." Today, looking at photographs of the artist, one cannot help but see a resemblance with one of those insubstantial courtiers whom one sees in Watteau's paintings. In April 1886, the W. Graham collection was auctioned at Christie's. It contained works by Rossetti, Burne-Jones, Holman Hunt, and a canvas by Whistler, *Nocturne in Blue and Silver: Old Battersea Bridge* (now in the Tate Gallery.) On the day of the sale, when the picture appeared there was a little sporadic applause followed by whistles from the crowd. The *Nocturne* was sold for a trifling amount. By whistling at it, wrote Whistler in *The Observer*, the crowd had paid involuntary homage to him. He then published a series of Proposals on what he called the "laws" of engraving for the attention of portrait painters explaining the main ideas behind his art: "Placing the main figure within the frame and painting the flesh tones in the light in which one sees them."

In May, he exhibited his *Notes, Harmonies* and *Nocturnes* and again took charge of decorating the hall, as was his custom. He chose brown colored paper and painted the dado gold. The color scheme was terracotta, burnt sienna, yellow ochre and white for the walls, yellow and brown for the drapes. A yellow canopy was stretched across the center of the room. A Mr. Theobald who greatly admired Whistler's work bought up anything that had not been sold by the end of the exhibition. A French critic living in London demanded that the American's works be found a place in the Louvre as quickly as possible, beside those of Velasquez and Tintoretto! Praise indeed!

His friends called him "the President." Prior to his election as president of the Society of British Artists, James had written in *World*, "No hesitation is possible! The eyes of a whole continent are upon me." After his re-election he tried to change the old established principles of the institution and for its next exhibition he offered his *Nocturne in Blue*; *Nocturne in Brown and Gold: St. Mark's, Venice*; a *Harmony in Red*; the portrait of Mrs. Godwin; and *Harmony in White and Ivory: Lady Colin Campbell...*

This last painting was still unfinished but James did not worry and decided to show it anyway. The members of the Society were scandalized, withdrew the painting and voted an amendment to limit the powers of the President. Whistler was undismayed and tried to make the Society better known by eliminating as many of the paintings as possible which he judged to be without merit. New members were exhibiting, including Alfred Stevens. In 1887, dissent increased within the institution when the Prince of Wales honored the exhibition with a visit.

On the day before the opening, Whistler stayed late in the hall to put the finishing touches to the decoration.

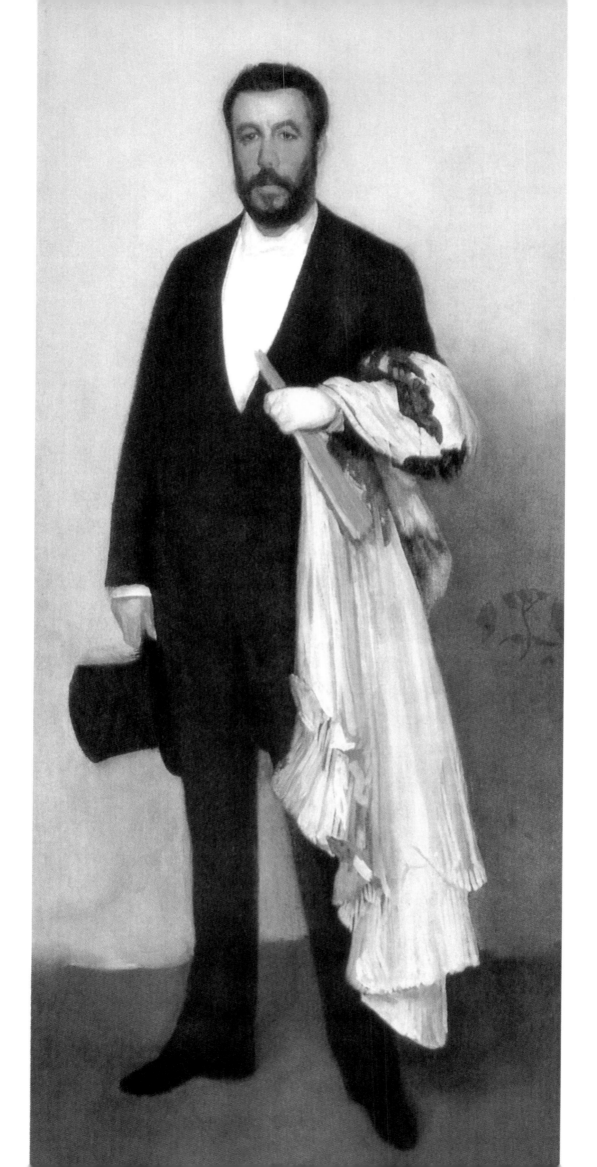

Next morning, to everyone's horror, it was found that the doors and mantelpieces had been painted in yellow gold. The members protested and Whistler abandoned his unfinished work. That evening at the Hogarth Club, at the "smoking concert" (a Victorian all-male institution) there was talk of nothing but the "arrangement in yellow."

A telegram was sent to the president begging him to come and complete the decoration. He replied, "You really are too kind!" Naturally, he stayed at home and merely arrived the next day to greet the Prince of Wales. Workmen had labored all night to finish painting and subdue the colors. After this episode, every measure adopted by the President was rescinded by decree.

Henceforward, as many paintings as possible were accepted and their worth was calculated on the basis of the amount of wall space they occupied. The future showed Whistler to be in the right because shortly after his death, paintings were hung to harmonize with the room, and were well spaced out, with frames that were accorded their due importance.

Queen Victoria's Golden Jubilee was celebrated in 1887. The societies of artists presented Her Majesty with congratulatory messages to mark the occasion, as tradition decreed. Whistler worked alone on a presentation. Using sheets of cartridge paper, he drew the royal arms on the first page, on the second there was an etching of Windsor Castle and on the third he wrote a message and on the yellow leather cover there is a dedication to the Queen. The message contains a request from Whistler to the Queen, asking her to grant the Society of British Artists her royal patronage, so that it could call itself the Royal Society of British Artists. On the last page there is a woodcut of Whistler's house in Chelsea. He signed the back cover with a butterfly.

The Queen granted his request and invited him to the Jubilee ceremony at Westminster Abbey. He also attended a Royal Garden Party at Buckingham Palace as well as the naval review at Spithead. He made several etchings for the occasion, which he called "The Jubilee Series." At the Winter Exhibition, he was accused of having accepted works by Monet for display and for having spaced out the paintings.

The crisis came to a head in April, 1888 when the conservative opposition made a move to oust him.

A petition signed by eight members demanded an Extraordinary General Meeting, at which Whistler and his supporters offered their resignations. "The artists have come out," he quipped, "and the 'British' remain!" The rebels met in a room at the Hogarth Club. Whistler was in good form, singing and beating time with a child's rattle. Mempes asked him what he intended to do about his friends.

The artist replied, "Lose them." The newspapers were full of his rift with the Society. After his departure, the panel over the door to the exhibition hall on which he had himself painted a lion and a butterfly was turned to face the wall. Whistler informed the *Pall Mall Gazette* of this immediately. The artist had transformed the Society of British Artists. His exhibitions had become the most famous in London. Wyke Bayliss, his successor, never understood him. "Whistler's purpose was to make the British Artists a small esoteric set, mine was to make it a great guild of working artists of this country," to which the former president replied, "I wanted to make the British Artists an art center, they wanted it to remain a shop."

50. *Arrangement in Flesh Color and Black: Portrait of Théodore Duret.* 1882-1884. 76 3/8 x 35 in. (194 x 90.8 cm). The Metropolitan Museum of Art, New York.

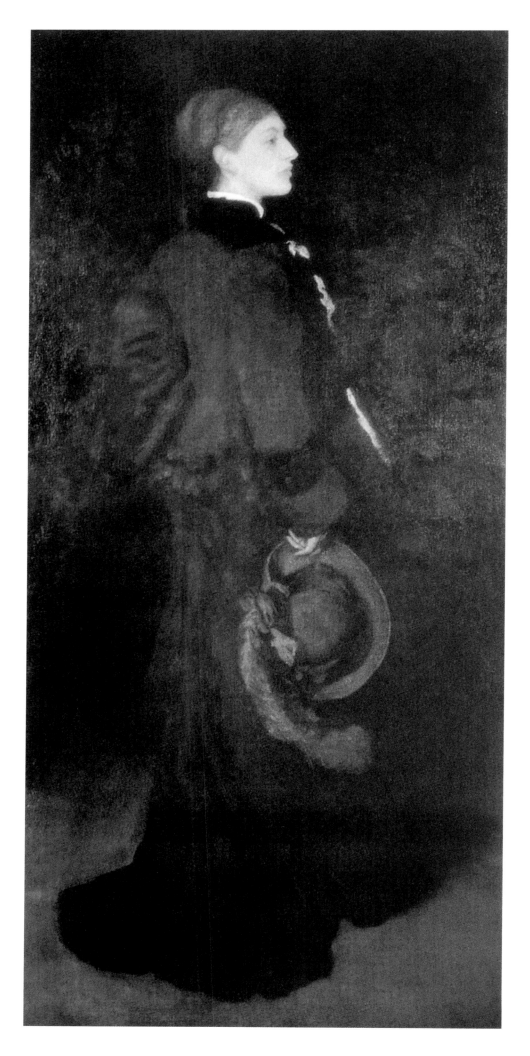

51. *Arrangement in Brown and Black:*
Portrait of Miss Rosa Corder. 1875-1878.
75 1/8 x 35 3/8 in. (190.8 x 89.8 cm).
The Frick Collection, New York.

102

MARRIAGE, HONORS,
THE GENTLE ART OF MAKING ENEMIES
(1888-1890)

Whislter delivered a series of lectures in the wake of the original *Ten O'Clock Lecture*. In 1888, one was even delivered at Oxford, Wilde's fiefdom, three years after the first lecture at the Prince's hall. However, Whistler was preoccupied by an article published in the *Fortnightly Review* in June, signed by his friend Algernon Swinburne, who reproached the painter with excessively praising Japanese art and creating a barrier between art and literature. "It would not have been very convenient to have asked him whether he was putting out his tongue to the public when it had its back turned. We are dealing with an 'acrobat', a 'clown' and a 'buffoon of genius,'" he wrote. Whistler replied. "What should one think of you, who have abandoned your Muse in order to come and insult my goddess and talk to her like a soap-box orator? ...I am renouncing her liberty to my last friend. I have lost a comrade-at-arms; but I have discovered a man I never knew, a certain Algernon Swinburne." (*World Journal*). The artist left for France to spend some time with firm friends who welcomed him warmly, especially Count Robert de Montesquiou (whom he had known since 1885), Théodore Duret and not forgetting Stéphane Mallarmé. Whistler had known Mallarmé in 1886, the year of the eighth and last Impressionist exhibition in Paris. The same year he participated in the Paris International Exhibition, at the Georges Petit Gallery where his paintings hung beside those of Monet, Pissarro, Renoir, and Berthe Morisot, fifty little paintings which drew praise from J. K. Huysmans and Octave Mirbeau.

His work was reproduced in the *Revue indépendante* (No. 1), the symbolist review run by Edouard Dujardin. Special editions of the publication contained as a supplement four drawings by Whistler preceding notes on the theater by Mallarmé. It was Duret who first introduced the poet to the painter's work. Their first meeting took place at the Café Riche, the café which was the Symbolists' and Impressionists' favorite haunt. Later, when Whistler rashly invited Monet to exhibit at the Royal Society of British Artists in London in December, 1887, Monet sent over four paintings which caused some lively reactions of a kind which neither painter expected. The painter had said before despatching them, "I hope the committee will not be too dismayed by my painting, as for me I am longing to find out what effect it will produce." Whistler went over to Paris to spend a few days there and met Monet one Sunday morning at the Hotel Garnier, facing the Saint-Lazare railroad station. Monet wrote to Mallarmé, "I am here with Whistler who is spending a few days in Paris and would very much like to get to know you. Would you be able to join us for lunch this morning? We meet

Following pages:

52. *Harmony in Fawn Color and Purple: Portrait of Miss Milly Finch*. 1880.
75 7/10 x 35 in. (189.3 x 88.7 cm).
Hunterian Art Gallery, Glasgow.

53. *Harmony in Red: Lamplight* (Mrs. Whistler). 1886.
74 3/5 x 35 in. (189.8 x 88.9 cm).
Hunterian Art Gallery, Glasgow.

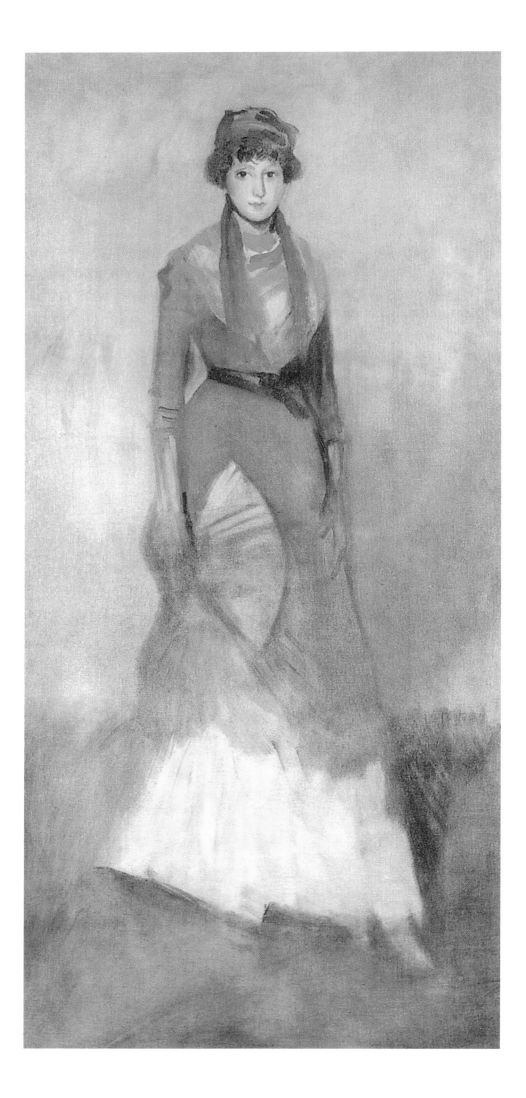

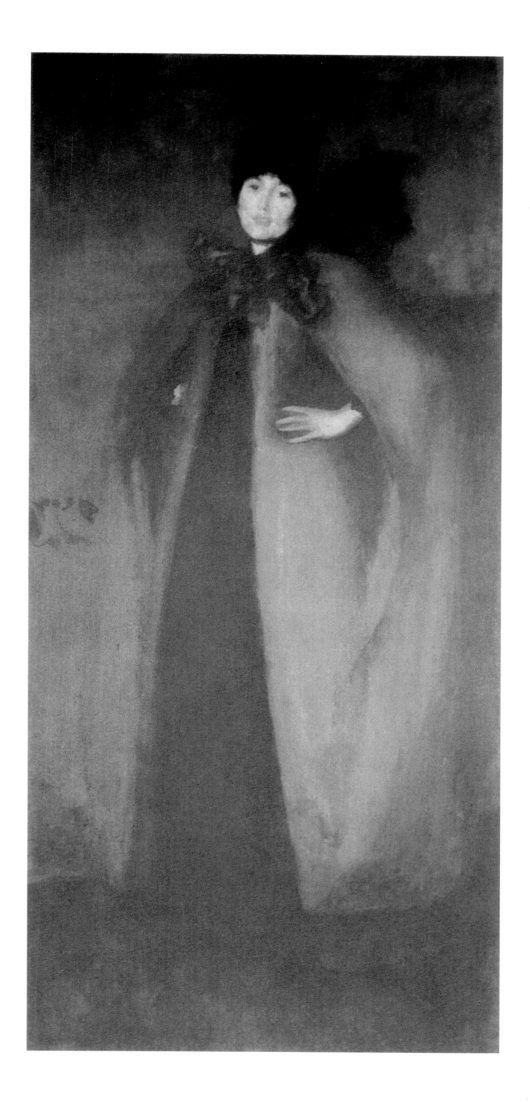

at 11:30 a.m. at the Café de la Paix." On that day the two men laid the foundation for a firm and warm friendship. Henri de Regnier wrote, "From the outset, Mallarmé submitted to Whistler's prestige and was touched by a magician's wand by the ebony cane with which the great dandy of painting played so elegantly. Everything about Whistler aroused one's curiosity, his mysterious, reasoned art, full of subtle practices and complicated formulae, the uniqueness of his personality, and the intelligent expressiveness of his face. His white lock of hair, the frown of the eyebrow which held his monocle, his quick-wittedness, sharp retorts and biting comments…which were his weapon of defense and attack."

The London *Sunday Times* of January 15 announced that the *Ten O'Clock Lecture* was to be published in London and America, and that Mr. Stéphane Mallarmé had requested permission to make a French translation of it. He wrote to Monet to tell him how much he admired Whistler. Duret sent him an article about Whistler's work. The poet replied, "It was through you that I met him… he has made a rare impression upon me." While Whistler was working on a layout for the *Ten O'Clock Lecture* to show how it should be published in London and which he gave to Dujardin, Mallarmé was working on a translation of the text which appeared at the beginning of the May issue of the *Revue Indépendante*. On Sunday, May 20, 1888, the two friends paid a visit to Berthe Morisot and to Mery Laurent, who were holding a salon at home. Both their hosts asked for a "butterflied copy" of the *Ten O'Clock Lecture*. Whistler returned to Paris with the intention of exhibiting his paintings at the Durand-Ruel Gallery. On May 22, Whistler and Mallarmé spent the evening together and worked with George Moore to resolve the final translation difficulties (two hundred and fifty copies were published). Returning to London, the painter moved from his house and the Fulham Road studio to live once more in Tite Street. The move coincided with his final break with Maud Franklin, who had been his model and mistress since 1874.

Mallarmé and Whistler had much in common; both were artists, and the painter once confided in the poet, "You are alone in your art as I am in mine." They shared an ideal, the desire for perfection in their art. The poet was constantly reworking his manuscripts to the despair of his publisher; the painter demanded much of his models making them sit for numerous, interminable sessions… By the time they met they were already middle-aged. In 1888, Whistler was 54 and Mallarmé 41. They remained attached to their values of dandyism, elitism, and aristocracy. Shortly before leaving the Society of British Artists, Whistler married Beatrix Godwin, widow of E. W. Godwin, the architect who had been responsible for building his house. Beatrix and James had known each other for a long time and had been attracted to each other from the first. The marriage which thus seemed to be a logical end and a happy beginning took place on August 11, 1888. Mrs. Whistler was tall and dark, her olive complexion gave her an exotic air. She had studied art in Paris, and made drawings and etchings to illustrate a fairy story called *Little* by Van Eeden. In the July issue of *The Truth*, Henri Labouchère told how he "made the match." Mrs. Godwin was a very beautiful and charming woman. "One evening, dining with friends, I met both of them. They showed a strong attachment to each other, that was clear. I was even convinced that they would have liked to become man and wife. But they needed to be made to make the decision. Jimmy, I said to Whistler, do you want to marry Mrs. Godwin? Of course, he replied… And you madam, would you like to marry Jimmy? Of course! And when will you

do so? One of these days, said Whistler. That is not good enough for me, I replied. You must set a date. The newly-engaged couple then asked me to take care of everything. It is I who had set the date, choose the church, reserve the priest, and give the bride away… The ceremony was held a few days later. On leaving the church, the guests went to Whistler's studio where a banquet had been laid on. The dishes were on the table but there were no chairs. Someone went off to get some crates, and people did their best. When I took my leave of the couple, they did not yet know if they would leave for Paris that night or stay in London. They were decidedly lacking in practical sense. The day before, I had met the future Mrs. Whistler in the street. 'Don't forget what you have to do tomorrow,' I reminded her. 'Oh no, I was just off to buy my trousseau.' 'It's a little late for that!' 'Oh no, all I need is a sponge and a toothbrush. One really ought to change them when one marries!'"

The newlyweds left immediately for France where they honeymooned, traveling all over the country then staying in Paris at the Hotel du Tibre, rue du Helder. Whistler introduced Mallarmé to his wife in November. This was the first time the artist had really taken a vacation. Prior to this, whether alone or with Maud Franklin, he had worked ceaselessly. It was the start of a happy period; he admitted to being transformed by his marriage. The couple lived a Bohemian lifestyle, and Whistler was extremely attentive to his wife (he would nevertheless bring back thirty etchings from the trip). The painter had done a great deal of work prior to this and for a while he preferred to concentrate on family life. He received commissions but had neither the time nor the desire to fulfil them. "Why didn't all these people want my paintings twenty years ago, when I needed commissions? I could have done them then and do them just as well as I do now!"

Whistler was aware of the confusion caused by his undated works and decided to catalog them. To this end, he asked his main American benefactor, E. G. Kennedy of Wunderlich, to inform him which of his works were in the United States. Honors flowed in from abroad. Whistler was elected an honorary member of the Royal Academy of Bavaria, and Munich asked him for paintings for the International Exhibition. Whistler sent them a portrait of which he was very fond. *Lady Archibald Campbell* won a second-class medal. Whistler thanked the jury for "this half-reward… I would ask the committee to accept the expression of my calmest and most moderate joy." In 1889, Whistler won a gold medal at the 18th Universal Exposition in Paris. In 1890, at the 19th Universal Exhibition in Amsterdam, he was also awarded a gold medal. This was recognition at a time when he had come never to expect it. Whistler's paintings were exhibited in New York as well. In early January 1889, he sent Mallarmé, Alfred Stevens and Monet press cuttings which told the story of an affair, which was still the talk of London. Whistler wanted this matter to become known abroad, so as to give it some publicity… For reasons connected with Maud Franklin, the painter William Stott, upon encountering him one evening on January 3 in a London club, immediately shouted at him, "You are a liar and a coward." Whistler boxed his ears on he spot. The two painters had quarreled in 1887 at an exhibition at the Society of British Artists. Each was exhibiting a painting for which Maud Franklin had served as the model. Stott's work showed a red-haired Venus and that of Whistler a woman in a hat and fur coat. Some critics noted that the same model had been used and had made pointed remarks such as, "Here she is naked and here she is conventionally dressed."

54. *Stéphane Mallarmé, No. 1.* 1893.
Lithograph on Japanese paper,
Frontispiece to the first edition of *Verse et Prose.* 7 x 8 in. (19 x 21 cm).
Hunterian Art Gallery,
University of Glasgow.

They abandoned their plans to go to Paris in the immediate future. In *The Decay of Lying*, the essay which Wilde first published in *The Nineteenth Century Review*, the *Ten O'Clock Lecture* is bitterly attacked. The two men were now exchanging journalistic blows every morning in the London press. The painter wrote, "Oscar loses his head and roars, whereupon Whistler pierces him through with his habitual delicacy and carries off his scalp." Another controversy emerged in the *National Observer*, after the publication of a work by Sir Hubert von Herkomer in which photo-gravures of pen-and-ink drawings were published under the name of etchings. Whistler protested against what he considered to be an imposture. The artist had always been on bad terms with Henley, the newspaper's managing editor, because the latter had been less than kind to Whistler during his early years. Henley, a writer and poet, claimed that Whistler had profited from the publicity afforded by the scandalous affairs in which he had become involved. Their common love of the Thames reconciled them. Henley was the first to describe the beauties of the river, just as the artist had been the first to paint them. He dedicated verses to Whistler which were inspired by the *Nocturnes* and which evoked the river's mysterious charm. Henley looked nothing like the traditional idea of a poet, with his tall, heavy build and emphatic speech. He did not appear on the surface to be the type of man with whom Whistler would strike up a friendship and yet the painter was in the habit of attending the *National Observer's* editorial dinners and he painted the writer's portrait.

At the urging of his friend, the publisher William Heinemann, Whistler produced a book containing the wisdom he had accrued over the years. The work was called *The Gentle Art of Making Enemies* and contained all the documents produced in 25 years of combat – public altercations and long-forgotten newspaper articles. Yet there were also theories on art and justifications for the incessant attacks of which he had been the victim both as a painter and as a man. Whistler wanted to let the public judge for itself and worked at what he called "making history," that is to say, re-establishing the truth. On the title page there is an inscription, "In which the gentle art of making enemies, as is pleasantly demonstrated with the help of numerous examples in which one finds the serious men of this earth, savantly exasperated and gently pushed into the inconvenience and lack of tact, becoming the victims of the excessive sentiment of being in the right." Whistler asked Sheridan Ford, an American journalist, to collect and classify the material. Once the work had been completed, Ford published the results of his labor in his own way. In this he misjudged Whistler who, meticulous artist that he was, fired him on the spot. Ford disappeared only to reappear some time after, announcing the publication of the book in England and in America. The artist sued him, and the court had all the printed copies seized. The matter came to court in France, and the painter gave evidence in impeccable French. Judgement was for the plaintiff.

Having overcome this hurdle, Whistler resumed work on the layout. He chose where he would decorate the text with butterflies. Depending on the context the butterflies may be dancing with joy, laughing or even using their sting. Where mention is made of the symbolic farthing damages awarded in the Ruskin trial, the butterfly drops its wings with sadness. The wings are wide open however, for the adventures in France and Holland. The book title was based on Whistler's speech at a banquet of the subject of *The gentle answer that turneth not away wrath*. This biblical saying would remain attached to his personality and his choices, so that the book dedication reads "to the

56. Photograph of Whistler. 1885-1886. Glascow, University Library.

small number who, from the start of life, have gotten rid of a large number of friends, I dedicate this sad story." The book was published in 1890 and is considered as an outstanding artistic autobiography. Whenever he was asked about his life thereafter, he would reply, "All you need do is consult the Bible." Indeed, the numerous documents, letters, and catalogs presented chronologically prove the stupidity of some of his contemporaries. On the other hand, the author's thoughts emerge clearly showing how ridiculous most of the opposition was he encountered during his career. Nowadays, his ideas appear self-evident.

"We must respect art for itself and not introduce the judgements made on external elements. Art must be divested of anything that is dust in the eyes. Art must act through the impressions it communicates to the eye or to the ear. Let us not confuse these impressions with those produced by certain sentiments such as devotion, pity, love, or patriotism. That is why I content myself with giving my paintings the title of Arrangements or Harmonies…"

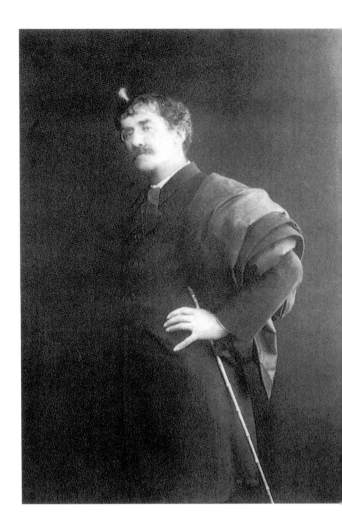

The art historian and critic Gustave Geoffroy understood the stature of the artist when he wrote at the Decennial Exhibition of painting in 1901: "Finally in the American section there is a great artist whose influence has been most extensive and profound not only in the New World but also in the Old World. James McNeill Whistler is a painter equal to the most savant, an admirable poet of life spiritual, strange and mysterious and distinguished in the manner of Velasquez or Edgar Allan Poe. I have deliberately chosen these two names in order to try and define the refined and unique personality of the author of this delightful work, *Young Woman with a Japanese Fan* the portrait itself, at first as vague as an apparition but so striking, so real, this woman dressed in black and gray viewed from behind, but showing her profile, this powerful shape like a classical statue with a modern face which will remain in the memory as an admirable, an unforgettable masterpiece."

The Gentle Art of Making Enemies crystallized Whistler's reputation as a man of letters of a rather cruel nature. The graphic design of the book features tiny characters surrounded by large blank spaces decorated with marginal annotations and butterflies. The critic Ellen Moers points out the influence of Barbey d'Aurevilly's book, *Du dandyisme et de George Brummel* (1845), which was similarly decorated with notes in the wide margins.

The butterflies on the pages of *The Gentle Art of Making Enemies* balance the text and are often placed diagonally to it. Whistler used them in his drawings and paintings to emphasize and balance the other shapes and colors in the painting. As in a Baudelaire poem, the creature reveals human folly. Its carefully studied anthropomorphic poses are reminiscent of the dances of Loïe Fuller, the American dancer, who so enchanted Toulouse-Lautrec, and especially her famous Dance of the Butterfly. Despite their grace, the long tails of the butterflies introduce a visual counterpoint to the acerbic comments of the book.

Using this image, the author impales his victims, then flaps his wings and files away, in order to ask the few remaining critics: "Who breaks a butterfly on a wheel?" A haughty butterfly decorates a letter addressed to a critic who was defending a former member of the Royal Academy. Whistler called this defensive attitude "the cheap camaraderie of senility" and illustrated the text with an unnaturally large butterfly, its chest puffed out and its wings widespread, reflecting the spirit in which he confronted the artistic establishment. The letter is headed, "We are going to change all that."

Irritated by another pompous article attacking his ideas on interior decoration, he replies with an article entitled *Another Poacher in the Chelsea Preserves*, accompanied by a butterfly which seems to be dancing with rage. Whistler comments on the article in these terms. "Oh, Atlas, they say that I am incapable of keeping a friend. My God, I cannot allow this." Atlas was the pseudonym adopted by Whistler in *The World*, a newspaper which regularly featured his letters. Another attack was aimed at a *World* reader who wanted to correct the titles of Whistler's 1881 exhibition. "Is the oriental café supposed to be French or Italian? There is an "e" too many for it to be French, but it lacks an "f" for it to be Italian."

To this, the artist replied by indicating that he considered these details to be far beneath him. "Do you know the story of the witness who, when asked how far he was from the point at which the incident took place, replied unhesitatingly, "sixty-three feet and seven inches." When asked how he was able to be so precise, he replied, "I knew some idiot would ask me that, so I took measurements." Another butterfly accompanies a letter addressed to the critic Tom Taylor, who had said of his art and writings that they were both "wooly." The painter replied quite simply, "With time, truth will collapse on you and when you look back and see your life, there are chances that many of the situations which you had taken seriously as an art critic, will to your great sadness, appear to be very wooly."

An anecdote illustrated by a butterfly raising its wings heavenward is one whose target is Harry Quilter, dressed "in an extraordinary combination of mustard-and-cress color with a delicate blue vest," wrote the painter. The critic was standing before a painting by Whistler in the Grosvenor Gallery. According to Whistler, the critic's exotic choice of dress clashed with the subtle harmony of the painting. Having completed its work, the butterfly turned its back on its enemies and fluttered away into the clouds on the last page of the book.

Whistler ended the 1892 edition with a parting shot. "It has amused us to accuse although they thought we wanted to convince. Well, they have served our purpose well!" The artist took great trouble in the preparation of the book for press, both in the text and in the illustrations. The critics pinioned in *The Gentle Art of Making Enemies* would write, twenty years later, articles which were full of praise for the painter. The battle that Whistler was fighting was similar to that of the Impressionists in France. The pretentious establishment painters derisively called "pompiers" were the only ones to receive official commissions. It was their task to illustrate and exalt bravery on the field of battle, soldierly virtues and maternal sacrifice. All that mattered was the choice of subject and the result was often excessive. J. Garnier painted a "shocking" painting called *Constat d'Adultère* (Taken in Adultery), J.-P. Laurnes depicted *The Deliverance of Those Walled Up in Carcassonne*, L. Gérome produced *Hand-to-Hand Fighting*, and F. Cormon created *Funeral of a Chief in the Iron Age*.

E. Detaille painted *Salute to the French Casualties*, followed by another depiction of the same scene, the only change being that the soldiers were wearing different uniforms and their hair was a different color, and here we had *Salute to the German Casualties*. What did Whistler and the Impressionists have in common with this rabble?

The Third Republic wanted to show itself to be a patron of the arts in the tradition of Louis XIV and Napoleon III. Artists were chosen by the State and became official painters, each of whom was to have a "speciality": war, the family, mythology, faith. The bemedalled "pompiers" supported by the critics were awarded the major decorative commissions.

57. *Blue and Violet*. 1889. 10 x 6 in. (26 x 15.2 cm). Hunterian Art Gallery, Glasgow.

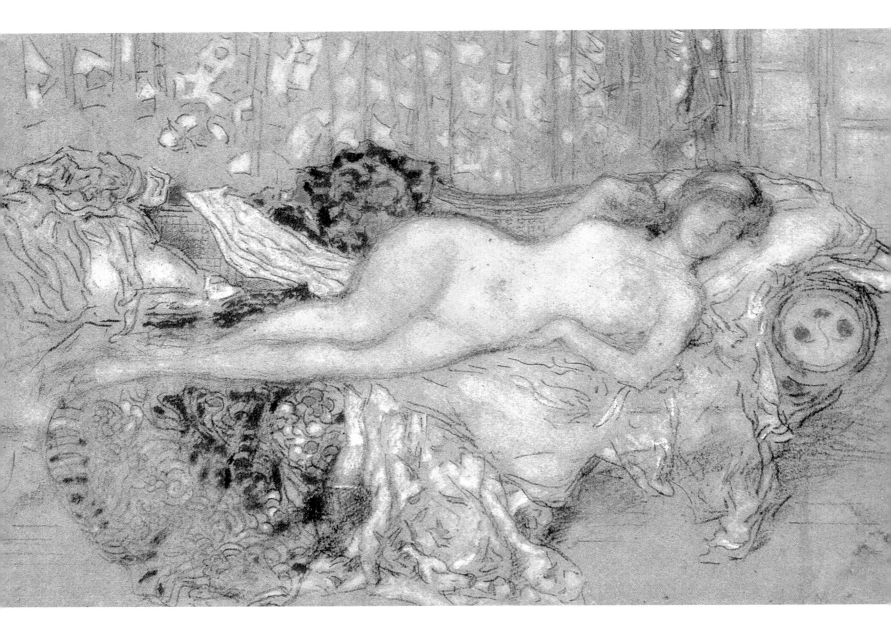

114

They enjoyed the same privileges as government employees. A code was even devised which laid down the conditions necessary for becoming an official painter. "Only those shall be admitted to the guild of painters who have shown evidence of their abilities through a vocational examination. Such persons shall have the right to append to their signature an official mark which in exhibitions or private galleries shall indicate to the public their status as professionals…"

The situation was similar in England. The official painters were members of the Royal Academy and were all-powerful. In France, Léonce Bénédite, who was suddenly promoted to the rank of curator of the Luxembourg Museum, had a mentality similar to that of John Ruskin. At the death of Toulouse-Lautrec he was offered the choice of taking all of the painter's works, but would only accept one, *Lady with a Boa*.

Fortunately, there were enlightened and generous philanthropists who had always appreciated the talents of James McNeill Whistler. As early as 1863, Fernand Dunoyer wrote, "The most original painting is that of Mr. Whistler." Huysmans wrote of *Portrait of the Artist's Mother*, "An old lady depicted in sharp profile, wearing black clothing against a gray background continued by a black curtain splashed with white.

It is disturbing, the coloring is different from what we are accustomed to. Nevertheless, the canvas is barely covered with paint, and the weave even shows through slightly.

The harmony of gray and Chinese ink black is a joy to the eyes which are surprised by these daring and profound harmonies; it was realist painting, very intimate, but somehow extending beyond a dreamlike quality. At almost the same time, at the International Exhibition in the Rue de Sèze, Whistler was exhibiting the canvases which had made him famous in London, the dream-like landscapes, his delightful *Nocturne in Silver and Blue* in which a city built on the shore melts into the azure haze, his *Nocturne in Black and Gold* and finally his *Nocturne in Blue and Gold* representing a view of the Thames above which, in a fairylike mist, a golden moon illuminates with its pale beams the vague outlines of vessels sleeping at anchor."

On Monday, September 8, Whistler wrote to Mallarmé informing him of the "licking" he had administered to Augustine Moore after meeting him at the theater and hitting him in the face with his cane. The critic had brought down Whistler's wrath upon him by writing in *The Hawk* about the architect Godwin, Mrs. Whistler's first husband, in less-than-flattering terms. Whistler also claims that *The Gentle Art of Making Enemies* was enjoying "enormous success in London." Whistler sent his friend a file of press cuttings of which some had just appeared in *The Whirlwind*, a publication which described itself as "eccentric, original, and discreet." Echoes of the Augustine Moore affair appeared in *Le Temps* and then in *Courrier de l'Art*. Mirbeau reported the incident in *L'Echo de Paris*, in the following terms.

"The other night in London… there was a very elegant performance full of emotion. Mr. Whistler, the great painter and incomparable etcher, confronted Mr. Augustine Moore, with an air which bode ill for him. Mr. Moore, editor of a little scandal sheet entitled *The Hawk*, had in the last issue gravely outraged the memory of a recently deceased friend of Mr. Whistler. "You are the Hawk, aren't you?" inquired the artist, seizing Mr. Moore by the arm and spinning him around like a top. "Yes", he replied. Immediately, with a swift movement of his slim bamboo cane, famous in London and Paris, Mr. Whistler elegantly struck Mr. Moore in the face.

58. *The Arabian*. 1892. 7 x 11 1/5 in. (18 x 28 cm). Hunterian Art Gallery, Glasgow.

Following pages:
59. *Arrangement in Yellow and Gray: Effie Deans*. 1876. 77 x 37 1/8 in. (194 x 93 cm). Rijksmuseum, Amsterdam.

60. *Red and Black: The Fan*. 1890s. 75 x 36 in. (187.4 x 89.8 cm). Hunterian Art Gallery, Glasgow.

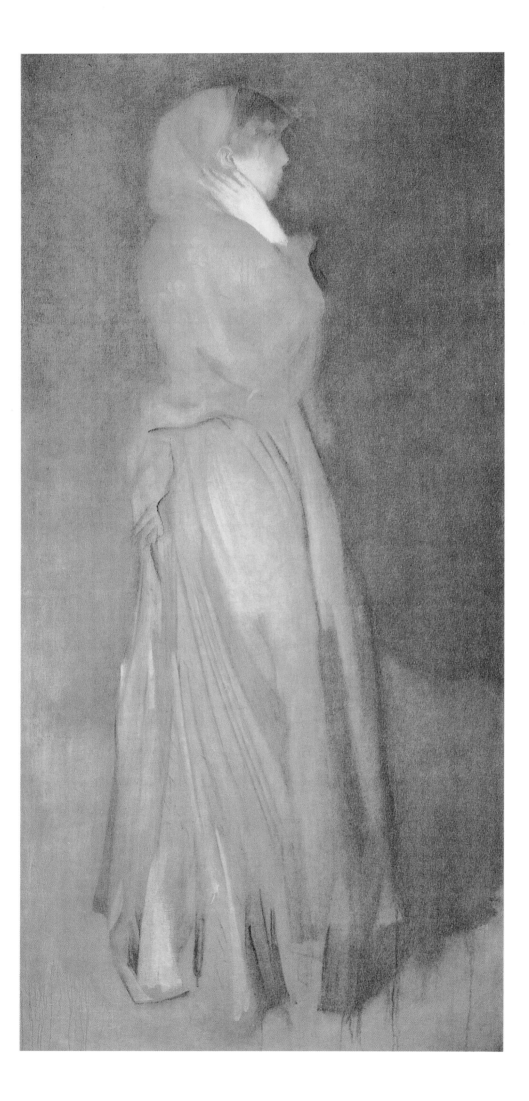

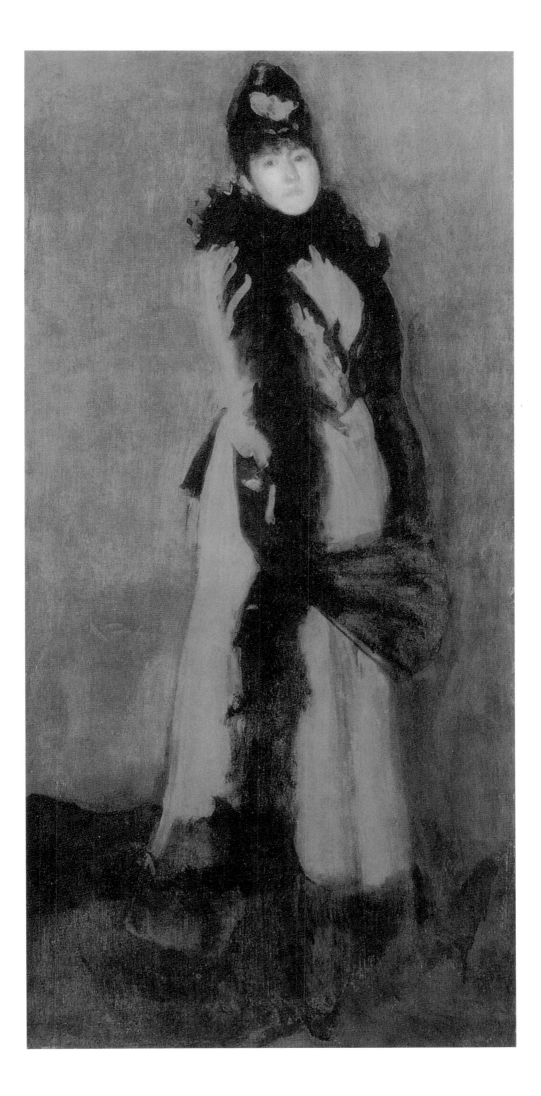

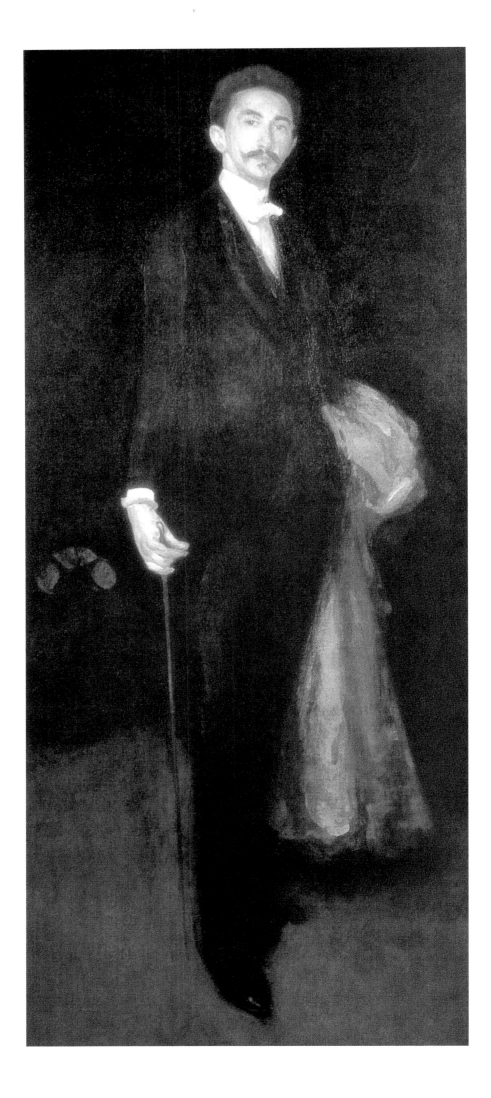

61. *Arrangement in Black and Gold:*
 Robert, Comte de Montesquiou-
 Fezensac. 1891-1894.
 81 x 35 in. (205.7 x 88.8 cm).
 Frick Collection, New York.

Then since Mr. Moore, who had at first been stunned, sought to throw himself at Mr. Whistler, the latter parried each blow as it came with an amazing dexterity. Interfering friends intervened and managed to pull the unfortunate Mr. Moore whose face was as striped as a zebra, away from Mr. Whistler's blows. The latter, with his well-known laugh, accompanied each crack of his stick with the words, "Hawk! Hawk! Hawk!" The artist emerged unruffled, well-disposed, and smiling from this encounter. Even his monocle was still in place, in his right eye. He threw his visiting card at the unfortunate Mr. Moore whose face was criss-crossed with red stripes. The incident ended, to the great satisfaction of the public, who do not like *The Hawk* very much. Naturally, the incident was much talked of in London."

On June 11, 1891, Whistler was once again in Paris. He visited the Champ de Mars gallery and Durand-Ruel, to see paintings by Renoir and Degas. He visited the Salon of the Société Nationale des Beaux-Arts. "It looks as though the 'analytical' colors of the Impressionists have invaded every palette. Even Sannat, whose painting is right next to my sacred Valparaiso is pouring ultramarine into the huge legs of his Spaniard…

Sargent's Boy, which everyone considered a masterpiece, is horrible! Boldini is exhibiting crusts. As for Gandarini (La Gandara), my imitator, I think I can actually perceive some talent there." Those were the painter's opinions of the artists whom Montesquiou cherished. In October, he returned to Paris and dined on the evening of his arrival with Mallarmé at Mery Laurent. It is here that he met J.-K. Huysmans, the writer. The latter notes his impressions. "Whistler was eating pickles and butter all the time. He is pleasant and even simple in his refinement. He is another Rops – he makes a great fuss of me – but is straight with me. He is frail, delicate and with a slender body and sapphire-blue eyes, there is something of the meticulous old maid about him."

As for Oscar Wilde, he was now dining from time to time with Mallarmé. Whistler was unruffled; he merely refrained from putting in an appearance when Wilde was there. "I owe you that much," he confessed to Mallarmé, "although it might even have enlivened your evening." Mallarmé's Tuesday evenings at homes were famous, many artists of all kinds were eager to attend. On Tuesday, November 3, Whistler sent a telegram to Mallarmé just before the poet's soirée to which Wilde had been invited. Camille Mauclair recounts the telegram episode in *Le Soleil des Morts* ("Sun of the Dead"), a roman à clef in which Whistler becomes Mr. Neils Eistiern, a Norwegian painter (Proust would use the same name in the form of Elstir in *A La Recherche du Temps Perdu*). In his *Souvenirs*, Camille Mauclair wrote, "One evening when Wilde was expected, Mallarmé received a telegram at 9:00 p.m. "Wilde is coming over, lock up the silver – Whistler." One can imagine how hard it was to smother one's giggles when a few minutes later, the English aesthete made his grand entrance, an orchid in his buttonhole."

Whistler discovered Geoffroy's article in *Le Gaulois* of Wednesday, November 4, 1891 on the subject of *Portrait of the Artist's Mother*, exhibited at Boussod-Valadon. This was a rare opportunity to introduce one of the masters of contemporary painting and of all time into this museum of modern artists. Toward mid-November, Whistler was in the company of Montesquiou and tried to pump him for the reactions of the powers-that-be as regards his painting. Mallarmé was working hard in Paris with the painter's other friends to ensure that the State acquired a painting.

Whistler was hoping this would happen but insisted that the painting would be sent to the Louvre.

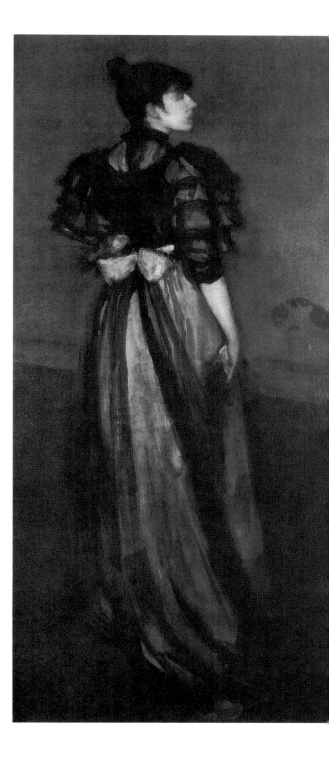

62. *Mother of Pearl and Silver: The Andalusian.* 1888-1900. 76 x 36 in. (191.5 x 89.8 cm). Harris Wittmore Collection, National Gallery of Art, Washington.

119

He wrote, "You understand that for here, it would be the *coup de grâce…* You knows how sweet such an artistic triumph would be for me at this moment in the capital of art! All the suffering of former years in this country, of insult and of ribald misunderstanding, would seem insignificant to me and I would even find a poetic justice in the severe test which an artist must pass before daring to hope for such a reward in his lifetime." Joyant, who was exhibiting *Portrait of the Artist's Mother* and other works by Whistler in Paris at the time was overjoyed. He again made efforts to receive the minister who was to come and view the painting. He was expecting to sell the *Nocturne in Blue and Gold, St. Mark's*. On Saturday, November 21, 1891, the official letter asking to acquire *Portrait of the Artist's Mother* for France reached Whistler while he was working on a portrait of Montesquiou. Montesquiou was present at the time, and shared the couple's joy. Whistler felt himself to be a son of France now that this country "owned his mother." He wrote to Mallarmé, "You know that Montesquiou is here and I am working every day until nightfall on his portrait." The purchase of the painting was widely publicized. *Le Figaro* announced the event on November 27: "I think there will be quite a fight over this acquisition but Whistler is used to the stir that each of his works causes. It will not stop him pursuing the path he has traced for himself. He produces marine landscapes and portraits, or rather impressions of color. He calls a view of Venice *Impression of Green and Yellow*. The portrait of Sarasate which once caused an outcry is called *Impression in Various Blacks* and the portrait of Lady Archibald Campbell which is shown in the Salon under the title *The Woman in a Boa*.

Indiscreetly, I shall tell the story of a still unfinished portrait of Count R… [this was the portrait of Count Robert de Montesquiou, of course] which was to have been called *Impressions in Pearl Gray*, and for which the model had to spend months in London and Brighton, waiting with Whistler for a gray light that never came. Despite his eccentricities, he is a great artist, it ought to be said…" This is not a true representation of events. In November, 1891, Montesquiou came to London for the very purpose and with the agreement of the painter, to have his portrait painted. The two men soon became firm friends. Their refined taste and their aesthetic ideas led them to the same passions – art and beauty. They were both slim, dry-looking and nervous, very touchy about their honor. They were both dandies, making them extremely fussy about their dress. They were very cultivated and had very definite ideas about art so they could engage in deeply interesting conversations. They had met for the first time in London in 1885 while Montesquiou was in England with Jacques-Emile Blanche. Blanche described the painter's studio during their first visit. "When we arrived, Whistler was combing his hair and a young and delightful (intimate) guest was arranging yellow flowers in blue vases in front of the table to create a blue-and-yellow harmony. The servants were completing the table setting with elegant and valuable tableware. The centerpiece was a blue-and-white Japanese bowl in which goldfish were swimming among waterlilies. There was a large table in the center of the room and smaller tables in the corners. At about 1:30 p.m., the guests were presented. There were nothing but lords and ladies, and a few Americans. I was seated opposite a lady in black and yellow, because all the ladies wore something yellow or something blue in order to echo the colors of the dining-room. The food was served buffet-style and consisted of the following: smoked fish, lobster curry, pressed beef, creamed chicken pie, polenta, eggs with saffron, Italian cakes, and Moselle wine cup. The conversation was such as to defy any parody.

63. *The Fortune Teller.* 1892.
Hunterian Art Gallery, Glasgow.

People went into raptures over a flower, a particularly round garden pea was passed around the table on a little dish. After the dinner there was a big reception, the whole of London society passed through the studio. Whistler took me aside and opened whole boxes of drawings and pastels which were pure works of art."

Whistler and Montesquiou got on famously, and the Count asked the artist to paint his portrait. Whistler agreed and went to Paris to do so. The Count organized aesthetic events for him during his stay in the French capital. However, a rumor was circulating that Whistler was having a pernicious influence on Montesquiou.

Goncourt wrote, "Whistler is pumping the life out of his model." The French aesthete acquired the habit of keeping his hair black and wavy,

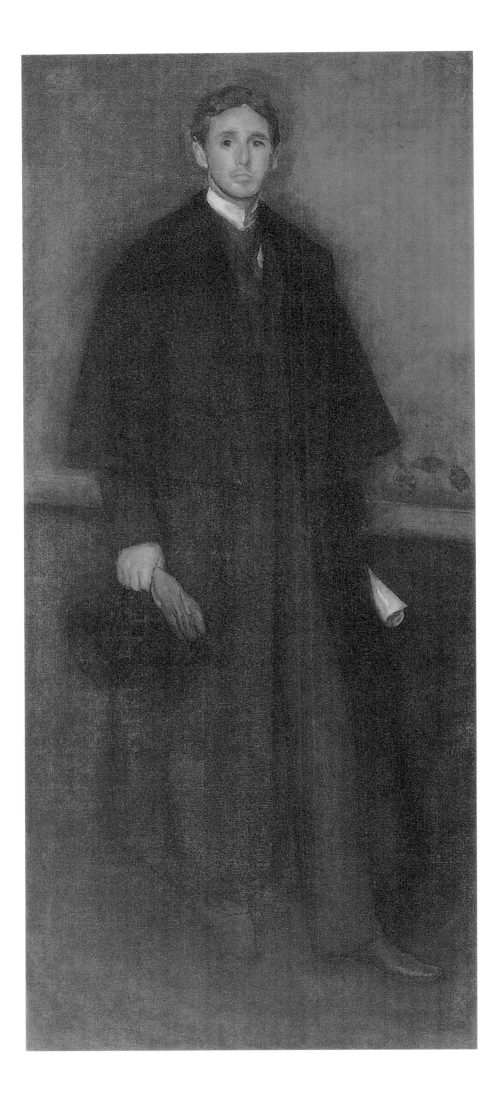

copied the shape of the mustache worn by the painter, and all of 'the gentle art of making enemies' (of which his rift with Jacques-Emile Blanche remained a typical example). When Montesquiou asked why Whistler had never painted the portrait of Lady Grey, the latter replied that he had always found her "too handsome a man."

He would tease the Count about his concessions to worldliness; the Count bought the *Nocturne* entitled *Harmony in Violet and Mauve*. He had already had the opportunity of seeing the painter's other work and recalled his astonishment upon beholding *The White Girl*. Count Robert de Montesquiou found Whistler excessively fascinating and one of the great thinkers of the age. He believed that Whistler's ideals were best expressed in his portraits which captured the sur-natural essence of being. Whistler was able to detect and capture this ultimate and intangible substance, a fleeting emotion forever fixed on the canvas, as if the painter had made off with part of the soul and personality of his model.

In January, 1892, Whistler welcomed Monet to London and presented him to the young painters of the Chelsea Arts Club which had held a banquet for Whistler on December 19 to celebrate the purchase of the portrait of his mother. He continued the portrait of Montesquiou in the studio at Rue Monsieur-le-Prince which La Gandara had placed at his disposal. On December 30, he was decorated with the Legion of Honor a distinction to which he attached considerable significance since it was the reward for thirty years of struggle. He wrote to his wife, "My dear, I can hardly give you an idea of the importance this has over here! They have no idea in England, where they will pretend not to understand all that this signifies."

The newspaper, *Le Temps*, organized a banquet in Whistler's honor, attended by 150 guests. In England, only the *National Observer* took the painter's part and denounced the attitude of the Royal Academy "which has been asleep for half a century. This institution is determined to ignore the very existence of the greatest painter who has ever lived and worked in England."

In March, the Goupil Gallery in London exhibited Whistler's finest paintings, a true retrospective. The catalog of *Nocturnes, Marines and Chevalet Pieces* was compiled in such a way as to teach the art critics a lesson. Each painting was accompanied by a critique. This time, however, the press were almost unanimous in their praise. Whistler had finally become fashionable and would never lack for commissions again. His circle of friends sold their paintings at considerable profits.

A second Salon du Champ de Mars in Paris enabled Whistler to extend his success by exhibiting the portrait of *Lady Meux, Harmony in Gray and Pink* and the *Nocturnes*. In Paris on June 17, 1892, he went to the theater with Mallarmé to the first night of a play by Dujardin, *Le Chevalier Pussé* (The Past Knight). Maurice Denis's set was in the Japanese taste and inspired by Impressionism. Women moved across the stage dressed in simple Liberty print muslins. The performance was acclaimed and Whistler greatly enjoyed himself.

On Tuesday July 7, Goncourt wrote in his diary, "Visited Robert de Montesquiou in the rue Franklin. As I admired an etching by Whistler, Montesquiou told me that he was in the process of making two portraits of him, one in a black suit, with a fur under his arm, the other in a long gray coat with a high collar with a thin necktie showing of a shade which he could not explain but of which his eye would express the ideal color. It is very interesting to hear Montesquiou develop his explanation of Whistler's way of painting, to whom he gave seventeen sittings while he spent a month

64. *Arrangement in Flesh Color and Brown: Portrait of Arthur J. Eddy.* 1894. 82 x 36 in. (210.2 x 93.3 cm). Art Institute of Chicago.

in London. The initial sketch consisted of a frenzied attack on the canvas; one of two hours of feverish activity, from which the whole thing would emerge in outline… Then sittings, long sittings, during which most of the time the painter would bring the paintbrush up to the canvas but would not dare to touch it, and would eventually throw down the brush… sittings at which it seemed to Montesquiou that Whistler was fixing him with all his attention, was sucking the life out of him… and in the end he found himself to be so drained that he experienced a sort of contraction of his whole being but fortunately he had discovered a certain *vin de coca* which restored him from these terrible sessions."

Enthused by the painter's verve, Montesquiou confided in Goncourt how much he admired this man who, he said, "had managed his life in such a way as to obtain the sort of victories in his lifetime from which most people are only able to benefit posthumously." The Count added a few more details about the sittings.

"If this is buzzing, the canvas is not yet happy…" Whistler would complain, and then suddenly shout, "That's it!" The first sessions were frenetic, "He was like a polecat whose cage has just been opened, to such an extent that the furniture needs to be removed so as to prevent the painter from overturning it as he leaps about, and when he draws back, one would say that he was drawing out the essence of the model and transferring it to the canvas without even leaving it time to evaporate or disperse. Look at me once again, an instant, and you will see yourself forever!" Once the painting had come to Paris, Whistler began retouching it.

He wrote to Montesquiou, "The visit was delightful and just at the right time. Everything is going well now. I see what was missing. A few more retouches before giving it the impetus and the perfect finesse which it needs before it can be sure of its future." The painting was created slowly, but once it was finished the Count was satisfied enough to want to exhibit it at the Salon in May 1894.

Whistler replied to him, "You are right, dear poet! I was crazy! It is splendid, a real d'Artagnan, I shall never forgive my unworthy modesty and fear, but what inspiration to have sent for it and just at the right time because an ultimatum arrived from the Champ de Mars, so the Black Knight has been sent over there." As partial payment for the portrait, Montesquiou gave Whistler an antique bed which had been presented to his ancestors by Napoleon. Whistler replied. "Your surprises are like Aladdin's cave – how appropriate – and the splendid gift of the beautiful Empire bed exceeds all the hopes which the desire for friendship could dictate to us or the unrestrained passion of collectors like us…!"

Henceforward, Montesquiou would deliver his lectures in front of the portrait of this Musketeer, this Black Knight. He invited his protégé to take tea with him at the home of the Duke of Aumale at Chantilly or with the delightful Madame de Casa Fuerto, as well as with Madame de Montebello. Montesquiou applauded the caprices and arrogance of his master who used the scandals about him for publicity purposes. He learned from this behavior and would later excel at the same art. For many years, *The Gentle Art of Making Enemies* was his breviary. "Enemies need my nature." For him, friendship was merely a stage leading to the culmination, a feud. He began more and more to take on Whistler's appearance.

His mustache was raised and became pointed, he stopped wearing the suits he had been used to and adopted black or gray Prince of Wales check. He threw back his shoulders and made his gestures more abrupt.

65. *Pink and Silver: La jolie mutine.* 1890.
76 x 35 in. (190.5 x 89.5 cm).
Hunterian Art Gallery, Glasgow.

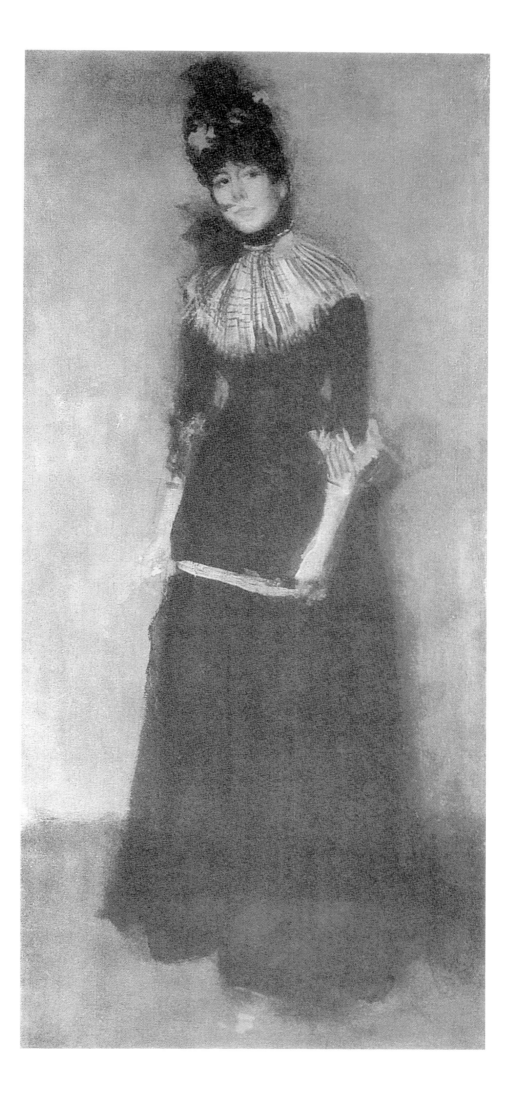

The two men professed the same devotion to beauty. Montesquiou called Whistler, "Dear angelic devil." This religion of beauty was to cause the Count to despise anything unconnected with it; he felt he was an adherent of a great cause. He wrote to Whistler, "Mystery in all its forms being, I believe the thing in the world with which I am on the best terms and far from frightening me, it attracts me even more as I say in a noble epigram at the beginning of one of my poems: 'There is nothing more beautiful, greater or sweeter in life than mysterious things.'" Whistler became a fashionable person. Portraits were commissioned from him and his older works, previously ignored, were snapped up. Private American collectors began buying.

A price of $21,000 was paid for *Nocturne in Black and Gold: The Falling Rocket*. The painter would send packing any so-called patron who pleaded poverty; they were talking to someone who had long suffered from lack of money.

He even saw pictures he had given as gifts resold by their owners. Whistler was anxious to destroy paintings which he did not consider to be good enough, and he confided. "All my life, I have carefully destroyed copper plates, torn up woodcuts, burned canvases, in order to spare future collectors from disappointment. In this way, they do not risk buying worthless items, merely because I signed them." For the first time, Whistler was claimed as an American artist at the Chicago World's Fair; he was awarded a gold medal. He returned to Paris for the opening of the Salon with Robert Ross, Stevenson, and Aubrey Beardsley.

He worked on engravings and tried to create multi-colored woodblock prints of the kind created by the Japanese which yielded bright, clear, fresh colors while the process used in Europe was unable to produce such results. Whistler's studio in Paris was on the seventh floor at 86 rue Notre-Dame-des-Champs. It was a vast room with pink-painted walls.

A midnight blue awning represented a *Nocturne*, and depicted a church, a river and a gold-colored moon. There were two easels and rows of pictures were arranged round the room. It also contained a printing press. Above the studio was a gallery opening on to two rooms, with a large window offering a view over the rooftops of Paris with the Luxembourg Gardens in the foreground, and further away the Pantheon...

Whistler's Parisian apartment was at 110 Rue du Bac, at the end of a vaulted covered walkway and a garden. One entered the hall, then the blue drawing-room with white doors and window-frames. There was a sofa, a few Empire chairs, a grand piano and a table. The floor was covered in blue matting. *Venus* hung on the wall, as did a birdcage containing a white parrot. The focal point of the dining-room was a chandelier representing a fishing net containing seaweed and shells.

Whistler received guests on Sunday afternoons. His visitors included such famous names as Octave Mirbeau, Stéphane Mallarmé, Henri de Regnier, Robert de Montesquiou, Giovanni Boldini, Helleu, Puvis de Chavannes, Fantin-Latour, Alfred Stevens, Aman Jean, Arsène Alexandre, Rodenbach, Duret, Droutet, Henri Oulevey, and members of the French aristocracy. Collectors and British and American artists also came – Walter Gay, A. Harrison, Frederick MacMonnies, E. H. Wuerpit, J. W. Alexander, H. Johnston, John Singer Sargent, and so on... Mrs. Whistler had very little command of French, which did not always make contact easy. The artist would meet British and American art students at the American Art Association in Montparnasse, in a little house where Whistler regularly attended receptions.

66. *Green and Blue: The Dancer.*
Watercolor, 10 x 6 in. (26.6 x 17.2 cm).
Private Collection.

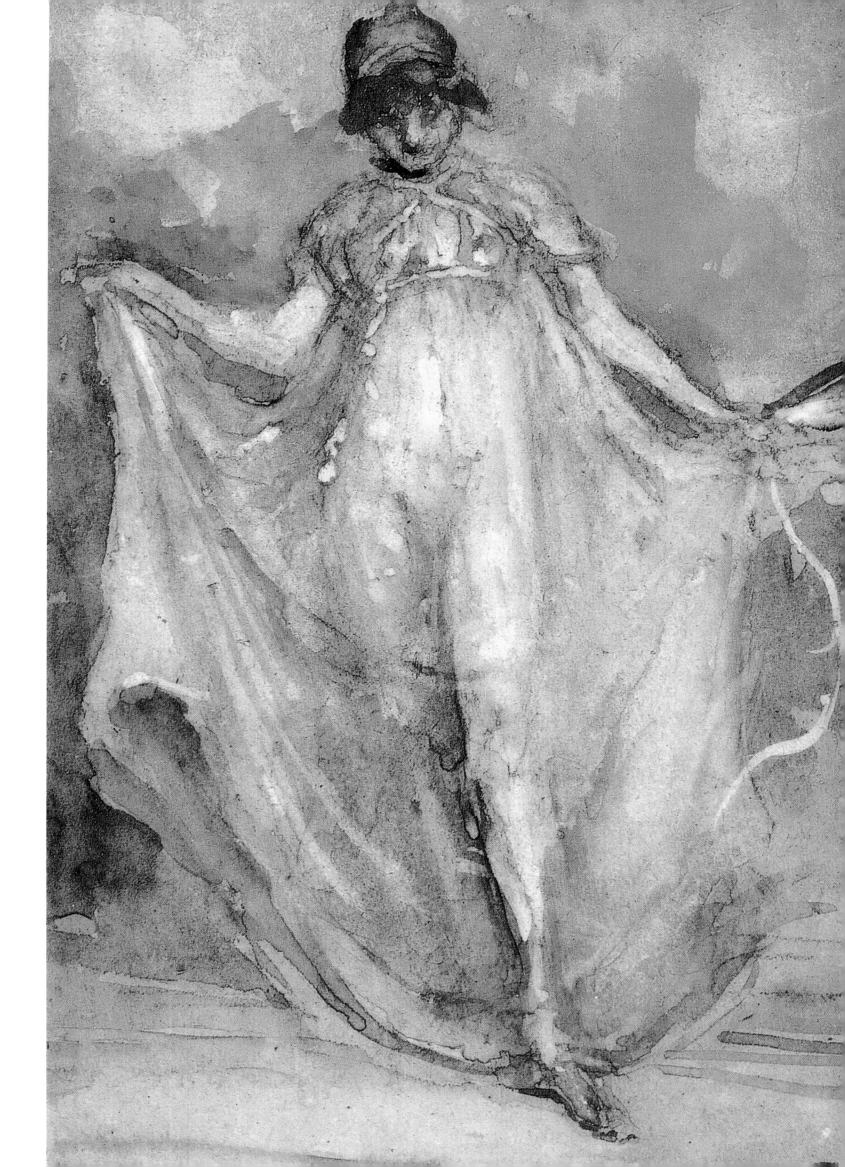

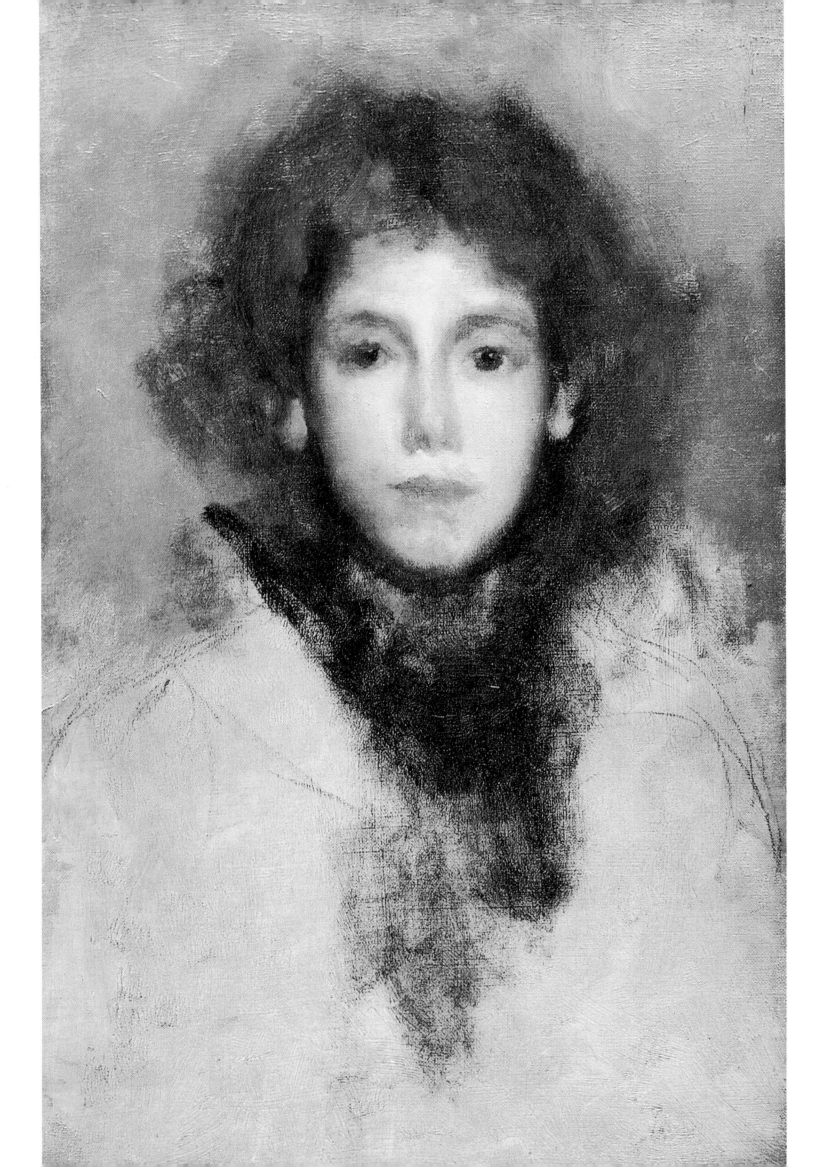

One day, Washington's birthday was being celebrated and after all the speeches had been made, he asked for the floor. He improvised, "In England, people do not yet know what tradition is. An artist can follow his own inspiration. In France, tradition is respected; the French student at least learns which end of the paintbrush to place on the canvas and which end he can put in his mouth. In England, good heavens, it's all a matter of taste!"

In September, 1892, the painter produced a portrait of Mallarmé which, said Rodenbach, fascinated anyone who knew the poet. "Mallarmé is an astonishing likeness, waving his arm and his head bent as he would stand when talking to friends. People who knew him might believe they could hear him speak. Yet the image was caught so fleetingly, it came from the swiftest stroke of a pencil. It was an improvisation and one does not improvise the essence of a human being so swiftly, one must have penetrated deep within him in order to give him such intensity of life and character. The small face which may have been the result of improvisation is nevertheless the result of thorough and prolonged effort. Whistler made Mallarmé, pose for a long time.

He drew swiftly, as required by the concept of the light work he wanted to create but the first images thus obtained before he had penetrated his model seemed to him to be inadequate and he tore them up in order to start over. Mallarmé who did not explain his method clearly had almost given up hope of success when at the last moment Whistler produced a final improvisation. This was perfect and condensed into it all the accumulated observation of the preliminary sketches." (Théodore Duret)

As soon as the Whistlers became Parisians, they would attend Mallarmé's Tuesday evening soirées. On Sundays, Mallarmé would come to Paris versions of the *Ten O'Clock Lectures*. In May, the two friends attended with Claude Debussy and Henri de Régnier the first Parisian performance of Maurice Mataerlinck's symbolist drama *Pelléas et Mélisande*. In July, the couple left for Brittany due to Mrs. Whistler's poor health. In fact, she was suffering from cancer.

Returning to Rue Notre-Dame-des-Champs, James undertook a series of portraits of A. J. Eddy, J. J. Cowan, Miss Williams, and G. Kennedy.

For the full-length portrait of Miss Peck entitled *Harmony in Green and Silver*, Whistler required numerous sittings. Miss Peck is shown in a ballgown with a green coat over her shoulders. At the same time, he began a portrait of Miss Kinsella in Paris; this was completed at the moment when everyone who saw it considered that it was fine as it was and ought not to be touched. But the painter decided otherwise and scraped it off in order to begin again. He obliterated the face and neck simply because he was not able to reproduce the same flesh tint as on the hand.

He painted the portraits of Mrs. Charles Whibley, *The Andalusian: Mother-of-Pearl and Silver, Pink and Gold, The Tulip: Miss Ethel Birnie Philip*, and *Mrs. Walter Sickert, Green and Violet*… The Philadelphia Museum of Art purchased *Woman in A Yellow Buskin, No. 1*.

In 1894, he painted another self-portrait showing himself in a white linen vest. He did drawings of the streets of Paris, contributed to a revival of lithographic techniques and continued his experiments, working from morning until night to complete his commissions. He was sometimes ill-tempered as a result of inaccurate articles written about him. He discovered a magazine article which described him as "Whistler, Painter and Actor." A biography produced and published by New York University quoted as references critics whom Whistler detested.

67. *Little Juniper Bud: Lizzie Willis.* 1896-1897. 20 x 12 in. (51.5 x 31.3 cm). Hunterian Art Gallery, Glasgow.

But the painter was even more preoccupied with the suffering of Mrs. Whistler since their return to London. She had to enter a clinic while honors flowed in and at the time when he least needed them. He was otherwise preoccupied and did not have the heart to work. He was thinking of his "princely residence" in the Rue du Bac and his "dream studio" in the Rue Notre-Dame-des-Champs. Pennsylvania awarded him a gold medal, then the city of Antwerp, Belgium, did likewise.

Two events were to make the year 1894 a particularly bad one for him. Du Maurier, Whistler's old friend, published a novel in which the painter was caricatured in an insulting manner. The second event was to be more consequential.

The novelist George Moore asked Whistler to paint the portrait of the wife of one of his friends, Sir William Eden, for the "special" price of one hundred or one hundred and fifty guineas (between $2,500 and $3,000). Whistler would never paint a portrait for less than fifteen or twenty thousand dollars. However, he eventually agreed to it in February. The sittings began and once the portrait was finished Whistler was very satisfied with it. The painting was shown at the Société Nationale des Beaux-Arts, with the portrait of Montesquiou and was extremely successful. Whistler recounts what happened next.

"Sir William Eden heaped praise and homage upon me… Fine! Gradually, thanks to his amiability, we became closer, we ate at my home, took walks in my garden, etc., very good! Ah! Yet I ought to have been on my guard a little… During the conversations, Sir William talked to me of a French painter who had painted his wife's portrait for nothing but who had managed to persuade him to buy a frame costing three hundred francs out of his own pocket which was rather expensive! Ah! I was rather preoccupied with my painting, that happens to artists, you know and instead of the sketch, the rough drawing, God knows what, that George Moore had asked from me, I had finally produced a portrait, a real portrait, brown and gold, which people called a masterpiece, ah! ah! But let that pass… Once the painting was finished, or nearly so, because there were a few small retouches to be done, it was St. Valentine's Day…

You know that in England, St. Valentine's Day is a big occasion. Presents are exchanged on that day, sometimes quite substantial ones. Oh, yes! Even diamonds, etc. So on that St. Valentine's Day the baronet paid me many compliments again, too many, far too many and took from his pocket a sealed envelope, a large envelope and with a charming air, holding it between his two palms, you know, like that, he said to me, 'Today is St. Valentine's Day, permit me to offer you this little "Valentine"!… But for Heaven's sake, for Heaven's sake, do not open it before you get home, I beg you!'

So we took our leave of each other. Sir William was due to leave for South Africa on safari the following day, so we said our good-byes. Bon voyage! How so! Delighted, etc. Very well!

"Upon my return home, I told the whole story to my wife, who said to me, 'Sir William Eden is a very tactful gentleman who did not want to enjoy your surprise… It must be a lovely present, mustn't it!' We opened the envelope… it contained a letter and a check; the check was for one hundred guineas ($420). The letter read:

'Dear Mr. Whistler,

Herewith your "Valentine" a check to the value of one hundred guineas. The painting will always be of inestimable value to me and will remain in my family as long as legacies last. I shall always remember with pleasure the time

68. *Portrait of Lilian Woakes*. 1890.
21 x 14 in. (53.5 x 35.3 cm).
Phillips Collection, Washington.

130

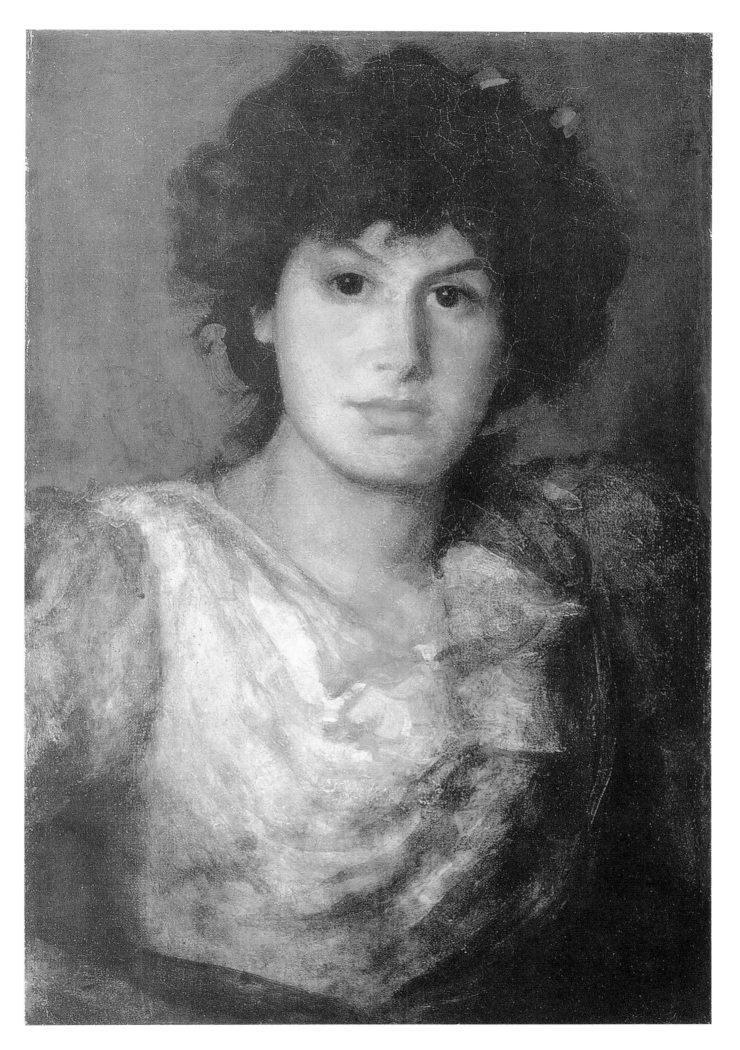

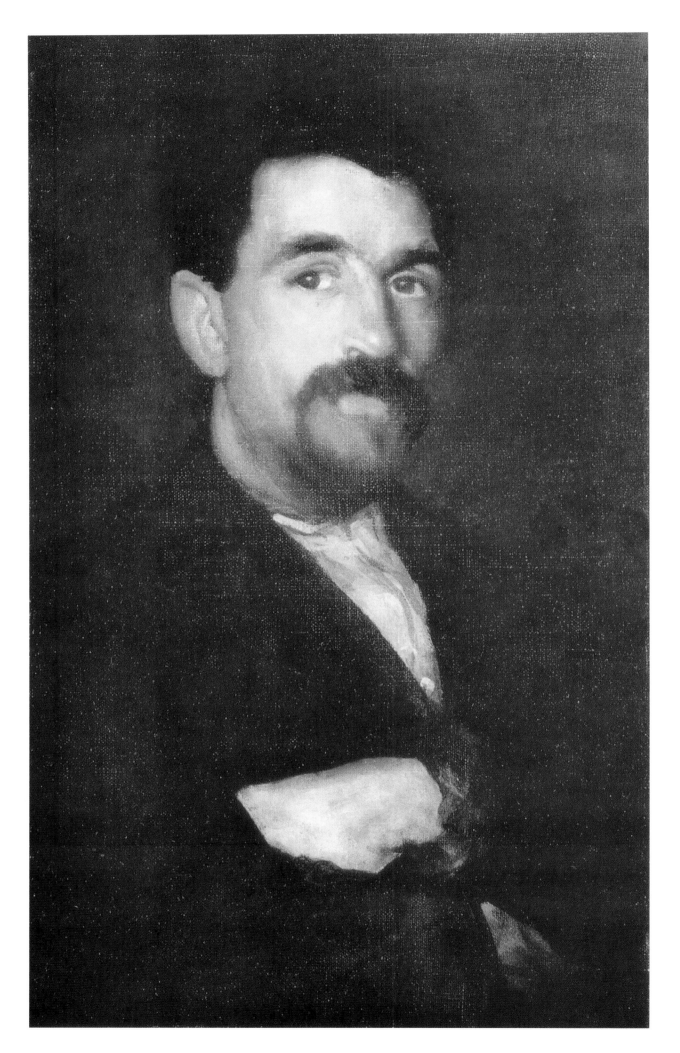

during which it was being created. With my thanks, Yours sincerely, William Eden'"

Reading the letter, Whistler broke into laughter, endless laughter, bent over the back of his armchair in a childlike joy. But he suddenly stopped and said, in a serious tone. "I have been had! That's it, I've been had... A swindle!"

"I immediately took up my pen and wrote to Sir William:

"My dear Sir William, "I have your 'Valentine.' You are really magnificent! And you have won game, set and match! I can only hope that the little painting will become much less worthy of all of us and I am counting on Lady Eden's amiable promise to allow me to add the finishing touches you know about. She has been so brave in playing her part!

With best wishes for your trip, etc.

M.-N Whistler"

"I asked myself", continued Whistler, "Whether he would understand. Well, the next day, he arrived at the house, booted and kitted out like an African hunter. I was delighted! I said to myself: a nice little scene is brewing. And indeed, Sir William said to me, 'I have received a not very nice letter from you.' I was calm and smiling, as suited the occasion. I replied, 'Impossible! I never write such letters!'

'I don't understand...'

'Ah, that's possible. You are not the only person to fail to understand me... But show my letter to your friends at the club, they may be able to explain it to you.'

'You have insulted me...'

'That's another matter... If you find you have been insulted, I am at your disposal.'

'But did we not agree that I would pay you one hundred guineas?'

'No.'

'What do you mean, no? What about his letter written by you 'There is no question of my prices... And because Mr. George Moore spoke to me of one hundred guineas...'

'Excuse me, would you show me that letter, my good sir?'

"I took the letter which he was clutching between his fingers like a precious contract and I read, 'Mr. Moore talked to me of one hundred or one hundred and fifty guineas...'

'Why don't you read it right to the end, eh? And since we are talking "figures" and you force me to bargain, my dear sir, why did you make out you were giving me a generous gift of one hundred guineas, when you really owed me one hundred and fifty, eh?'

'Well, give me back my check for one hundred guineas, I want to give you another for one hundred and fifty...'

'No my dear sir, keep your money, join milady who is waiting for you below in her carriage and bon voyage.'

"Whistler once more broke out into echoing laughter and screwing his monocle back in its place, he continued, 'What do you think of this story? The painting was exhibited at the Salon, it was quite a success, you may recall it. I shall skip the details that followed.

I did not want to give my painting to this man who had played such a dirty trick on me and by exposing myself to a law suit, I wanted everyone to know how Sir William Eden had behaved.

He sent in bailiffs but I indicated to him that I was still holding his hundred guineas at his disposal.

69. *The Blacksmith of Lyme Regis.* 1895.
20 x 12 in. (50.8 x 31.1 cm).
Museum of Fine Arts, Boston.

Finally, I was disgusted and decided to wipe the canvas completely. And since I had another lady's portrait to do (that of Mrs. Males), I started with brown and gold again. I placed the same gold curtain behind my model; I sat her on the same couch; she had a brown dress similar to the other one, the same fur collar and the same sleeve, and took the same pose. The painting would thus henceforward belong to the new model, wouldn't it?"

Mallarmé followed the preparations for the trial and was concerned as to Mrs. Whistler's state of health.

On November 19, it was thought she needed an operation. Whistler begged his brother, William, a doctor, to come to Paris, but the operation did not take place and the painter returned to England with the hope of consulting other specialists. He did not yet know that she was suffering from cancer and that the case was hopeless.

The trial began February 27, 1895. Eden did not appear, but his wife was present. When her attorney asked to see the picture, Whistler refused. He finally produced it and as if by magic, the face of Mrs. Males had replaced that of Lady Eden. On the following day, a stroke of genius came to him. Why not ask Mrs. Males to come to court on Wednesday, when his attorney would show the painting to the whole court?

There would be a "sensation in court," the public would discover the identity of the lady in the brown dress, the one shown in the painting, who had just sat down next to Lady Eden. There could then be no doubt as to the identity of the model. Whistler rushed over to Mrs. Males and explained the whole story to her. He obtained her promise of cooperation, offering her various assurances. Whistler explained the matter to his attorney who decided to make a subtle reference to the lady in his pleadings. The trial was as sensational as the Ruskin trial had been, with the major difference that in 1870 the artist's career was at stake whereas in 1895 his reputation was well-established.

On March 6, the trial resumed and the painting was exhibited, but to the great dismay of the painter, Mrs. Males did not appear in court. Had she taken fright? The case was adjourned for a week. Whistler returned to London to be with his wife. Then he returned to Paris where he organized a dinner with Mirbeau and Mallarmé.

On March 13, the jury returned a verdict against him. He wrote to Jules Huret, "Do you know what the judgement was? To return Sir William Eden his hundred guineas plus interest at 5% of this amount from February, 1894; to pay him another $1000 damages and finally on the pretext that Sir William Eden recognizes the old picture in my new work, minus his wife's head, which is untrue because I scraped it off completely and began afresh, they have condemned me to give Sir William Eden the new portrait I have just painted! I want all painters to know this and let anyone tell me whether a millionaire baronet, who rides to hounds, would not do better to stay in Africa hunting wild animals rather than come into civilized society in this way and speculate in the naiveté of artists!"

The judgement unleashed a flurry of articles in the press. Whistler attacked Sir William Eden, who allowed himself to be interviewed by the *New York Herald*.

In England, his friend Henry Cust gave Whistler carte blanche in the *Pall Mall Gazette* in which he responded to an attorney who had the audacity to approve the judgement of the Paris court. In Paris, he tried to raise funds among Mallarmé's friends. An article by Mirbeau in the *Journal* of March 24 gave him complete satisfaction.

70. *The Jade Necklace.* 1896-1900.
20 x 12 in. (51 x 31.7 cm).
Hunterian Art Gallery, Glasgow.

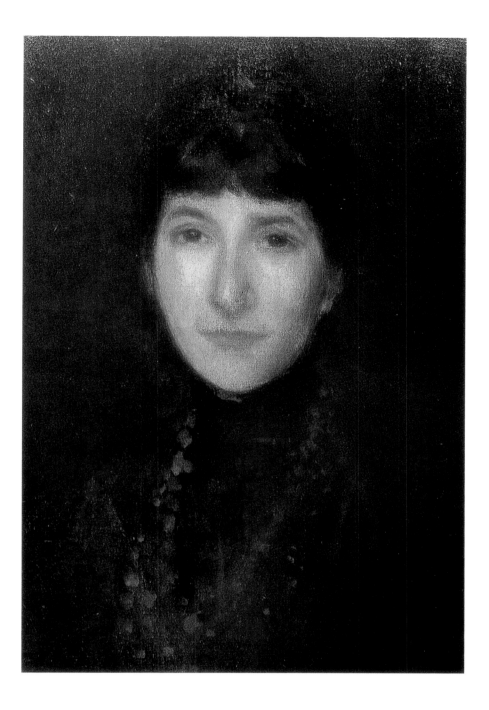

He thanked Mirbeau in the following terms, "The gaiety of the true artist makes the fool mad."

In December, Mallarmé, having heard nothing from the Whistlers, wrote to them: "How are things with you? Around me, there is sometimes a fear that Mrs. Whistler will not recover her good health, although this appears impossible when her strength and grace are known... Best wishes from the bottom of my heart for the happiness of you both, your old, shared friend... My wife, Geneviève, and I deplore the Rue du Bac being empty." Whistler was with his wife at Lyme Regis. He painted *Little Rose of Lyme Regis*, and another portrait of his companion.

Octave Mirbeau, who traveled to England after Mallarmé, wrote to the poet: "But how dreadful English art is! Or at least, what is called English art, because there is no English art; there is only one art common to all countries. Mediocrity! Even Watts, Burne-Jones (oh!), and Crane are pitiful. Rossetti is the only one who will survive...and Millais...But the rest!...

They have nothing to compare them with Manet, Monet, Renoir… They only had one: Whistler, and they let him go." Mallarmé replied to him: "I am just about to tell Whistler your evaluation of English painting which is accurate, and you will hear him laugh." Having no studio for the present, Whistler painted in Sargent's studio. He began a portrait of Mr. S. Pollitt. In the spring he left to install his wife in St. Jude's Cottage, Hampstead Heath, where she died on May 10, 1896. Mallarmé wrote to him, "The mourning which distresses you is ours, we who combined in the same affection and the same admiration of your genius and the woman who had become your smile and your pride.

My poor Whistler, what a mustering of all your forces you will need! Affectionately, Stéphane Mallarmé."

Whistler, in despair, destroyed a large number of pictures including that of Mr. Pollitt, that of the daughter of Mr. R. Barr, that of Mr. Crockett, *The Man in Gray*, the portrait of Mr. Cowan, etc. He repainted two of his self-portraits in black where before they had shown him in a white suit.

He went back to the wandering life, traveling extensively. In the summer of 1896, he visited Rochester, Canterbury, Honfleur, Calais, and traveled through Holland. Then he returned to London.

Alone now (he never had children) he took as his ward his wife's younger sister, Miss Rosalind Birnie Philip and amended his will to make her his sole legatee. He installed her in his apartment in the Rue du Bac and once again began to care for his paintings with maternal affection. In October, 1896, he wrote to Mallarmé the day after the poet held a soirée:

"Alone in your art as I am in mine and in shaking your hand this evening I felt the need to tell you how much I am drawn to you, how sensitive I am to all the intimacies of thought which you have shared with me."

"He would sometimes appear unexpectedly on Tuesday evenings in the humble dining-room-drawing-room, always in evening dress, small, thin, lively, with the air of a worldly Asmodeus with his lock of white hair, oddly curly on his unruly, dark wavy hair which was still black, his monocle, his face tense, his laugh acerbic, and his nervous tics. He was like a character out of Edgar Allan Poe." (Camille Mauclair, *Mallarmé chez Lui*).

In a letter to his wife, Mallarmé wrote, "Last night, there was a fog like a Whistler *Nocturne*, over the forest and the barges, white as the moon." This was the year in which Mallarmé created a portrait of Whistler which was published in the magazine Divagation: "If externally he is, is one asking the wrong question, the man of his painting – on the contrary, at first in the sense that a painting like his own is innate, eternal, renders beauty, and secret; plays with miracles and denies the signatory. A rare gentleman, a prince of something, an artist decidedly indicating that it is he, himself, Whistler, as a whole, just as he paints the whole person…

Of small stature, to anyone who sees him thus, haughtiness equalling his tormented mind, knowledgeable, pretty; he enters into the obsession with his canvases. The time to provoke! The enchanter of a work of mystery as closed as perfection, through which the mob passes even without hostility having understood the need for his presence.

Interrupting all this for some fury of bravura so as to defy the complete silence composing the maintenance, for a little, without losing anything of his grace, explodes in vital sarcasm which aggravates his black evening dress, here the gleaming linen like the laugh whistles and presents contemporaries with the exception to sovereign art, which only they ought to know from the author, the demons who have appeared as the guardians of a genius, a Dragon, fighting, exulting, aesthetic, worldly."

71. *The Little Rose of Lyme Regis.* 1895. 20 x 12 in. (50.8 x 31.1 cm). Museum of Fine Arts, Boston.

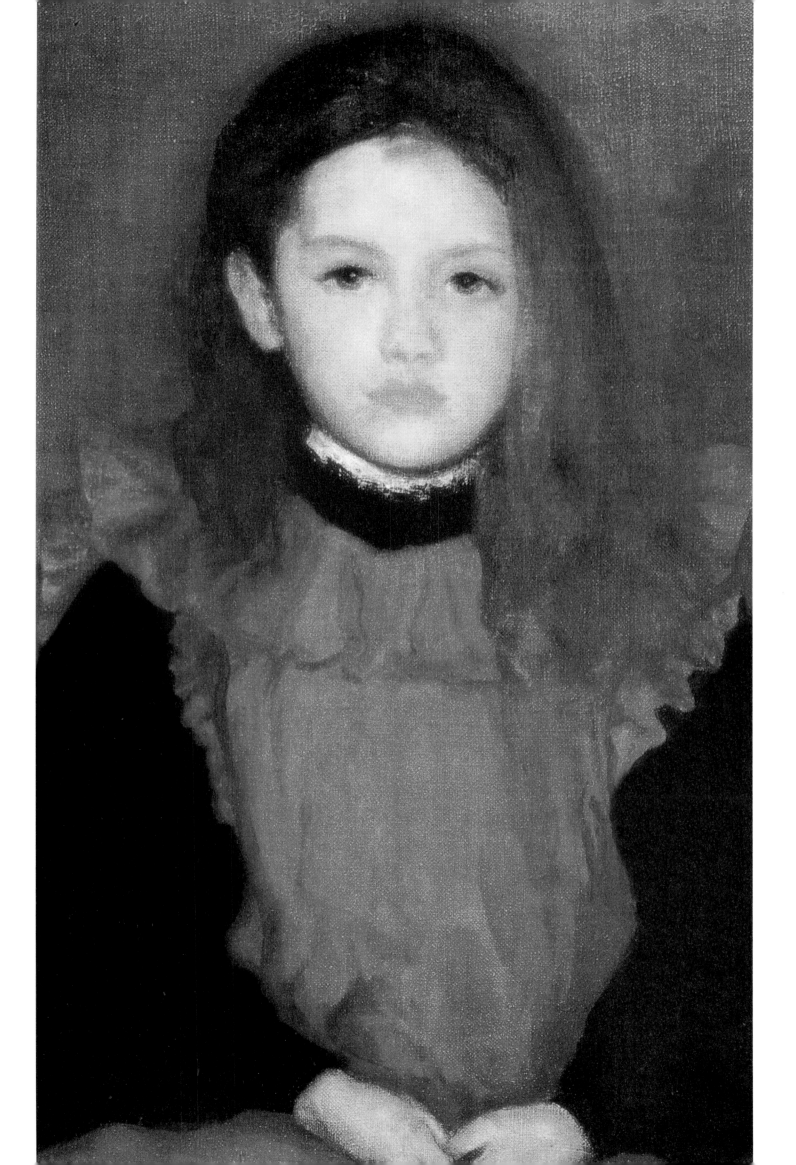

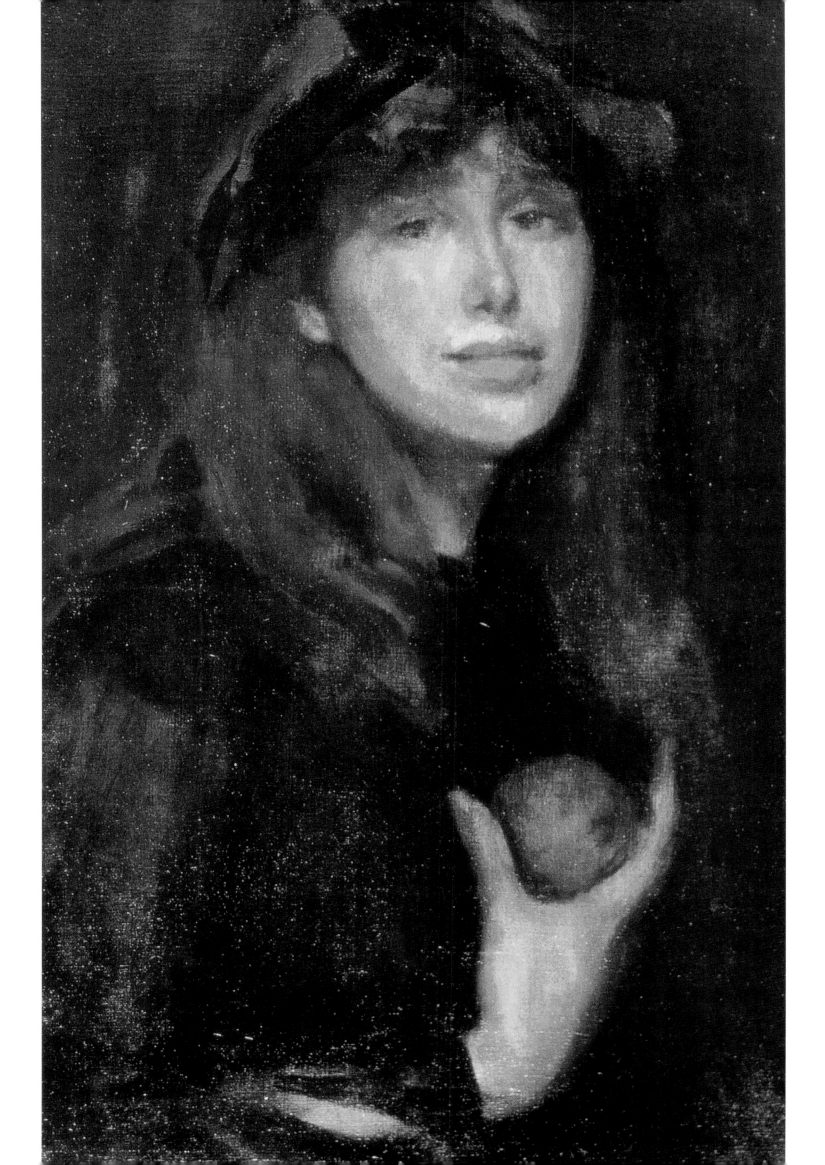

HANDSOME PRAISE (1897-1903)

Through Robert de Montesquiou Whistler met the portraitist Giovanni Boldini in Paris. The two men were wary though admiring of each other, and were interested in each other's work. Whistler was persuaded to sit for a portrait, Montesquiou having played the role of public relations man. The painting was completed in a few sessions, Boldini, being as much of a virtuoso as his sitter, worked fast with great sureness of touch. James frequently fell asleep during the sessions and complained when he awoke. The painting was a great success and was shown at the Universal Exposition of 1900.

Whistler did not like it, however, no more than he liked Helleu's drypoint. "I hope I don't look like that!" The portrait and the drypoint were very good likenesses, full of life and movement. The artist has a devilish air with his arched eyebrows and strangely elongated fingers. One day when he was asleep, Boldini created a drypoint on zinc.

James' difficult nature made him into an unusual and provocative character. During a conversation about the "pompiers," the French establishment painters, he interjected, "Their works may be finished but they have certainly not been started." Marcel Schwob reported that while visiting Alphonse Daudet's house at Champrosay, Whistler pretended ignorance by asking Francis Jourdain, himself a "pompier," for explanations about the Impressionists. "There's someone called – Monet or Mounet, something like that, and Pissa… Pissora…" "Pissarro, Camille Pissarro," naively replied Schwob. "Yes, that must be it. Pizarro, that's it." While shuttling between Paris and London, Whistler produced the commissioned portraits of Mr. and Mrs. Vanderbilt, Miss Kinsella, Miss Birnie Philip, Mr. Elwell and Geneviève Mallarmé. He established a great friendship with the dealer E. G. Kennedy, a relationship which was originally of a business nature, since Kennedy represented Whistler's interests in America. During a trip to France, he inquired about a little store which had attracted him and which he wanted to paint. On November 17, the appeals procedure in the Eden case opened. The advocate-general, the judge, completely overturned the previous judgement and ruled in favor of Whistler who remained the owner of the controversial portrait on condition that it remained unrecognizable as the portrait of the original model. In any event, the affair remained an inexhaustible source of argument for the pro- and anti-Whistler factions. Once judgement had been delivered, Whistler prepared a book about his encounters with Eden. The proofs were never out of his pocket, so eager was he, as he put it, "to make history." The book was called *The Baronet and the Butterfly* and was published on May 13, 1899 but was a flop. The affair caused the painter to think again about the middlemen who came

72. *Dorothy Seton, a Daughter of Eve.*
1903. 20 x 12 in. (51.7 x 31.8 cm).
Hunterian Art Gallery, Glasgow.

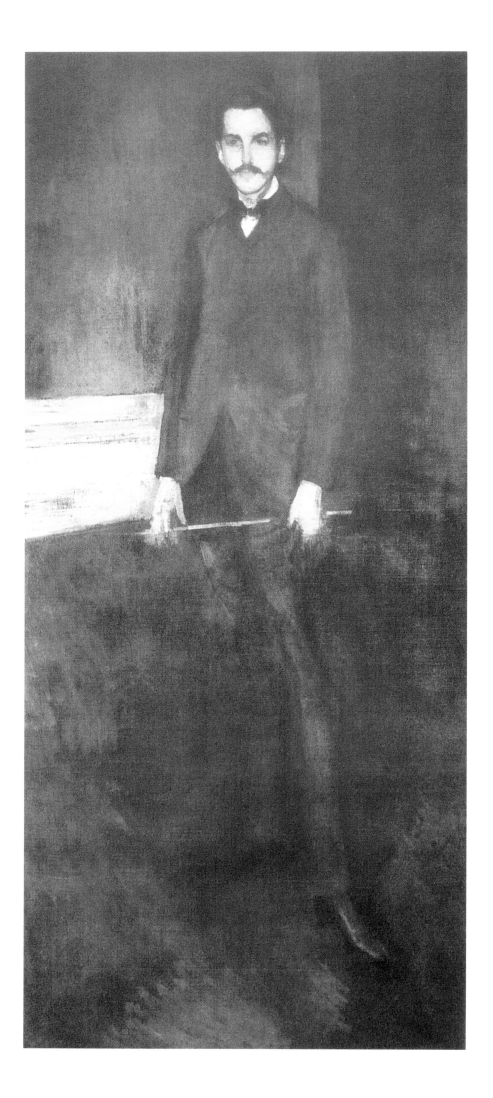

between him and his clients and enriched themselves at his expense. He therefore created the Butterfly Company at the end of 1897. He rented premises in London, near Manchester Square, which he decorated as a gallery. But since he was so often away, the store was closed for three-quarters of the time, and there were no precise opening hours. Curious visitors streamed into his studio, causing a distraction, but he was not a man to permit himself to be incommoded in this way. A critic once wrote announcing an imminent visit without leaving him the time to reply. Upon arriving at the studio, he found the door locked. He heard Whistler whistling behind it, to make the point that the owner was, in fact, at home. The two apartments in Paris were very bad for Whistler's health. The studio in the Rue Notre-Dame-des-Champs forced the painter to negotiate six flights of stairs although he had a weak heart. The Rue du Bac apartment was damp, and Whistler caught easily cold. He had three attacks of influenza that winter. "I am tired," he said, "Me, who has never known fatigue." He then had a severe attack of tonsillitis which left him unable to speak, until someone he did not like was announced as a visitor, when he found the strength to shout, "Let him go to the devil!" Weakened, rejecting the idea of death, Whistler launched himself into more and more projects and continued, as he said, "Like an old nag who can keep going while he is in harness, but as soon as he is unhitched he collapses."

In 1898, Whistler created a new, full-length self-portrait in which he shows himself wearing a heavy overcoat.

The painting was shown at the 1900 exhibition under the title *Gold and Brown: Self Portrait*. At the same time, Marian Vaughan, a beautiful American, began to pose for him. The painter also started a very important series of paintings of children, which were half-length. Leaving his Paris studio one fine day in the company of Mrs. Clifford Adams, Whistler spied a group of children playing. "Let me look at them. You know, I love children." The painter entered a new phase in his career, the third after that of the *Nocturnes* and the full-length portraits. He organized an international exhibition which was open to all artists and was even prepared to allow members of the Royal Academy or any other such institutions to belong to his association. A leaflet was circulated announcing "exhibitions in London of the most noble of the modern arts…"

Whistler's fame was worldwide, and most of the members of the International Society of Sculptors, Painters and Gravers found it perfectly natural for him to assume the presidency. Many painters had been influenced by him, and Whistlerisms had become popular expressions used in artistic circles (including those of the critics) to define painting. Numerous Impressionist, Decadent, and Symbolist schools were now emerging, beside whom Whistler appeared a traditionalist. The International Society was inaugurated in a favorable climate with the support of the most promising artists, and Whistler took it very seriously. "Only Napoleon and I are able to do things like this," he claimed.

The first exhibition was held in London in opulent surroundings featuring the Society's official seal designed by its president. It included works by Manet, Degas, Monet, Knopf, van Thoroop, Aman Jean, Fantin-Latour, von Stuck, Renoir, and Puvis de Chavannes…

Whistler's contributions were *At the Piano, La Princesse du Pays de Porcelaine, Rosa Corder, Brown and Gold: The Philosopher, The Little Blue Bonnet,* and a self-portrait. A place was reserved for the drawings of Aubrey Beardsley who had just died.

73. *Portrait of George W. Vanderbilt.* 1897-1903. 80 x 37 in. (208.6 x 91.1 cm). National Gallery of Art, Washington.

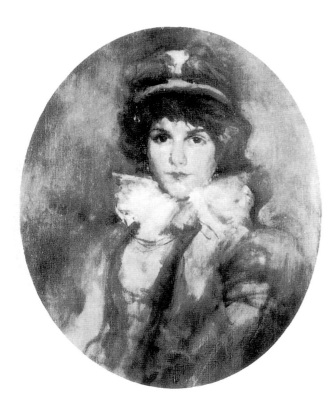

After the exhibition, Whistler went to Paris, where he invited Mallarmé to visit his studio with Duret to show them the Vanderbilt portrait and his self-portrait and to talk about Renoir. Whistler played a major role in the recognition of the French painters in America by showing their work in the exhibitions of the International Society of Sculptors, Painters and Gravers. It came as a terrible shock when only a few hours later, he received a telegram from Mallarmé's daughter, "Oh, dear Mr. Whistler, father died this morning." – G. M. Whistler replied, "I weep with you both – inconsolably! My Mallarmé! You know how much I loved him!"

The artist began a new series of nudes on large canvases. He was particularly satisfied with the first one, entitled *Phryne the Superb: Builder of Temples*, which was exhibited at the International Society in 1901 and at the Paris Salon in 1902. Whistler intended to produce a series, which would include an Eve, an Odalisque, a Bathsheba and a Danaë. At the same time he was working on a series of pastels on gray paper showing a woman in various attitudes – dancing, reading, playing with a fan, bent over a large bowl, drinking a cup of tea, and always clothed in transparent draperies. It can be seen how prolific the artist still was, despite his numerous preoccupations.

Now that he was at the peak of his career, he found it easier to obtain the desired color harmony. "Finally, I am beginning to understand," he said. On returning to London, he made comments on the Spanish-American War, siding with Spain. The price of his canvases was rising constantly and they were now being exploited by speculators. Paintings appeared at auctions and dealers which were "attributed" to Whistler, and people sent canvases to the artist to get him to sign them. As soon as he became aware of a forgery being offered for sale, he tried to stop it. Whenever a forgery was sent to him, he would keep the painting. In Paris, one of his models, Carmen Rossi, had the idea of starting a school of painting.

She announced the creation of the Whistler Academy in the press, but Whistler himself soon corrected her by declaring that his "patroness" was funding a studio at which he undertook to teach his method of painting and to design the premises (a two-story house with a little garden in the Passage Stanislas). The school finally took the name of the Carmen Academy. Students flocked to it from many countries. Miss Inez Bate, one of the first, became Whistler's star student. At his encouragement, she wrote an essay about the studio and his teaching methods. The artist assured students from the outset that he wanted them to behave impeccably within the school confines. There was to be no singing, smoking, or decorating the walls (sic); men and women were separated and taught in separate classes. On Christmas Day, he aroused the interest of his students by allowing them to visit his studio. He displayed his *Propositions* in the school, of which the following is an extract:

"Proposition No. 2: A picture is finished when all trace of the means used to bring about the end has disappeared.

To say of a picture, as is often said in its praise, that it shows great and earnest labor, is to say that it is incomplete and unfit for view… for work alone will efface the footsteps of the work.

The work of the master reeks not of the sweat of the brow – suggests no effort – and is finished from its beginning.

The masterpiece should appear as the flower to the painter – perfect in its bud as in its bloom – with no reason to explain its presence – no mission to fulfill – a joy to the artist – a delusion to the philanthropist –

a puzzle to the botanist – an accident of sentiment and alliteration to the literary man."

Whistler considered Miss Bate to be a talented artist and permitted her to teach his methods to the Academy in 1899. He exhibited in Russia, then took a trip to Italy. In 1900, the Carmen Academy moved to the Boulevard Montparnasse. The master was absent, because his brother, Dr. William Whistler, had just died and the artist himself was sick and was forced to end the year recovering in the South of France. Consequently, students gradually began to drift away from the Academy.

Soon, all that was left were two students, and the studio closed for lack of support. "His method," wrote Miss Bate, "was designed to obtain perfection in the preparation of the palette. Before the brush touched the canvas, the artist had to have all the elements necessary on his palette in order to paint the canvas."

Whistler advised using small oval palettes which were easier to hold and were better for arranging the colors. One had to start by putting abundant amounts of white at the top center. On the left, there should be a series of colors starting with yellow ocher, then Sienna, umber, cobalt blue, and mineral blue; on the right vermillion, Venetian red, Indian red and black. Sometimes, when the color scheme of a canvas seemed to require it, burnt Sienna would be interposed between the Venetian red and the Indian red; but in general he insisted on arranging the colors as above.

Suitable colors were then mixed in order to obtain flesh tones, which were spread over the center of the palette toward the top.

A thick band of black was added along the bottom edge to show that this was the darkest shadow possible.

Between the flesh color and the black, the pure colors were to be mixed in order of intensity so as to obtain in advance all the tones which would be required. A range of tones were created on the right-hand side of the palette which would be used in the main subject of the painting, the background coloring being prepared with the same care on the left-hand side. Many brushes were used, each being reserved for one of the dominant colors so that each time the range of tones had been prepared, there was nothing to delay the colors being applied directly into the canvas.

Whistler would tell his student, "I am not looking for an obstacle to the development of your originality; I am simply putting into your hands the safest means with which to express your tendencies.

If you want to understand my method, you can continue to see Nature in your own way."

Each student, while preparing his or her palette according to the Whistler method, was given the freedom to vary the importance of the various colors. "I am not here to teach you art," he would say to them, "That is something that one learns on one's own or that one never learns!

But want to show you how one can use paint and paintbrushes scientifically." He insisted on a single point, the one essential: one must start painting a canvas only when there remained nothing further to do on the palette.

With Whistler, one learned to look at the model with the same eye as a sculptor; one modeled on the canvas as one models in clay; one used a paintbrush as one used a chisel, to create the minutest differences in tone which are nothing but differences in shape. But according to Whistler, it was preferable to first deal with the basic element of a face and not to try and reproduce the thousand changes of color which the eye perceives.

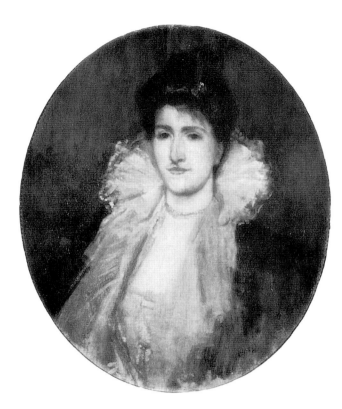

75. *Ivory and Gold: Portrait of Mrs. Vanderbilt.* 1899-1902. 26 x 21 in. (66 x 54.6 cm). Private Collection, U.S.A.

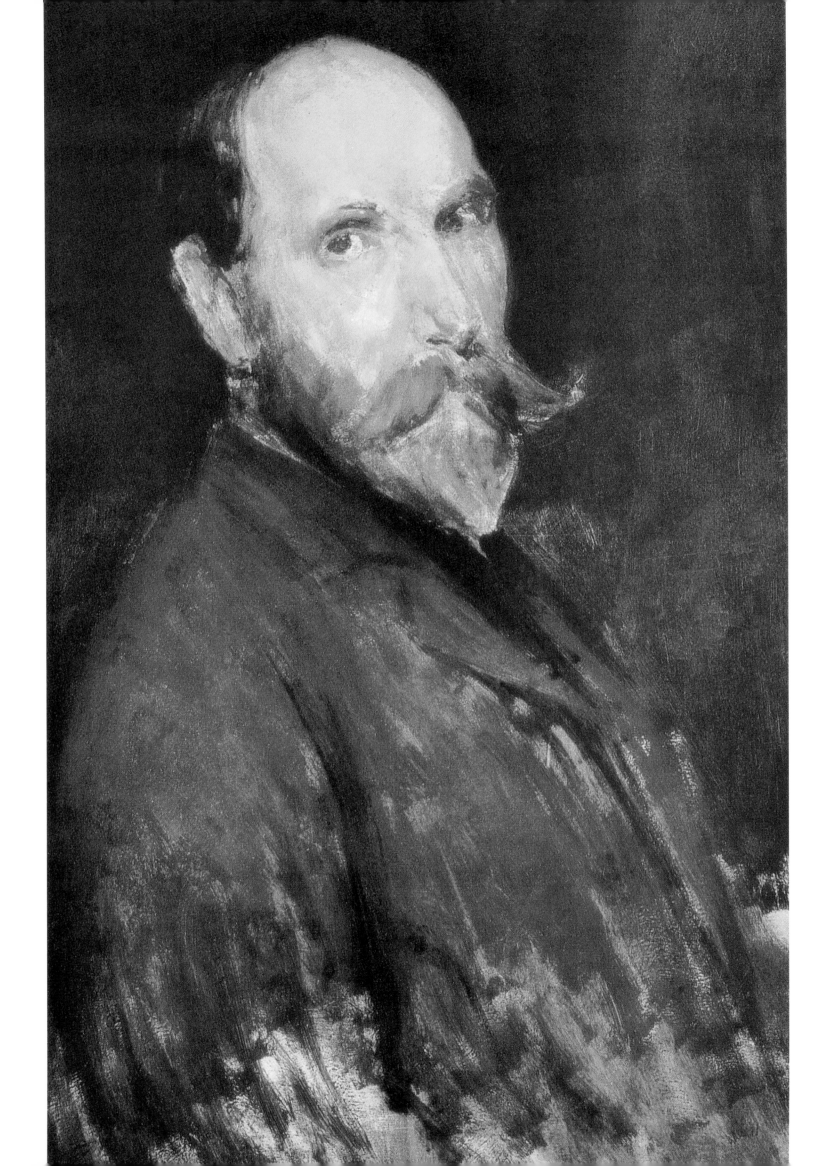

The main thing is to give the impression of the reality of an object placed in its own atmosphere. A painting was of no interest if the image it presented to the eyes was lifeless, despite the bright and brilliant color scheme. That is why Whistler recommended painting the background with great care; only the background could give the main subject the character of reality. For the same reason, he insisted that all the various shades of shadow were very precisely reproduced; it is the shadow which more or less determines the lighting of a face which thus gives it the same necessary relief. "An artist is recognized by they way he paints in depth," Whistler would say.

No studio at the time had a master who would discourse so learnedly on the subject. Whistler wanted to return to the techniques and teaching of the Old Masters. After two years at the Carmen Academy, many of the students had had the time to familiarize themselves with the artist's technique.

For the Universal Exposition in Paris, the director of the American section, John M. Caldwell, wrote a letter to the artist, who was then aged 70, informing him that he was expected "at four thirty precisely." Whistler replied politely that he could not oblige because he had never gone anywhere "at four thirty precisely." It sounded like trouble was brewing once more. Yet when the two men met, everything turned out fine. Mr. Caldwell was extremely respectful to Whistler.

The American section's galleries were magnificent and he was very proud to exhibit *The Andalusian, Harmony in Black: Mrs. Charles Whibley*, his self-portrait in black and gold, *The Little Girl in White* and some etchings. He was awarded a Grand Prix for engraving and a Grand Prix for painting. He was now quite wealthy and had to pay for the upkeep of his two rooms at the Hôtel Chatham in Paris, his room at Garland's Hotel in London, his house in the Rue du Bac, two studios, one in the Rue Notre-Dame-des-Champs and the other in Fitzroy Street, as well as the premises of the Butterfly Company.

Whistler called them "my collection of castles and pieds-à-terre." As former West Point cadet, he commented upon the Boer War, taking the side of the Boers against the British. These sympathies for the Boers are quite understandable; their desperate struggle against the encroachment of the British Empire were so reminiscent of his own struggle against the narrow-mindedness of the British public.

He constantly denied being English, "I do not have a drop of Anglo-Saxon blood in my veins." Yet he loved London and could never do without it (he once confided in Sidney Starr that the only landscape which interested him was that of London.)

This was where most of his friends lived but he had no sympathy for a nation which had rather seriously ill-treated him.

Ever since he had become famous, he enjoyed observing frequently that all his models were American citizens. He retained a deep-seated grudge against the English, analyzed their defects, always using satire to make sure his gibes hit home. When European diplomats were massacred in China and the Europeans and the Americans cried vengeance, Whistler took the side of the ancient civilization, "If Europe and America satisfy their so-called demand for satisfaction of their outraged honor by breaking a single piece of Chinese porcelain it would be against the natural order of things!" That summer, it was very hot in London in July. Whistler suffered from the heat but fooled his entourage by seeming to be in good health.

76. *Private Charles L. Freer.* 1902-1903. 28 3/8 x 23 in. (51.8 x 31.7 cm). Freer Gallery of Art, Washington.

He took the train to spend a few days in the countryside north of London, at Amersham, but soon returned. "My, how detestable the countryside is!" He then rented a house near Dublin with Mrs. Birnie Philip. Then he left for Holland with a friend, Mr. Elwell.

He stayed a week at the seaside in Domburg and fell in love with this little village with its red roofs beside the sand dunes, the large white beach, under a blue sky which he preferred to the skies of Italy. He produced a few watercolors, then left to spend ten days in Ireland, where the weather was bad throughout his stay.

In October 1900, Whistler's health deteriorated noticeably and he quite often began to feel tired for no reason. An article in the *Saturday Review* published a report of the paintings exhibited at the Universal Exposition in Paris, but hardly mentioned his own works at all. Whistler was so disgusted that he did not want to spend the winter in London and sailed for Gibraltar with Mrs. Birnie Philip. But he was due for a disappointment upon arrival at Tangiers, where an icy wind made him fear for his health, and when he got to Algiers it was raining.

When he returned to Marseille, it was snowing and he had to remain in his hotel room for quite some time.

The doctor advised him to go to Corsica where he promised the weather would be fine. He sailed alone for Ajaccio, enchanted at the prospect of visiting "Napoleon's island."

Unfortunately, here again he was greeted with bad weather. His friend, the publisher William Heinemann, joined him soon afterward, in response to the distress signals from the painter who wrote to him to tell him how bored he was on his own, without being able to go out. The two friends played dominos as a distraction, Whistler cheating shamelessly. At this time the City of Dresden awarded Whistler a gold medal and unanimously elected him a member of the Royal Academy of Art.

After another series of trips, Whistler returned to London in 1901 and went to live with Mrs. Birnie Philip and her daughter, then in April, he bought a house in Chelsea. He worked very discreetly, none of his friends knew what he was up to.

One day, he invited Pennell over and installed him in a room adjoining the studio; he went back to work and talked to him in a loud voice through the doorway. When Rodin came to London and the whole town was bestowing honors upon him, the sculptor visited with Whistler.

"It was a delightful meal. Rodin was a wonderful guest, and yet... Before the arrival of the others, I was careful to remove any trace of my work. I had turned all the canvases to face the wall; none of my paintings were on view. Yet, not once, after the meal, did Rodin ask to see any of my work! It is not that I am so eager to show something to Rodin; but from a man of such worth, this surprised me!" In fact, Rodin did not ask out of politeness, he had the highest regard for the painter's work.

Whistler worked on the portraits of Miss Birnie Philip and Miss Kinsella, a *Venus*, and several portraits of children.

On June 17, Charles L. Freer, the philanthropist, came to London and took a trip to Holland with the painter. Freer increased his knowledge of the painter's work by discussing it with him. Freer founded the art museum in Washington, D. C. which has the largest collection of Whistler paintings anywhere in the world. The artist helped to establish the museum and profoundly influenced Freer's taste when it came to other paintings and oriental art objects. Whistler had been introduced to him by

77. *The Little Red Glove.* 1896-1902.
20 x 12 in. (51.3 x 31.5 cm).
Freer Gallery of Art, Washington.

a Mr. Mansfield, another collector, in 1890. Freer spent time with modern artists and had the pick of the best works. He first built up a wonderful collection of Japanese pottery and engraving. This was another question of taste which the two men shared and which brought them closer together. In 1900, Freer's tastes had developed considerably.

He was no longer interested in exclusively American artists, but concentrated on Whistler's work until his death. The last item he purchased was *Nocturne: Cremorne Gardens No. 3* which he acquired in August, 1919 a month before his death. Freer spent a quarter of his fortune on American art, and most of this money was devoted to his Whistler collection.

At first, his interest in the artist's paintings came from a desire to improve the decoration of the mansion he had built in Detroit in 1892. He wanted his collection to become a museum. On July 9, 1899, Whistler wrote to him: "I think I can tell you without the slightest chance of a letter being misunderstood that I want you to have a great Whistler collection, perhaps *the* collection." In 1906, an article appearing in a Washington newspaper mentioned that Whistler's collaboration with Freer was no longer a secret to anyone. "For the past ten years, Mr. Freer has been trying to discover how his art collection could best be presented to the American public.

The problem has frequently been discussed with Whistler." The four oil paintings which Freer had bought in 1901, three of which were purchased with the direct help of the artist, were a good omen as to Freer's desire to present a complete sample of the painter's work. When he was negotiating the purchase of the third painting, *Nocturne in Blue and Silver: Bognor*, Freer wrote, "This is a painting which I must have in order to help me balance my collection of paintings." Freer had engravings by Whistler before they ever met.

He really began his collection with his purchase of the second Venice series under the nose of Mansfield, the other major collector of Whistlers. The first purchase of a painting was of *Gray and Silver* in 1889. Freer once said that the error of collectors was to spend the first ten years of their time in buying minor works and spending the rest of their lives trying to get rid of them.

When Whistler and Freer arrived in The Hague, the painter fell ill and Freer decided to stay with him. He informed Mrs. Whibley and Miss Birnie Philip who came over to join them. A zealous reporter, smelling a scoop, telegraphed a message to the newspapers announcing that the painter was very sick. The *Morning Post* published an article that read more like an obituary. The painter sent a letter to the newspaper informing it that it could put the article back in the library "but keep it by, the header already set, and the obituary up to the minute." When Freer left, Heinemann came to stay with the artist. The Dutch painters Mesdag, Israëls, and Van s'Gravesande paid visits to their convalescent fellow artist. Van s'Gravesande wrote, "I like him a lot. Whistler, despite his 'quarreling' with everyone was 'a good old boy' and very charming to his colleagues. I spent several days with him, twenty years ago, at Dordrecht. We made sketches and went for walks by the water… I have always retained a happy memory. One cannot imagine a more joyful, amiable companion unpretentious, enthusiastic, yet a hard worker without equal." James decided to go and stay with Elisabeth Pennell in Amsterdam. He wanted to see the Rijksmuseum, so as to contemplate the Rembrandts and his own painting, *Effie Deans*, which he had not seen since it had been acquired by the

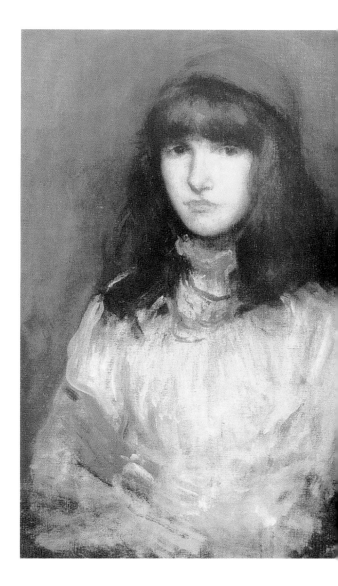

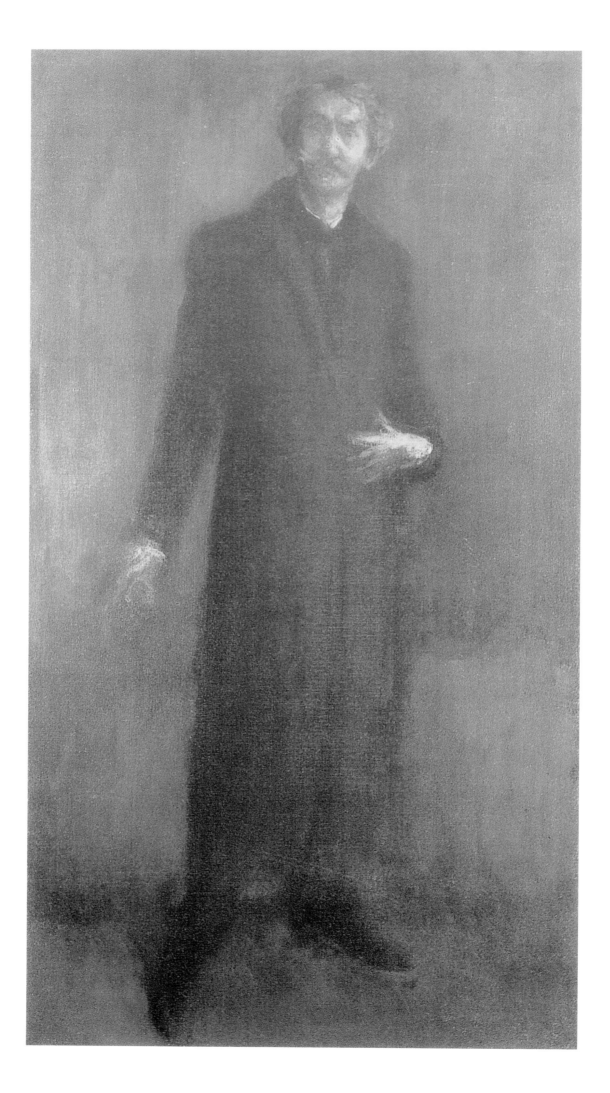

museum. Upon returning to London, Whistler came under doctor's orders, being forbidden to climb stairs. Miss Birnie Philip stayed with him during the winter and spring of 1902. The house was partially unoccupied, the hall was full of trunks, and the artist walked around in an old topcoat.

On bad days, he could not walk and remained in bed. He became fond of his pet white cat which had kittens, and Whistler would spend hours playing with them as with children. When he found the strength, he asked for a model. The painting he produced was given the title *A Daughter of Eve*. The artist paced the room with his friend and autobiographer, Joseph Pennell, holding him by the arm and telling him, "Well, Joseph, how long do you think it took me to do that?... I completed it in two hours, this very morning," he added, without giving him the time to reply.

One of the things about Whistler which people found scandalous was the speed at which he pretended to produce a painting.

In fact, his painting was as swift as the workings of his mind, and it was the technique he employed which enabled him to achieve such rapid results. Andrew McLaren Young understood this only too well, when he wrote, "Painting is not an abstract construction, it derives from what one feels through what one sees, that is to say that it is an art which passes through the fine-tooth comb of sensitivity. His painting is moving, alive all nuance, impetus, fervor."

Whistler began work on a painting of Lady Heinemann. A few sittings would have enabled him to finish the portrait but unfortunately, they never happened.

An American, Mr. Canfield, bought his portrait, *Rosa Corder*. Before he let the painting go, he called in his friends and wiping the painting with his handkerchief, repeated proudly, "Huh? It's beautiful, isn't it?" Mr. Canfield posed for his portrait entitled *His Reverence,* and Whistler expressed a great friendship for him which was as deep as it was inexplicable, saying that "he was the only man in my studio who has never committed a faux pas."

In New York, people were surprised at this friendship because Canfield had a bad reputation (he managed gaming houses). The painter was also visited by art dealers. David Kennedy brought him the collection of his etchings assembled by a Mr. MacGregor, and Whistler bought it back. The painter sorted out what was sent to him from his Paris studio and destroyed whatever displeased him.

He no longer attended the meetings of the International Society of Painters, Sculptors and Gravers due to his poor health but demanded detailed reports. For the annual dinner he gave advice which went as far as recommending a seasoning for the salad! The University of Glasgow bestowed an honorary doctorate of laws upon him. His joy was cut short by his concern that so many publications were writing articles that looked back on his life. A new disappointment arrived from France. Without having consulted Whistler, Count Robert de Montesquiou had sold his portrait by Whistler to Mr. Canfield who was touring Europe in order to amass all the Whistlers on which he could lay his hands. It was a shock for the artist. He could not understand it, the portrait had been the Count's pride and joy, and Whistler had been his aesthetic guide. It seemed to him that Montesquiou was denying all this; in fact, Canfield had seduced the Count by mentioning an incredibly large amount of money. What afflicted the artist was to think that the person who had sold the painting was "a descendant of one of the greatest families of the

78. *Brown and Gold.* 1895-1900.
38 1/8 x 20 in. (95.8 x 51.5 cm).
Hunterian Art Gallery, Glasgow.

French nobility […] Sometimes events occur which seem to deny all your beliefs and part of your past."

Montesquiou had devoted his lectures to Whistler. His aesthetic beliefs were in reference to the artist. This disavowal seemed to be more than treachery. Later, Proust would remember the way in which Montesquiou had spoken to him of Whistler and how he would constantly refer to the painter. In *Remembrance of Things Past*, Charlus is the incarnation of Montesquiou and in *Sodom and Gomorrah*, Charlus tells the narrator, "Look […] as Whistler would say, the moment is ripe for the bourgeois to come into his own (perhaps he wanted to interpret this as amour-propre) and when it is right to begin to look. But you do not even know who Whistler is…"

Later, Proust would return to the attack to make sure no one was in doubt as to the true identity of the characters. The similarity of the tastes of Whistler and Montesquiou were perfect and when they met Parisian society was worried at the way in which the Count underwent a metamorphosis. The narrator, seeing Charlus, says, "I had every opportunity… to admire the will and the artistic simplicity of his tuxedo, which in tiny details which only a tailor would notice had the air of a harmony in black and white by Whistler." In *The Prisoner*, Proust places Whistler's name in Charlus's mouth a fourth time, Charlus being meticulous as to conventions and aesthetics: "That surprises me particularly as I saw someone who had known Whistler and yet did not know what taste was." The United States paid unprecedented homage to a man it claimed as its greatest artist. Artists claimed to have been influenced by him, museums boasted of having acquired his paintings. The Carnegie Institute in Pittsburgh bought the portrait of Sarasate. An exhibition at the Pennsylvania Academy in Philadelphia won him a gold medal. But some of his paintings showed signs of premature ageing (it is impossible to count the number of restorations they have been through). *The Lady in a Yellow Buskin* was bought, as well as the *Blacksmith* and *Little Rose of Lyme Regis* by the Boston Museum. Almost all of Whistler's work left Europe. In the spring of 1903, Whistler's friends believed that the end was near as his naps became more frequent and his heart weakened. Freer, Heinemann, and Pennell visited him. On July 1, the artist stayed in bed, his expression vague. On July 6, he thought he would get up, dress, and even take a ride in a carriage. Duret visited him the next day; Whistler tried to speak to him but was unable to do so. The friends exchanged long looks. On July 14, his face became sunken; he found his voice again and said to Elisabeth Pennell, "I envy your freshness."

On Friday, July 17, 1903, he had a last and fatal attack after lunch; a legendary figure had disappeared.

The burial took place on July 23. The funeral service was held in the Old Chelsea parish church which Whistler knew so well because he took his mother there so many times when they had lived in Lindsay Row. There were few mourners, his immediate family and a few friends, the Pennells, the Whibleys, Lord Alma Tadema, Charles Freer, Sir William Heinemann. The United States sent no diplomatic representative. The Pennells wrote in their biography, "From the house to the church, along the river which Whistler had made his own, the coffin was born on a bier. It was covered with a purple velvet cloth on which rested a gold laurel wreath sent by the International Society… The family, the International Committee, and a few friends went to the cemetery in Chiswick. It was one of those summer days

79. Whistler and Mortimer Mempes.
Photograph, mid-1880s.

150

on which a lowering sky warns of a coming storm. While the vicar recited the last prayers, as the coffin descended into the grave, the heavy atmosphere of London put in this green corner of the funeral enclosure a little of the mystery which Whistler had been the first to see in it and reveal to the world. The grave had been dug next to that of his wife, beneath a wall covered in clematis. A wooden railing, similar to the trellis in the garden in the Rue du Bac, surrounded a bank of flowers which overflowed as if they were in a basket.

A tombstone has since been placed there. "Here lies in peace the greatest artist and the most original genius of the 19th century, not far from the house of Hogarth whom he had always considered, since his childhood in St. Petersburg, as the greatest of English painters, close to the tomb of the man he admired as a master." As Alan Bowness has written, "The history of modern painting in England begins with Whistler, who almost single-handedly broke the blessed isolation of the Victorians and opened the eyes of the English to what was happening on the opposite side of the Channel." In the *Times*, Andrew MacLaren Young had written about Whistler's paintings of the Thames in 1864, "If Velasquez had painted our river, this is the style in which he would have done so." Velasquez had indeed always been a source of inspiration to Whistler. He also fell under the influence of Ingres whose student he would have liked to have been, as well as that of Rembrandt and of Vermeer, who can be felt everywhere in the portraits he made at the end of his life. Then there were the influences of the Old Masters as well as of his contemporaries – Courbet and some of the Impressionists – the orientalising influence of the Japanese woodcuts.

The artist was able to ingest all of these inspirations and create a unique style while following one of his grand designs, namely to develop in the traditions of great art by drawing from its history. Although the stamp of the Old Masters is to be found in his work, his painting is profoundly modern and original. Their influences never overcame his own sensitive and vibrant originality. All his innovations were met with incomprehension and disavowal on the part of his contemporaries. During the trip to Venice he became disheartened and confided that there was no point in painting pictures which no one understood. "One year after his bankruptcy, he was producing little pastel drawings of Venice, such as *Red and Gold: The Church of Santa Maria della Salute at Sunset*. Their brilliant coloring is a forerunner of the paintings Monet made of Venice in the early 20th century. The great portraits of his middle and old age have something of the classical about them, but curiously from the aristocratic elegance of Lady Meux though to the bravura of the last self-portrait, *Gold and Brown*, they are never repetitious, the unfinished portraits of children and young models such as Dorothy Seaton, have a presence and a freshness which he had not achieved earlier.

One can find certain affinities with Bonnard and Vuillard in the little portraits the size of a cigar-box, such as *The Pink Scarf*, in which very young people are painted full length in familiar surroundings. Yet it is above all in the paintings showing storefronts which was Whistler's favorite theme in the last twenty years of his life, that he was so prophetically modern. He reached the end of his artistic adventure bringing his innovations to fruition. Great subjects, great modernist, and personal choices from the beginning of his career would remain powerful until the end of his life, their richness and content were so vast.

The experience of the *Nocturnes* is an absolute in itself, begun in Valparaiso and reaching maturity in London beside the Thames. There would be another nostalgic experience in Venice, and another in Amsterdam where Whistler would use watercolor to make a last study for a *Nocturne*. This is the way in which all of Whistler's artistic experiences evolved.

He satisfied Baudelaire's wish, when the novelist wrote in 1840 about the previous Salon, "We are looking for a true painter, one who can seize the quality of life today and can make us see and understand with his paintbrush and pencil how great and poetic we are in a necktie and in shoes." The painter has left us a number of portraits which are absolute masterpieces. He is a witness of the times and the dandyism which Baudelaire loved so much, yet at the same time, his portraits are original in the way in which they are created. They have nothing in common with those of Meissonnier or Bouguereau, those "creators of jowls" as Baudelaire called them. Whistler's portraits are in reality "an ideal construction, a sort of reconstruction of the soul... a discipline for making the artist look with all his optical senses, the body's eye as well as the mind's eye. Obedience, but at least as much 'divination.' The portrait painter worthy of the name is attempting to expose a secret, he is awaiting a revelation of a drama inherent in every human being." Whistler was able to make tangible contact between the subject and the artist and to transform this creative stage through his vibrant work in which one is seized both by the painter's artistic emotion and the interior nature of the subject. For example, in his portrait of Stéphane Mallarmé, the drawing has captured all the emotion. Mallarmé does not seem to be adopting a pose. The subject seems to be moving within its setting, the painter having captured a fleeting gesture, though this does not represent an immortalized instant or a pose but instead a very palpable continuity. It is not a fixed image but something like a frame from a movie.

Like his fellow painters of the Impressionist generation, Whistler never failed to enthusiastically support the great poets and writers. He influenced them, and they have left their traces in his own work. On the other hand he was very good at translating his painting into literary terms. In part constrained by the critics and the public, he was forced to defend himself to try and make them understand his aesthetic message. In any case, he always received adulation from writers. It is this that many artists lack, the ability to express their art, the link between the image and the word. With Mallarmé the artistic link was firm. Montesquiou shared Whistler's convictions – the elegance, distinction, and mystery of painting. Finally, Marcel Proust was a discreet but convinced admirer. Did he not lay siege to Montesquiou's apartment in order to meet the painter whose reputation so fascinated him? After their meeting at Montesquiou's home, Proust proved he had an attachment that was almost a fetish, by taking away a glove dropped by the artist. Proust's empathy and surprising understanding for Whistler's painting is manifested in *Remembrance of Things Past*. Toward the end of his life, Proust changed his mind about his sympathies for Ruskin's theories (although the academics frequently forget to mention this). *L'Ombre des Jeunes Filles en Fleurs* (*Within a Budding Grove*) contains many references to Whistler. Firstly, Saint-Loup exclaims, "It's as beautiful as a Whistler or a Velasquez." Further on, the narrator says, "And sometimes, on the uniformly gray sky and sea a little pink is added with an exquisite refinement while a little butterfly which had fallen asleep at the bottom of the window seems to add its wings to the base of this gray-and-

pink harmony in the taste of Whistler, as the signature of Chelsea's favorite master." Proust constantly juxtaposes fact and fiction by mentioning Elstir and Whistler, the character and one of the models he used. The first time, he writes, "This behavior, this initial behavior of Elstir's was the most onerous birth certificate for Odette… because he was making her portrait contemporary with numerous portraits which Manet or Whistler had painted after so many models had disappeared and who belonged to oblivion or history." In *Over at Guermantes* (*Du côté de Guermantes*): "But like Elstir, after the bay of Baalbek had lost its mystery and had become for me a nondescript part, interchangeable with all the other stretches of salt water on the face of the earth, it had suddenly yielded an individuality by telling me that here was the opal gulf featured in Whistler's blue and silver harmonies…" In *Time Regained* (*Le Temps Retrouvé*), he writes, "Without doubt, young people had emerged who also loved painting, but another kind of painting one which, unlike that of Swann or Mr. Verdurin, had not received lessons in taste from Whistler, lessons in truth from Monet, permitting them to judge Elstir fairly." Proust also evokes Whistler in *The Fugitive*, in poetical, laudatory terms which he takes from his deep understanding. "I considered the admirable sky incarnadine and violet against which tall encrusted chimneys stood out, their bell-shaped forms and the red flowering of tulips reminding me of so many of Whistler's Venices." Montesquiou had permitted Proust to make a great dream come true by introducing him to the artist, just as he had opened the doors of so many Paris salons for him. At the Count's sumptuous abode in the Pavillon des Muses, the young Proust contemplated the *Nocturne in Mauve and Violet* which Montesquiou had bought from Whistler. He also admired the full-length portrait of Montesquiou which was then the Count's pride and joy. Rodin would succeed Whistler as president of the International Society of Painters, Sculptors and Gravers. He spoke of Whistler's work in the following terms: "Whistler was a painter whose drawings had great depth, and they had been prepared by careful study because he must have studied assiduously. He felt shape, not only as do the good painters, but in the way that good sculptors do. He had an extremely sharpened appreciation which has made some people believe that his grounding was not very strong but on the contrary, it was strong and sure. He understood atmosphere admirably and one of his paintings which impressed me most strongly, *The Thames at Chelsea*, is wonderful from the point of view of the depth of space. There is nothing in the view. There is only this great expanse of atmosphere rendered with consummate art. Whistler's art will never become outdated; it will only gain in importance because one of his strengths is energy, another delicacy, but the above all it is the scale of his drawing."

In 1905, the International Society of Painters, Sculptors and Gravers paid homage to the painter by assembling a magnificent collection of his works in a retrospective exhibition.

At the very moment when Montesquiou was selling his portrait by Whistler, betraying their friendship, Proust was hanging a reproduction of the portrait of Carlyle in his bedroom. Upon his return from the great retrospective held at the Ecole des Beaux-Arts in Paris, he confided in a letter to one of his friends, "The other day, defying death (and alas! Almost finding it) at the hour when I normally went to bed, exhausted, I took a hansom cab on the square and went to see the Whistlers. These are things one would never do for someone who is alive…"

80. Whistler painting in his studio on
 Fulham Road.

81. Marcel Proust. Photograph,
 Bibliothèque Nationale, Paris.

154

BIOGRAPHY

1834
> July 10, born in Lowell, Mass., christened James Abbott Whistler.

1842
> Major Whistler, James's father, settles in St. Petersburg, Russia.

1844
> Mrs. Whistler and the children join Major Whistler.

1845
> J. W. takes drawing lessons at the Imperial Academy.

1847
> J. W. spends most of his time in England with his half-sister, the wife of the well-known engraver Seymour Haden.

1849
> Major Whistler dies. The family returns to the United States.

1851-1852
> J. W. enters West Point Military Academy from which he is discharged in 1854.

1854
> Various apprenticeships, first in a locomotive factory, then at the U.S. Coastal Geodetic Survey in Washington. Resigns in 1855.

1855
> J. W. goes to Paris in November. Universal Exposition in Paris. Courbet Exhibition.

1856
> In June, Whistler enters the Académie Gleyre.

1858
> Produces his first etchings in London, while staying with Seymour Haden. Visits Amsterdam, then the East. Returns to Paris and meets Fantin-Latour, and Manet. Starts working on his canvas, *At the Piano*.

1859
> *At the Piano* is rejected by the Salon. Exhibits a few etchings in England. Exhibits *At the Piano* in François Bonvin's studio. Goes to live in London.

1860
> *At the Piano* is exhibited at the Royal Academy, where it is well-received by the critics and bought by the artist John Philip. Starts the painting entitled *Wapping* and meets Jo, his model and mistress.

1861
> Landscape painting in Brittany. Meets Degas.

1862
> Takes a house in Chelsea where me meets the pre-Raphaelites, whose members included Rossetti, Swinburne, William Morris and Burne-Jones. Exhibits *The White Girl* at the Salon des Refusés in Paris. Wins a gold medal in Holland for his etchings.

1864
> Under the influence of Japanese art, paints *Rose and Silver: La Princesse du Pays de Porcelaine*. J. W. poses for a group portrait by Fantin-Latour entitled *Homage to Delacroix*. Paints *The Little White Girl* and *The Gold Screen*. First use of the butterfly signature.

1865
> Exhibits received badly at the Royal Academy in London. Stays in Trouville, France with Courbet and Jo.

1866
> Visits Chile, paints landscapes of Valparaiso, first night-time landscapes. Separation from Jo.

1867
> Exhibits *At the Piano* and *Thames in Ice* at the Salon as well as at the royal Academy and the Universal Exposition in Paris. Works on *Six Projects*, heavily influenced by Japanese art.

1868
> First meeting with the philanthropist F. Leyland.

1871
> Publication of the *Thames* series. Paints *Arrangement in Gray and Black: The Artist's Mother*, reluctantly accepted by the Royal Academy.

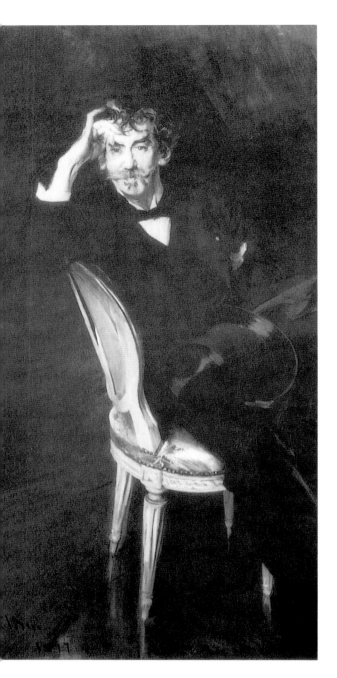

82. *Whistler.* Portrait by Giovanni Boldini, Brooklyn Museum, New York.

1872
For the first time, uses the word "Nocturne" and other terms borrowed from the vocabulary of music.

1874
First one-man show at the Flemish Gallery in London. Meets Maud Franklin, model and companion.

1875
Portraits and *Nocturnes.*

1876
Starts work decorating the Peacock Room for F. R. Leyland, completed in 1877.

1877
The Falling Rocket is exhibited at the newly-opened Grosvenor Gallery. John Ruskin makes an acerbic remark about it. Whistler sues him, and wins but is ruined. Publication of *Whistler v. Ruskin.*

1879
Leaves for Venice with Maud Franklin. Brings back a series of etchings and pastels.

1880
Returns to London at the end of the year. Exhibits his series of etchings which are poorly received by the critics.

1881
Death of J. W.'s mother. Meets Oscar Wilde. Exhibits pastels of Venice.

1883
Exhibits at the Fine Art Society. Wins a medal at the Salon de Paris for *The Artist's Mother.*

1884
Major one-man show of watercolors at the Dowdeswell Gallery in London. J. W. is elected member of the Royal Society of British Artists.

1885
Delivers his *Ten O'Clock Lecture* for the first time in London. Trips to Belgium, Holland and Dieppe, France.

1886
Elected President of the Society of British Artists which the following year becomes the Royal Society.

1888
Marries Beatrix Godwin. Mr. and Mrs. Whistler spend the summer in France.

1889
Receives the French Legion of Honor as well as the Gold Medal at the Exhibition in Amsterdam.

1890
Publication of *The Gentle Art of Making Enemies.* Meeting with Charles Freer, who becomes the greatest collector of works by Whistler.

1891
The Artist's Mother is bought by the Museum of Luxembourg. J. W. begins a painting of Count Robert de Montesquiou.

1892
Buys a house in the Rue du Bac in Paris and opens a studio in the Rue Notre-Dame-des-Champs.

1893-1895.
Produces several portraits including one of Mallarmé for his collection *Verse and Prose.* Lawsuit against Sir William Eden.

1895
Moves to Lyme Regis, Dorset, England, with his wife who is suffering from cancer. Works on his second portrait of the Count de Montesquiou.

1896
Whistler's wife dies.

1898
Becomes President of the International Society of Sculptors, Painters and Gravers. Mallarmé dies. Spends the fall in Paris and opens an art school with Carmen Rossi.

1900
Wins the Grand Prix in Painting and the Prize for Engraving at the Universal Exposition in Paris. Trip to the Mediterranean.

1902
J. W. falls ill. He gives up his Paris workshop and home. Starts a portrait of Charles Freer which he will never finish.

1903
Whistler dies of a heart attack in London.

BIBLIOGRAPHY

CURRY David Park: *James McNeill Whistler at the Freer Gallery of Art*, Freer Gallery of Art, 1984.

EDDY A. J.: *Recollections and Impressions of James Abbott McNeill Whistler*, London and Philadelphia, 1903.

GREGORY Horace: *The World of James McNeill Whistler*, London, New York and Toronto, 1959.

HOLDEN Donald: *Whistler, Landscapes and Seascapes*, Phaidon, Oxford, 1976.

KENNEDY E. G.: *The Etched Work of Whistler*, New York, 1910.

LAVER James: *Whistler*, London 1930. Revised edition 1951.

LEVY Mervyn: *Whistler Lithographs*, London, 1975.

MAAS Jeremy: *Victorian Painters*, Barrie & Jenkins, 1969.

McMULLEN Roy: *Victorian Outsider. James McNeill Whistler*, London and New York, 1974.

MEMPES Mortimer: *Whistler as I Knew Him*, Adam & Charles Black, London, 1904.

PEARSON Hesketh: *The Man Whistler*, London and New York, 1952.

PENNELL E. & J.: *The Life of James McNeill Whistler* (2 vol.), Lippincott, Philadelphia, 1908.

SPALDING Frances: *Whistler*, Phaidon, Oxford, 1972 and *Magnificent Dreams: Burne-Jones and the Late Victorians*, Phaidon, Oxford. SPENCER Robin: *Whistler*, Studio Editions, London, 1982.

SUTTON Denys: *Whistler*, Phaidon, Oxford, 1966.

WALKER John: *J. A. McN. Whistler*, Harry N. Abrams, New York, 1987.

WAY Thomas Robert: *The Lithographs of Whistler*, New York, 1914.

WHISTLER James McNeill: *The Gentle Art of Making Enemies*, London 1890. Reprinted New York, 1967 and London, 1968.

YOUNG A. McLAREN, DONALD MAC, SPENCER R. and MILES H. *The Paintings of James McNeill Whistler* (2 vol.), Yale University Press, 1980.

EXHIBITION CATALOGS

The Early Years of the New England Art Club, 1886-1918, Birmingham City Museum and Art Gallery, U.K., 1952.

James McNeill Whistler (A. McLaren Young), Arts Council, London, Sept. 1960, New York, Nov. 1960.

The Influence of Whistler, Anthony dí Offay Gallery, London, Nov. 1966.

James McNeill Whistler, (Frederick A. Sweet), Art Institute of Chicago, 1968.

Romantic Art in Britain (A. Staley), Philadelphia Museum of Art, 1968.

James McNeill Whistler, Etchings, Dry Points and Lithographs, Colnaghi, London, Nov. 1971.

From Realism to Symbolism, Whistler and his World (A. Staley), Wildenstein, New York and Philadelphia Museum of Art, 1971.

INDEX